Using Your Digital Camera

Using Your Digital Camera

GEORGE SCHAUB

Amphoto Books
An imprint of Watson-Guptill Publications
New York

Acknowledgments

This book, the images, and the digital trip would not have been possible without the cooperation and sharing of tips, techniques, and inspiration from my fellow writers and photographers. I would also like to thank the manufacturers and suppliers who were so generous in their support, including Nikon, Canon, Olympus, Epson, SanDisk, and the many others who have blazed the digital trail. I would especially like to thank my wife Grace for her patience and support, and her vision and presence on this journey.

George Schaub is the Editorial Director of *eDigitalPhoto* and *Shutterbug* magazines. A graduate of Columbia University, he is a member of the faculty in the photographic department at the New School in New York City. He also worked as Editorial Director of Studio Photography and Design and as Executive Editor at *Popular Photography* magazines. Schaub has taught digital imaging workshops throughout the United States and overseas, and has exhibited his photographs at numerous galleries throughout the country. His bestselling books, *Professional Techniques for the Wedding Photographer* and *Using Your Camera*, have also been published by Amphoto.

Library of Congress Control Number: 2002117196

ISBN: 0-8174-6355-0

Printed in Malaysia

First printing, 2003

1 2 3 4 5 6 7 / 07 06 05 04 03 02 03

Senior Acquisitions Editor: Victoria Craven
Editor: Meryl Greenblatt
Designer: Jay Anning, Thumb Print
Production Manager: Hector Campbell

To Mom,
whose spirit still hears music and delights in light.

Contents

Introduction 8

1 The World of Digital Photography 12
Film Photography 13
The Digital Difference 15

2 Pixels, Bits, and Bytes 20
Image Capture 21
Memory Card Capacity 27
File Format and Compression 27
A Digital Imaging System 29

3 Picture Controls 34
The Camera 35
Understanding Exposure 37
Focusing 52
Flash Photography 58
The Digital Side 61

4 Image Menus 70
Record Menu 71
Image File Management 79
Playback Menu 80
Setup Menu 81

5 Downloading Your Images 82
Camera Software 83
Downloading Images 84
Card Readers 86
Dockable Cameras 87
Organizing and the Save As Command 88

6 Image Editing 90
Image Software 91
Image Edits 93

7 **Printing Your Digital Images** **100**

Equipment and Materials 101

Digital Printing 103

Kiosk and Lab Printing 109

8 **Internet Images** **110**

E-mail 111

Picture-sharing Services 113

Building Your Own Website 116

9 **Supplementing Your Digital Library** **118**

Doing It Yourself 119

Picture CD and Scanning Services 121

10 **Picture Projects** **122**

Exploring with Your Camera 123

Project 1: Composition 124

Project 2: Light, Color, and Exposure Controls 127

Project 3: White Balance Customization 130

Project 4: Camera Plus Computer 131

Project 5: Stitching 132

Project 6: Pixellate It 134

Project 7: Swapping Color 135

Project 8: Specialty Prints 136

Project 9: Scan, Retouch, and Print 138

Project 10: Color Variations 140

Project 11: Adding Color 142

Project 12: Plug-ins and Filters 144

Project 13: Color Moods 148

Project 14: Black and White 149

Project 15: Line Drawings 150

Glossary **151**

Resources **158**

Index **159**

Introduction

The digital image has revolutionized the photographic world, yet its most prominent ancestors are the satellite and computer. Rather than beaming photographs back to earth, early satellites captured shapes and colors that were first translated by imaging sensors into electronic codes and then transmitted to receivers on earth. Computers translated and processed these codes, reassembling the information as an image. The technology then used and the programs that transformed the information were the true forerunners of today's digital photography and all that goes with it.

As digital imaging technology developed, it drew upon many sources, including advances in television, medical imaging, the printing business, and even the entertainment industry. And, of course, photography.

The 1970s saw a true turning point in digital imaging's history. The development of the microprocessor forged the alliance of imaging and the computer, a marriage that would forever change how images are recorded, transmitted, processed, printed, and shared. The earliest attempts at consumer-grade electronic still cameras were not very successful, at least in terms of image quality. But they did pave the way for today's digital cameras that produce images without film.

The digital image continues to change the way we record and share our pictures. Indeed, digital cameras provide distinct economic and creative advantages over traditional photographic processes. Images no longer need be recorded on film that must be processed and printed before results are seen. With digital photography, an image can be viewed an instant after the exposure has been made. Your pictures are saved right inside the camera on small cards that can be swapped in and out of the camera without fear of light striking and harming them, unlike the process of changing rolls of film before they are fully exposed. The cards are reusable, which saves lots of money on film and processing costs. The images can be transferred to a computer by patching the camera to the computer via a card reader or slot right on the computer. The cards can also be placed directly into a printer for immediate use. Often, an image might never see paper, yet be shared with friends and relatives all over the world.

If you want prints you can make them yourself using a desktop or laptop and a photo-quality printer. This means that creative work with photographs no longer requires chemicals and darkroom equipment or using commercial photographic labs. And easy-to-use imaging software has radically changed what can be done with an image after the shutter is snapped, leading to a host of practical and creative paths.

If you have worked with film cameras you have a good foundation for using your digital camera. Whether you have worked with a point-and-shoot camera or a single-lens-reflex (SLR) camera, you probably know a lot about the "photo" side of digital cameras, including flash modes, picture modes, and perhaps aperture- and shutter-priority exposure modes. You may even have worked with advanced photographic techniques such as exposure compensation and setting the lens aperture for depth-of-field (the range of an image's sharpness) control or shutter speed for stopping action. Many digital cameras have this "photo" side to them and other features found in comparable point-and-shoot and 35mm SLR cameras.

If you haven't worked with film cameras, don't fear. We will cover all the features of the photo side of digital cameras in this book, and give you information that will help you decide when and how to use each one.

What might be most baffling about digital cameras is their "digital" side, that is, the issues that clearly differentiate them from film cameras. Terms like resolution, image-quality mode, file compression, digital print order format, and dpi (dots per inch) are new to everyone. It may sound like techno babble, but understanding and applying these features to everyday use of your digital camera can be a key ingredient in getting the most from it. For example, cameras are often rated by their "pixel" count and grouped by the megapixels they can record. Understanding the implications of what's called resolution will help you not only purchase the right camera for the type of photography you like to do but also allow you to use your camera creatively.

The aim of this book, then, is to explore both the photographic and digital sides of digital cameras, with the goal of helping you get the best images from your camera,

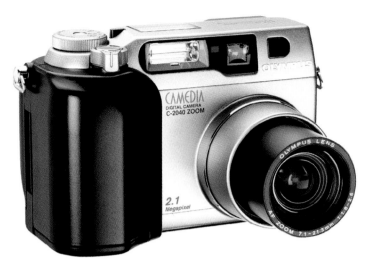

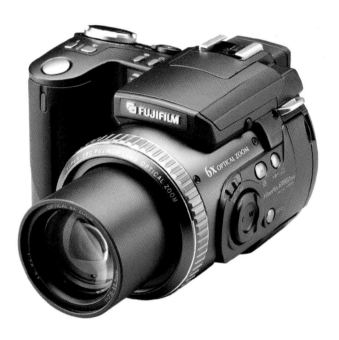

Digital cameras come in a variety of styles and with varying features. They come in point-and-shoot and single-lens-reflex models, just like film cameras, and match the comparable film cameras in almost every feature. Here is a sampling of digital cameras used to make the pictures in this book.

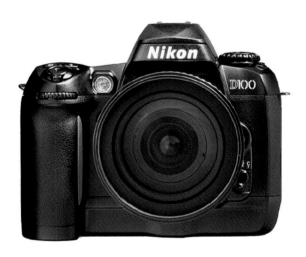

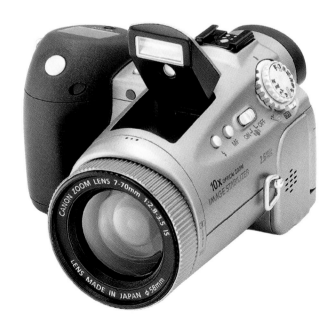

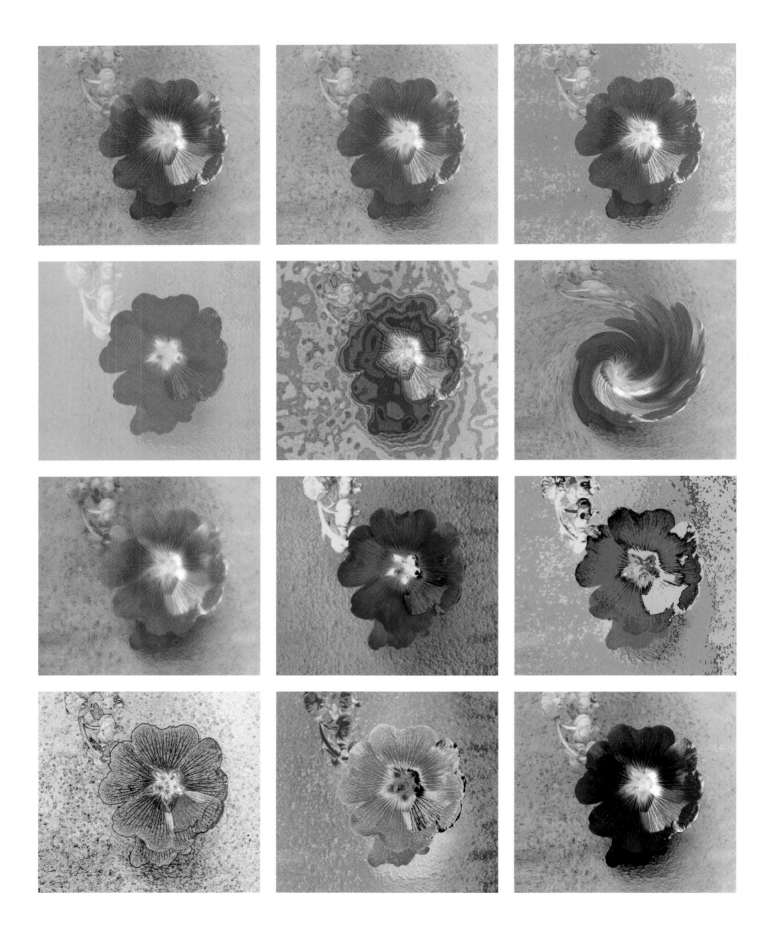

printer, and software. Whatever we cover will not be done just for the sake of explaining the technology—we'll work with real-world applications that can be used every time you pick up your camera. We'll cover some photographic basics that apply to both film and digital cameras, emphasizing how these principles work in the digital realm. We'll also take a guided tour of a digital camera to show you how to use every feature and capability. We'll describe the processes for getting images from the camera to the computer, sending and sharing images, putting images on-line, and obtaining the highest quality prints from your images.

Will digital photography replace film photography? Probably not, at least in the near future. However, the digital revolution has opened up many new avenues for creative expression that were previously available only to those with expensive cameras and darkroom gear and years of experience with both. Digital photography is an exciting field that can become a great hobby, and perhaps one that can even help you in your work.

With that in mind I invite you to join the digital photography revolution. It is young in some ways, but in others as old as photography itself. It is, in many respects, the next phase in the evolution of what many people, including myself, consider the most exciting and accessible form of visual expression—making and sharing images using camera and lens.

As a final note I'd like to mention that every picture in this book was made with a digital camera and processed in a computer using off-the-shelf software. The cameras used range from simple point-and-shoot cameras to full-fledged digital SLRs; the majority of images were made with mid–price-range digital cameras. There is no shooting technique or image editing process that could not be done with similar equipment.

—GEORGE SCHAUB

When you take a picture with a digital camera, you begin a process that can take you in many different visual directions. Exploration and experimentation are part of the fun. A simple image, such as this flower photographed against a stone wall, can start you off on a creative journey. The variations shown here, which include a range of differing color contrasts and special effects, were created using image-editing software. All the changes were made with push button ease and processed within seconds. Just one of these variations would have taken hours to do in the old chemical darkroom.

1 The World of Digital Photography

An Overview

- **Film Photography**
 - Light and Film
 - Developing and Printing
 - Camera and Film Formats
 - Film Quality and Speed
 - Film Types
 - Sharing Pictures
 - Viewing Film

- **The Digital Difference**
 - Light and Digital
 - Developing and Printing the Digital Image
 - Digital Camera Formats
 - Sensor Sensitivity
 - Color and Black-and-white Images
 - Digital Film
 - Sharing Digital Images
 - Viewing Digital Pictures

WHEN ELECTRONICS became a part of photography, it changed the way pictures are made, processed, manipulated, and shared. Memory cards holding digital code replaced film. The computer and desktop printer began to replace darkrooms and chemical processing. Photo albums became "virtual" and resided on CD ROMs or on the Internet. Photographers could see an image right after the picture was made without using a paper proof. Creative printing techniques previously available only in a photo lab or home darkroom became available to anyone who wanted to get involved.

Even with all those changes, the essential nature of making a picture has not changed all that much. The effectiveness of a photograph still relies on the quality of light, the photographer's point of view, and, of course, the content. As with film, neither the digital camera nor the computer makes a picture; the photographer does.

There's no doubt, however, that digital photography brings with it a new set of terms and tools that can open up new ways of making and sharing photographs, and perhaps even the way that pictures are seen. Part of mastering these tools is gaining an understanding of what makes digital photography work and how it may differ from, and resemble, traditional film photography.

Film Photography

Thanks to the wonders of automatic loading and rewind, the responsibility of making sure film has been inserted properly and later removed without unintended and damaging light exposure has been handed off in many cases to the camera. APS cameras make things even simpler—with the film firmly encased in a cartridge, there's no outward indication that it even exists. However, even with point-and-shoot cameras you do need to make certain decisions about film formats and exposure, so it's good to have at least a grounding in the basics.

Light and Film

All photography is based on the action of light energy and how it can cause change in a light-sensitive material. In film, that light-sensitive material is composed of silver salts known as silver halides. Light striking photographic film acts upon those salts. When the film is chemically developed, part of the process changes those light-struck salts to metallic silver. In color film the silver halide grains are placed within certain color layers. These act as filters and help to sort out the hue and intensity of the colors that are recorded. During the developing process the metallic silver is replaced by color dyes in proportion to how much metallic silver has formed in each color layer. Thus, the intensity and color of the light that strikes the film is proportional to the color (its hue) and tones (the light and dark shades of a color) produced. When combined, those color layers form a sandwiched composite that yields a full-color representation of the scene.

Developing and Printing

Development in film photography relies on chemicals that change the latent, or recorded, nonvisible image on the film to one that can be seen. Color negative (print) films are actually reversed representations of the colors and tones in a scene. To see the "true" colors and light and dark tones, a print is made by projecting the negative onto a sheet of light-sensitive photographic paper. This paper is then processed in chemical baths to yield a positive print.

Camera and Film Formats

Film cameras are divided into groups according to the type of film they hold. These films range in size from the standard 35mm to medium format (about 2.5 times larger than 35mm) to 4 x 5-inch sheet films and larger. One of the main reasons for choosing a larger film size is increased resolution—the capability of distinguishing details and fineness of lines—and enlargeability—the largest size at which the final print can be made with good results. All other things being equal, the larger the negative the more it can be magnified, or enlarged, and the finer the detail it reveals.

Film Quality and Speed

Film quality has reached a peak where even prints from 35mm negatives can be enlarged to 11 x 14 inches or more, given that the lens and steadiness of the photographer provide optimum conditions. Film speed, which

The image-forming foundation of film is composed of silver halide grains. The picture is created by millions of these microscopic grains that, when viewed together, give the impression of continuous tone. This photograph of a flower was made from 35mm slide film. To illustrate the salt-and-pepper pattern of grain that makes up the image a detail of the slide was greatly enlarged and converted to black and white (right).

reflects a film's sensitivity to light, has also gotten faster—that is, films are now better able to capture images in lower-light situations. Films with speeds as fast as ISO 800 are now commonly used in snapshot cameras and can provide very good results. ISO, which stands for International Standards Organization, indicates the lighting conditions under which you can shoot without using flash or steadying the camera to avoid blurry pictures. Camera shake is common when shooting at too slow a shutter speed, for example, an ISO of 100 means you can shoot in daylight and bright interiors without flash; an ISO of 200 or 400 extends the low-light range. An ISO 800 film allows you to shoot indoors without always having to use flash.

Film Types

Film comes in a variety of types such as color negative, color slide, and black and white. There are also specialty films for attaining proper color rendition under daylight or artificial light. Filters can be added over the lens for many special effects as well as to provide proper color balance and creative color casts.

Sharing Pictures

Once pictures are made, prints can be shared in many ways—through the postal service, by placing them in albums, or by framing and hanging them on a wall or placing them on an office desk or living room table.

Viewing Film

All film, whether negative or positive, can be held up to the light to see the image. The record is the representation of the scene itself.

When you work with a digital camera, it's like having every different type of film at your disposal for every photograph you make. This series shows the possible states of an image made on a variety of films. Pictures can be made on positive (slide) film and color or black-and-white negative film. Color slide film yields a positive image that you can project or print. Color and black-and-white print film starts out as a negative (top row) that is then printed onto photographic paper to create a positive print (middle row). All these variations were made from a digital file using image-editing software. As a bonus, an enhanced image was made from that same file (left). These conversions took a sum total of about a minute in the computer.

The Digital Difference

All of the above about film may be self-evident to anyone who has ever made a photograph or handled a camera. The differences between film and digital, however, are most easily understood when you compare the two mediums point by point.

Light and Digital

The light-capturing part of a digital camera is the sensor built into the camera that rests behind the shutter and/or lens. This sensor is composed of a large number of photo sites, each of which builds an electrical charge when exposed to light. The sites are covered with a checkerboard pattern of red, green, and blue filters, which select out the corresponding color and light values in the scene. The color and intensity of light that is recorded depends on the intensity of color and light hitting each site. Color and light values (brightness) are then integrated by a series of steps performed by a microprocessor inside the camera.

The individual sites are referred to as pixels, or picture-building sites. When an exposure is made the electrical charge created is transferred to a converter that changes the electrical signals to digital code. This is the analog-to-digital converter. Each pixel is then assigned a character that can be defined as "dark blue," "bright pink," etc. The binary (computer) code that contains each pixel's character and address (where it resides in relation to all the other pixels) is then transferred to a memory storage area or card that holds the information for later reading. This area is called a buffer if it is built into the camera or a memory card if it is removable.

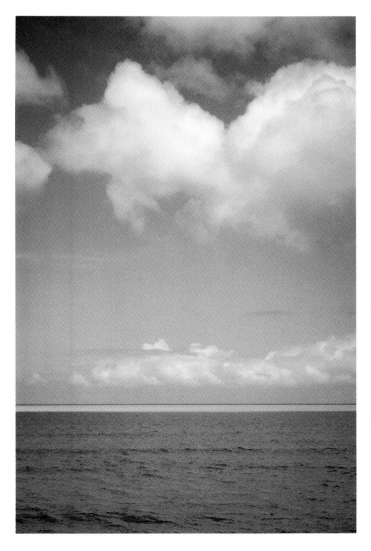

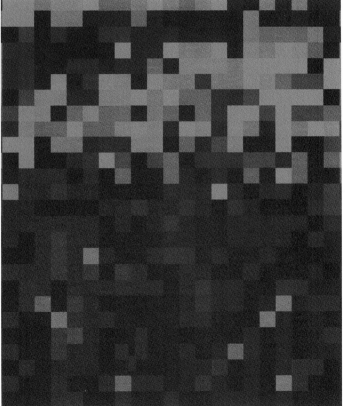

Digital images are "built" from geometric grids, each of which is a pixel. Each pixel has a distinct "identity" of color and brightness. This digital file of water and clouds (left) was enlarged and given added contrast to illustrate the mosaic of pixels that created the image (right). What you see are the sky and a wisp of clouds. This extreme magnification shows how continuous tone can be created from geometric forms.

Developing and Printing the Digital Image

No chemical steps or intervention of the photographer is necessary to "develop" or "process" digital images. This is done by the circuitry within the camera and involves sorting the binary code and assigning characteristics—such as color and light or dark tones—to each of the pixels. This stage, however, may take some time to complete, depending on the number of pixels used for recording and the complexity of the image itself. In some digital cameras the delay may be as long as a few seconds right after the photograph has been made. This "lag" is the reason that some digital cameras may seem slower in operation compared with their film counterparts. Film exposure is generally instantaneous and exposures can be made one right after another. Some digital cameras, however, do allow for rapid shooting sequences, or even "video" clips.

Digital printing involves transferring the image code to a printer that can read that code and translate it back to colors and shades. Digital printers generally come in two types. Ink-jet printers spray color from tiny nozzles fed by ink cartridges onto paper. Dye sublimation printers use heated print heads to force color from ribbons onto specially treated paper. This is quite different from traditional photographic printing, which uses a light source and projection. Digital printing can be done in broad daylight; photographic printing can be done only in a darkroom or in a printer shielded from all white light. Easy-to-use digital imaging software makes creative printing and image manipulation something everyone can do, while expert printing in the chemical darkroom might take years of experience.

Digital Camera Formats

Although the size of the chip—another term for sensor—in digital cameras may vary, one of the main things that differentiate one type of camera from another is the number of pixels that chip contains. This is referred to as pixel resolution or pixel count. All other things being equal, a digital camera that contains a greater number of pixels on its chip will be able to yield larger (and generally better quality in comparative enlargement sizes) prints than those with smaller pixel counts. These counts are often defined by height and width and by the inch. The term used is "pixels per inch," or ppi. Rather than get too deep into this here, suffice it to say that the greater the number of pixels in a sensor the better the possibility of getting larger prints from images produced by the camera.

One of the big advantages of digital cameras is that you can see the image right after the exposure is made and play it back again and again before you download it to your computer. That way you can judge whether the exposure and pose are right. The LCD monitor preview allows you to "trash" the record and makes more space on the card for other pictures.

Sensor Sensitivity

Like film, digital camera sensors are built with a certain sensitivity to light. Also like film, this sensitivity is measured and expressed as an ISO number. Many digital cameras have an ISO of 100. Unlike film, though, where you exchange rolls of different speed when you want a higher ISO, the digital sensor can be boosted to yield a higher speed.

More professional and expensive models allow you to vary the ISO according to lighting conditions. However, be aware that this modification does come at a price: as you raise the speed the image quality may suffer. On the other hand, having a sensor that offers a variety of speeds is certainly convenient. Overall, keep in mind that higher ISO numbers allow you to shoot in dimmer light without flash. With an ISO of 800, you can shoot indoors without camera shake, except in very dark conditions.

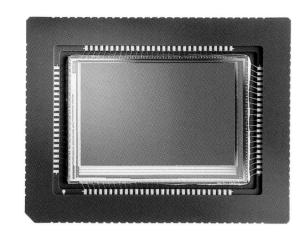

This sensor is the heart of digital photography. It captures light and sorts color information, all of which is then processed right in the camera. After exposure and image processing, the sensor clears the information and is ready for the next photograph.

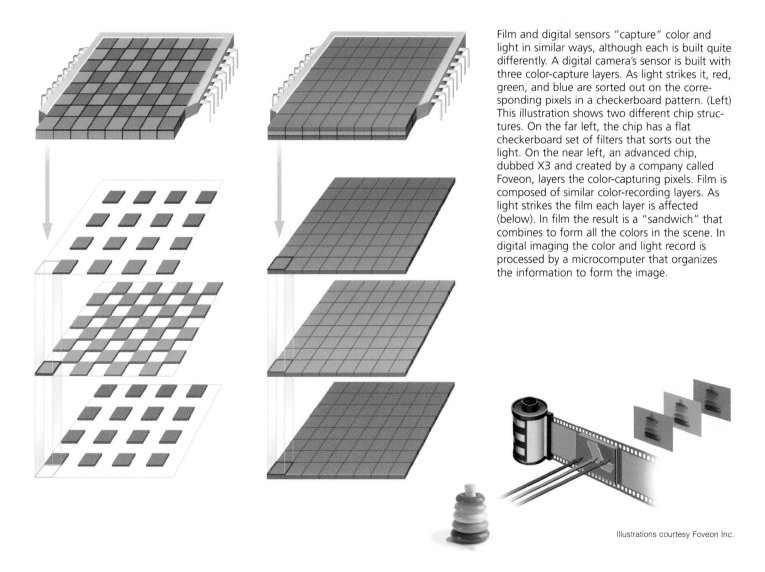

Film and digital sensors "capture" color and light in similar ways, although each is built quite differently. A digital camera's sensor is built with three color-capture layers. As light strikes it, red, green, and blue are sorted out on the corresponding pixels in a checkerboard pattern. (Left) This illustration shows two different chip structures. On the far left, the chip has a flat checkerboard set of filters that sorts out the light. On the near left, an advanced chip, dubbed X3 and created by a company called Foveon, layers the color-capturing pixels. Film is composed of similar color-recording layers. As light strikes the film each layer is affected (below). In film the result is a "sandwich" that combines to form all the colors in the scene. In digital imaging the color and light record is processed by a microcomputer that organizes the information to form the image.

Illustrations courtesy Foveon Inc.

Color and Black-and-white Images

Unlike film, where you choose a certain type for recording in color or black and white, you can use your digital camera to shoot color *and* black and white without worrying about swapping film. The digital image record can be viewed or printed in either full color or monochrome. Some digital cameras do have a black-and-white shooting mode, but you can always decide to change a color photograph to black and white later.

Specialty films are available for shooting in different lighting conditions, such as daylight or tungsten illumination. You match the film type with the lighting conditions, or use filters to balance the light to yield true colors on the film. With digital cameras you can change a setting, known as white balance, and have the sensor deliver the correct color under virtually every lighting condition. Normally, when you shoot daylight film under indoor lights you'll get an amber cast. That's because light bulbs are deficient in blue and the film can't correct for the color cast. With a digital camera all you need to do is switch the white balance to "indoors" and the microprocessor in the camera will do the rest.

When you use a digital camera, you can have every film type and speed available for every frame you shoot. Not all digital cameras have a variable ISO option, but most have white balance controls at the minimum. This feature really comes in handy for creative techniques and can allow you to make photographs under changing conditions that would require you to swap one film for another in traditional cameras.

Digital Film

Digital "film" is a memory storage card. You can keep or delete pictures from the card as you shoot, or after. You can change cards at any time without fear of having your pictures ruined by unwanted light. Like film, however, memory cards do have a certain storage capacity. Cards are available with very large capacity and in some cases you can get up to 100 or more images on one. You can also record short motion clips and sound if your camera offers these recording features.

Sharing Digital Images

Perhaps the most profound change with digital photography is the ability to share images with more people with greater ease. In fact, you can see a picture right after it is made through an instant preview feature on the camera's LCD (liquid crystal display) monitor. It's quite easy to make prints as well. With some printers you can pop the

memory card into a slot and print without a computer. You can even "order" the print size and quantity in the camera using the digital print order format feature, or DPOF. If you do download your images from camera or card to a computer you can apply corrective or creative touches to them. You can eliminate red eye, change the color and mood, and, with some digital cameras, even stitch together images for a wide panoramic view of any scene. In short, you don't need a lab and you don't have to wait to see the results.

The economics of digital printing makes sense as well. Rather than spend money on film and film processing, you only need to buy one memory card and one printer, as well as inks and paper for that printer. You pick and choose the pictures you want to print, rather than reviewing an entire roll of film and perhaps keeping just six photos out of 36.

Some digital photographs never see paper at all; they exist as "virtual" images on the Internet. Photo-sharing and albuming sites allow you to post (upload) your digital pictures to the web. You then notify friends and family of their posting, give them a password, and they can see the photos and even order prints right from the site. Professional photographers, like those who cover weddings and special events, have put this feature to great use. It has changed the way many photographers do business.

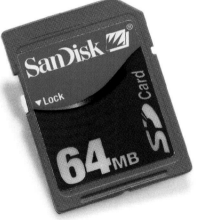

One of the chief differences between film and digital recording is that film can be held up to the light and viewed. (Left) This color negative is how we are used to seeing the photographs we make. Digital "film" is generally a solid-state memory card, one that holds image information in bits and bytes. Hold it up to the light and all you see is the card (right). Digital imaging requires "readers" and translators that convert the digital image information back to a visual image. This thumbnail-size memory card can hold as many as 100 images.

Viewing Digital Pictures

The only way to view digital pictures is with a viewer—either the camera itself, via a computer, or, with some cameras, on your TV set. Unlike film, you can't hold a memory card up to the light and see what you've got on it. That's why organizing your digital picture files and backing up those files on a CD or DVD is important. You might even want to make a copy of your copies every few years. Digital pictures are made up of code and without translation or a reader they're just a medium without a message.

Now that we've covered some of the similarities and differences between the "old" and new forms of photography, it's time to start exploring the digital photography realm in depth. As we do, keep in mind that your digital camera can do everything a comparable film camera can do, and more.

When you work in the "digital darkroom," you have access to tools and techniques that would take a long time to master in a film darkroom. These tools can be used to create abstracts or emulate the look of traditional photographic prints. As you work on your images you can experiment with ease, since you see the results as you work—unlike in a chemical darkroom, where you have to process each print as you go. This series of images begins with a black-and-white film negative scanned to create a digital file (above). (We'll cover scanning in Chapter 9, "Supplementing Your Digital Library.") It lacks character and fidelity. The next step is to darken the image overall while keeping some of the tree bark bright (above right). As a final touch, a color tone was added to the monochrome image (right). Even if you had years of chemical darkroom experience, this process would have taken a few hours to get right, including mixing chemicals and cleaning up after you were done. This final image required about five minutes of computer time without fuss or cleanup.

2 Pixels, Bits, and Bytes

A Technical Primer

- **Image Capture**
 - Pixels
 - Megapixel Count
 - Image File Size
- **Memory Card Capacity**
- **File Format and Compression**
- **A Digital Imaging System**
 - The Computer
 - Storage Devices
 - Printers and Paper
 - Monitor
 - Software
 - Memory Cards
 - Card Readers
 - Batteries
 - Portable Storage Devices

DIGITAL PHOTOGRAPHY has spawned a whole new set of terms that help define what the camera can do, the way that you can use the recorded image, and just what type of quality you can expect from the photographs you make. Understanding these terms will take the mystery out of this realm. There is a logic to the system that can be followed throughout the entire process, from making pictures to print to creating images for the Internet. This chapter goes into some technical matters that may seem confusing at first, but address the basic tenets of this new form of photography. While you don't need to know everything about bits and bytes to enjoy your camera, familiarity with the terms will help you get the most out of it. Read the chapter over and keep it in mind as we explore the applications of these principals throughout this book. Use this chapter as a reference that you can come back to later.

We'll begin with the foundation of digital image creation—the sensor in the camera and what the pixel count tells you about what you can and cannot do with your camera. We'll then cover a typical digital imaging system, including computers, scanners, and storage devices.

Image Capture

The imaging sensor, or chip—the heart of the digital camera—is usually a charge-coupled device (CCD) that sits inside your camera, just like film. It is composed of an array of photo sites overlaid with color filters. These sites convert light to electrical impulses, which are then transferred to microprocessors that "develop" or integrate the image information and send it to an analog-to-digital converter. This process "translates" the electronic information to digital format, in a binary code that specifies the character (color and brightness) of each pixel, or "building block." This digital information is then stored in memory, either on a memory card (digital "film") or in an area inside the camera itself known as a buffer. In many ways a digital camera "captures" an image using the same principle as film; it is writing with light, although it's more like using a word processor than a typewriter.

Pixels

When pixels are packed together, they form an image. If you magnify a digital image you will see a lineup of boxes. This is analogous to film, where millions of grains in black-and-white film or dye clouds in color film combine to form a continuous-tone image that we see as a photograph. Both film and digital images are illusions that work because we tend to see close-packed parts as a whole—a unifying principle that allows us to make sense of the world. The difference is that pixels build with boxes or close-packing geometrical forms while film builds with more randomly shaped grains.

Image quality is in part dependent upon the resolution—in digital photography this means the number of pixels per inch (ppi) in the sensor—and subsequently the image itself. The higher the image resolution (the more pixels used to capture an image) the better the print quality. Higher resolutions generally allow you to make larger prints.

If you want to see what a pixel looks like, you can "open" a digital image on your computer and start pressing the zoom-plus key. About the fifth or sixth zoom keystroke will show you the pixels. While interesting, you usually want to avoid seeing these in your image, unless you want to create a rather odd abstract of a scene. When you begin to see pixels, the illusion of the continuous tone image is shattered, lines break into jagged steps, and the picture becomes unclear. As you'll see, this loss of image quality due to insufficient pixels at a certain size has a profound effect on the results you get when using your digital camera for prints of different sizes.

In digital imaging, the end use and the resolution of the image are tied together. This doesn't mean that you need to get the most expensive camera to get good prints, and you definitely don't need a high pixel count camera if you want to shoot just for e-mail or web images. But if you want to regularly make 8x10-inch prints you should consider purchasing a digital camera with a higher count.

When you print digital images, the size of the image is very important. That size is determined both by the number of pixels per inch (ppi) you set and what is available in your camera. Too small a resolution will yield a poor print. This image was made with a digital camera and after cropping resulted in a 486 x 286-ppi image, or a 550 K image file size. When printed out at 3 x 5 inches, the nuance of color and tone is lost and you can begin to see jagged edges where straight lines should appear (top). The loss of quality becomes very apparent when the print is enlarged to 7 x 9 inches. The picture is fuzzy and all sorts of artifacts (color dropouts and poor edges) appear (bottom). However, this small file size makes sending the image as an e-mail quick and easy and will load quickly onto the web page.

Megapixel Count

One of the main specifications of any digital camera is the pixel count of its sensor. If you look at the "spec" list you'll notice an item called resolution modes. You may see a bunch of numbers like 1536 x 1024, 1024 x 768, or 640 x 480. These represent the number of photo sites—or pixels—per inch in the sensor; the larger number always refers to the horizontal measure.

Trying to figure out which dimensions yield the best pictures can be difficult. For that reason there are two guides that will give you at least a ballpark estimate of what you can expect to do with your camera: megapixel count and image file size. Let's cover megapixels first. In fact, that's how most cameras are sold today—by stating their maximum megapixel count.

Megapixel is a new term, a combination of two words. "Mega" means million in Greek. To translate the pixel resolution mode into megapixels you multiply the horizontal by the vertical pixel count. So, 640 x 480 = 307,000 pixels, or 0.3 megapixels. A 1200 x 1600 resolution yields 1,920,000 pixels, or 1.92 megapixels. The chart below illustrates how images of various megapixel counts can be used to their best advantage.

The megapixel count is not the only factor in image quality. The lens, the way the camera translates light into digital code, the shutter speed and overall exposure, and the quality of light in the picture also have profound effects. But matching pixel resolution level to the use of the image you have in mind is a good starting point.

BEST USES FOR SENSORS OF VARIOUS SIZES

Megapixels	Maximum File Size	Best Use
Less than 1	1–2 MB	Very small prints, e-mail attachments, web page images.
1	3 MB	Small prints.*
2	6 MB	Good 5 x 7-inch and smaller prints.*
3	9 MB	Good 8 x 10-inch and smaller prints.*
4	12 MB	Excellent 8 x 10-inch and smaller prints.*
5 and above	15 MB+	Excellent 11 x 14-inch and smaller prints. Higher counts will yield increasingly larger prints.*

*Can also be used for web and e-mail, when lower resolution options are chosen.

Digital cameras offer you a choice of resolutions when you photograph. You should choose a resolution based on what you think the end use of the image might be. Not all cameras indicate resolution levels the same way. Your choices might be Good, Better, and Best; Basic, Normal, and Fine; or even SQ, HQ, and SHQ (Standard Quality, High Quality, and Super-High Quality), with each sequence indicating higher resolution choices. The number of pixels in each quality setting depends on the total number of pixels the camera chip has. This photograph was made with the same camera at different quality settings and then enlarged to 8 x 10 inches. (Left) This image shows the detail from an picture made at the highest quality setting. Lines are sharp and the subtle colors are clear. The next image (right) shows an image made with the same camera at the lowest quality setting. Note the lack of sharpness and overall loss of quality.

Even images made at the highest quality setting will deterio-rate if you attempt to enlarge them too much or select a small portion of the frame to print just a small portion of the image. This photograph was made with a 5-megapixel digital camera at high resolution and can produce a very good 11 x 14-inch print (above). The software screen (Pho-toshop Elements) shows what happens when you crop and enlarge even this high-resolution image too much (right). Like film, digital files have a limit. With film, grain becomes objectionable. With digital image files the image breaks up into a set of fuzzy boxes.

Image File Size

Another shorthand you can use is the image file size, that is, the digital file size the sensor gives you at various resolution levels. Here we have to add another factor to our calculations, and that's the color-forming red, green, and blue (RGB) layers.

To figure out digital file sizes, multiply your megapixel count by 3 (for the three colors). If you shoot at maximum resolution with a 2-megapixel sensor you will get a 6-megabyte (MB) file when you "open" the image on your computer. Digital cameras that have a 4-megapixel sensor can deliver a 12 MB file. Be aware that this is the ideal formula, and that some sensors deliver less usable pixels than their pixel count might imply.

As a rule of thumb, a 3 MB file is good for small prints; a 6 MB file is good for up to 5 x 7-inch prints, and a file size of 12–16 MB will yield good to excellent 8 x 10-inch prints.

As with megapixel counts, other factors determine image quality, but the above is a helpful guide to getting very good prints. As you can see, as you get into higher megapixel counts the print size can increase. But if you just want to shoot for e-mail or your web page, a 1-megapixel camera will often do the job.

BIT- AND BYTE-SIZE LANGUAGE FOR COMPUTER TECHIES

Bits and Bytes

Computer data is measured in bits and bytes, a bit being the smallest measure. Bits are binary, which means that each one indicates an on/off or yes/no proposition. 1 byte = 8 bits; 1024 bytes = 1 kilobyte (K); 1024 K = 1 megabyte (MB); and 1024 MB = 1 gigabyte (GB).

Bit Depth

Each pixel in the digital camera's sensor captures light information, describing the light value and color of that pixel, which is expressed in binary code. It takes 8 bits to describe 1 level (or shade) of gray on a black-to-white graduated scale. In the computer imaging world, a black-and-white continuous-tone image can be made from up to 256 levels of gray. When color is added to the scheme, 8 bits are registered in each color channel of red, green, and blue (RGB), to describe over 16 million colors. The color image is referred to as 24 bit (three 8-bit channels). Some professional level cameras and scanners are made to capture a greater bit depth, such as 36 or 48, and by offering more information usually deliver better quality results. However, this depth is usually compressed to 24 when outputting the image on screen or a print, as that's the most information some output devices can handle. If you get involved with high-end equipment or pro imaging you'll likely be using 36- or even 48-bit image files, but for now you'll be working with 8-bit (grayscale, or black-and-white continuous-tone) and 36-bit (RGB color) files.

The effect of resolution on what you can do with an image can be seen when you print or work with Image Size in your software program. This feature is used for making images for the web or e-mail, or for printing an image. You can use it to understand how resolution and final use of the photograph are related. When you first open an image, it is set at a resolution of 72 ppi. You can keep this setting for e-mailing or posting images on a website or for any use where the photograph will be viewed on a screen. (A–C) Note the effect of file size (the pixels set in the Pixel Dimensions area of the box and expressed as either file size or pixel dimensions) on the size of the image at a certain resolution. In the first three images, as the resolution of the image changes, the size of the image follows. For example, a 16.2 MB image (1971 x 2868 pixels) at 72 ppi yields a nearly 27 x 40-inch image. This is too large for screen viewing and would take a very long time to send as an e-mail attachment or load as a web image. A better choice for a screen image is the 550 K setting (C) that, at the 72 ppi setting in Document Size, yields a nearly 5 x 7-inch image. This will load almost immediately and not clog up anyone's e-mail. A print at 72 ppi is never very good, so when printing you need to set the resolution for the printer. Experience shows that for many printers a setting of 240 ppi yields very good results. When you change the resolution in Document Size for printing to 240 ppi you can see how the Document Size changes. (D–F) At 16.2 MB the file would yield an excellent 8.5 x 11-inch print, while at 550 K you get a very good postage-stamp size print. These numbers are the foundation of making good prints and creating e-mail and web images that yield the best results. As you experiment with your system you will become more at ease with what seems to be some tricky math. To practice, open up the Image Size dialog box on your software program and plug in different numbers.

The Effect of Pixel Dimension (and File Size) on Quality Print Size

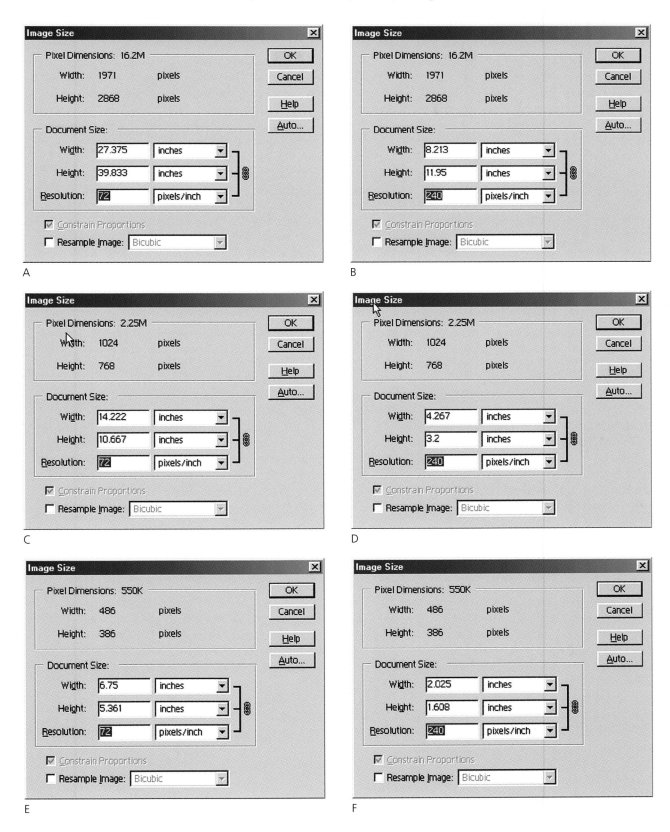

A

B

C

D

E

F

DIGITAL IMAGING MATH:
PIXELS PER INCH (PPI) AND DOTS PER INCH (DPI)

When we discuss the image file size that a digital camera can produce, we refer to it as the input; when we discuss the print or screen image, it is called output. While the input resolution is expressed as pixels per inch (ppi), output resolution is referred to as dots per inch, or dpi. We have covered pixels, but what are dots?

If you use a high-powered magnifier to look at a picture in a newspaper or magazine you will see that it is composed of thousands of small dots. When packed together closely and viewed from a proper distance we see all these dots as a picture, not as individual dots. A print from a digital printer is created in the same way—many small dots are placed on a sheet of paper. The same goes for the image you see on the computer screen, except here the dots are formed in the projected image on the monitor. As with pixel resolution, screen or printer resolution determines how large you can make an image. The dpi figure determines image quality at a certain size. It all works together.

These terms will become familiar as you photograph and print. You will use ppi when you are working with your digital camera and when scanning film or prints (an alternate way to get a digital image file ready to work on in the computer). You'll use dpi when making prints, and when preparing images as e-mail attachments or for the web. Think of (ppi) input as the image itself and (dpi) output as what you do with it.

Just how can you figure out the best ppi and dpi for different uses of an image? Luckily, we can use shorthand and a few general rules of thumb to get us where we need to go. Best of all, you often don't have to do any calculations yourself—your digital camera, printer software, or e-mail or web software will guide you. It's good, however, to understand these terms and calculations, as familiarity with them will get you the best results when dealing with any type of digital imaging device.

Output resolution requirements vary. For monitors (e-mail and web images), 72 dpi is a good working estimate. For prints, check your printer specifications; here we'll use a figure of 200 dpi. If you want a very good quality image that will be used on the monitor screen only (for e-mail, the web, etc.) from a 640 x 480 resolution image, divide that input resolution by the output resolution, or (640 x 480)/72. The result is an 8.9 x 6.7-inch image.

What if you want to make a print? Well, let's say we get a very good print with a 200 dpi printer resolution. Divide that into the 640 x 480 ppi image and you get 3.2 x 2.4 inches. If you want to use your digital camera for nothing more than wallet-size prints and web images of reasonable size, then a 640 x 480 resolution will usually do fine.

What if you want to use your digital camera for a 5 x 7-inch print? Then choose a camera with a greater pixel count or, if the camera offers a choice of resolution levels, a higher resolution to capture the image. If we divide our 200 dpi figure into a 1200 x 1600 resolution we get a 6 x 8 print, accomplishing our goal. However, if we divide our 72 dpi screen resolution into that sensor we get an image approximately 14 x 22 inches, way too big for most monitors. Does this mean that you can't shoot for the web with a 2-megapixel camera? No, because it's very likely that you can set the camera to 640 x 480 or a smaller resolution. You can also use a larger image size and "shrink" or resample it using imaging software. These options allow you to use that same camera for the web or a decent size print.

This can be especially confusing if you are used to working with a film camera and ordering different size prints from the same negative. In digital photography the quality of the image depends in very large part on the resolution capabilities of the sensor, the quality level you select (based on the various resolution options), and the resultant file size the camera can deliver.

In most cases you should record at a specific resolution by taking the photo's end use into account. You can often choose different pixel resolutions with the same camera. What should you do if you're not sure you want to use the image for a web page or a print, or if you want to use it for both? Shoot at the higher resolution; as mentioned, you can always "shrink" the file size later using image-editing software.

Memory Card Capacity

Like film, your memory card or in-camera memory can store just so many images. Unlike film, which comes in 24- or 36-exposure lengths and tells the camera and you how many pictures you have left as you shoot, the number of images you can get on your memory card depends on the capacity of the card and the file size of each image you photograph. Similar to computer hard drives, memory cards are available in different capacities. You can get 8 MB, 16 MB, 64 MB, etc. cards; the larger capacities are generally more expensive. Most cameras come with a 16 MB or larger card. Each time you record an image you are filling up that capacity until the card can store no more. "No capacity" on a card means you can't record any more pictures until you transfer (download) those image files to another drive and clear the memory from the card (or reformat it).

If, for example, you have a 16 MB card in a 3-mega-pixel camera and shoot nothing but full-resolution images (keeping in mind that to get the file size you multiply the megapixel count by 3) you can only get one image per card. Once the card is full or can't take any more data you must download the data from the card to a storage device before you can shoot any more of those high-resolution images.

If you vary the resolution of images as you work, the number of images per card goes up or down depending on the size of each image. If, for example, you shoot smaller resolution images your images-to-card ratio goes up. If you shoot only large files, the number of images per card drops. But there's another wrinkle to consider here, called file format and compression. This also has an influence on the number of pictures you can get with a given memory card capacity.

File Format and Compression

The way files are organized is called a format. There are two main file formats in use in digital cameras—JPEG (Joint Photographic Experts Group) and TIFF (Tagged Image File Format). Some camera makers have their own file formats that are usually grouped under the RAW format title. We'll discuss this and proprietary formats in Chapter 4, "Image Menus." JPEG actually shrinks the file size by processing the information and holding it as a smaller file until it is opened again in a computer. It compresses the information by making assumptions about what should be on a certain pixel according to the adjacent pixels. For example, in a photo containing blue sky, if there are three pixels next to one another, and pixels one and three are blue of a certain brightness, then it will toss out pixel two and mathematically add that blue pixel back again when the image is opened. It's rather amazing, but there is a catch.

The problem is that when a photo is made in JPEG, if any changes are made on it and it is then opened later, there is a loss of data. This is called a "lossy" compression scheme. Once that middle pixel in the above example is eliminated it exists only as part of a mathematical formula, and not as "real" data from the image. This loss may or may not degrade the quality of the image, depending on how much detail and color subtlety there is in the original and how great the compression of the file size is. This probably won't show up in a screen image, but it may well hurt print quality, especially in enlargements. There is nothing inherently wrong with photographing in JPEG format; indeed, many cameras offer only that format. However, this loss is cumulative; each time it is opened as a JPEG and edited or changed in any way, further loss of information occurs. When transferred to your computer, the image should be saved in a TIFF format to prevent this.

Most digital cameras allow you to choose from among three compression ratios, or degrees of difference between file sizes. These are usually 1:4, 1:8, and 1:16. A higher ratio means greater compression (and greater loss of data upon opening and editing). In many cases, digital camera makers assign names to these ratios, such as Good (1:16), Better (1:8), and Best (1:4); or Normal (1:16), Fine (1:8), and Super Fine (1:4). Again, there are no standards here.

Your best bet is to check the camera instruction book to see how the resolution and JPEG compression scheme are defined. You will need to know this lingo when you choose a format and quality level for taking pictures, something we'll cover when we explore the menu offerings in your digital camera.

The other file format is TIFF mode. This is an uncompressed format that holds all the image information when you reopen it. Although you can usually shoot at 1:4 JPEG to save file space without much worry of extreme

image data loss, it's a good idea to shoot TIFF for the best possible results. And, as mentioned, because you lose image data information every time you open and edit a JPEG file, it is a very good idea to save images from JPEG to a TIFF format right after you download them from the memory card to the computer.

Like many things, you have to strike a compromise when choosing the file format and resolution of each image you shoot. Are you shooting for prints and want more images per memory card with minimal loss of data? Then choose JPEG 1:4. Do you want the best possible image file regardless of how many images you can get on a memory card? Then choose TIFF format (or one of the RAW formats offered by certain camera makers). Do you want the maximum number of images you can get on a card, and plan to use the images just for e-mail attachments? Then choose JPEG 1:16, or shoot with a lower pixel resolution mode.

This may seem quite confusing, but once you work with your digital camera and try out the various options you'll quickly see that image quality depends on the interplay between resolution, file size, compression, and image quality. You'll also see how print quality is affected by your choices.

To summarize, with film you always get a set number of pictures per roll. Picture quality is based on the size of the film (also known as its format), the quality of the camera lens, exposure accuracy, film speed, composition, camera steadiness, and quality of light. Many of the same factors determine quality in a digital picture. The difference lies in how you set up the digital camera in terms of resolution, file format, and compression. The key elements in making digital setup decisions are knowing what you want to do with the picture (print or web, and what size), the capacity of the memory card in relation to how many images you want to put on it, and the type of pixel count the sensor in the digital camera can deliver. If in doubt, you can always shoot at the maximum resolution and compress the file size later.

SOME EXAMPLES

Memory Card Capacity at Various Digital Format Settings

The figures in this table represent a 2000 x 1312 pixel resolution image on a 96 MB memory card. Note how the image capacity goes up as the compression is increased. These figures represent the maximum capacity if every image is shot at the same format and compression. The capacity will vary if the formats and compressions are mixed. These figures were taken from a 96 MB card in a Nikon D1X digital SLR.

Mode	Image Capacity on a 96 MB Card
TIFF (uncompressed)	12
JPEG, 1:4 compression	66
JPEG, 1:8 compression	132
JPEG, 1:16 compression	265

Image File Sizes

The numbers in the right-hand column represent the file sizes generated by a pixel resolution of 2048 x 1536 in a 3.3-megapixel camera using TIFF and two different JPEG compression modes. Note that these are storage file sizes. When the JPEG file is opened it reverts to the uncompressed file size (9.1 MB), albeit with some loss of data. As you can see, when using JPEG 1:8 you get eight times the storage capacity on a memory card.

File Format	File Size (Pixel Resolution 2048 x 1536, 3.3-Megapixel Camera)
TIFF, uncompressed	9.1 MB
JPEG, 1:4 compression	2 MB
JPEG, 1:8 compression	1 MB

A Digital Imaging System

When you purchase a digital camera you are entering the computer world. Although some printers and storage devices allow you to work without a computer (offering direct camera or memory card connection), most times you'll want to use the computer in conjunction with image-editing software to touch up your photographs or add some special effects. That's part of the fun of digital—taking creative control of your pictures. Here are some components of a basic digital imaging system that will handle virtually every task.

A number of key components affect how your system will perform, including computer speed, hard drive capacity, memory, upgrade ability, connectivity, and monitor size. You will also need image-editing software, which usually comes with the digital camera. You can upgrade from the supplied software or use editing programs different than those that come with your camera.

The Computer

Any computer you buy today, and even a recent one you may already own, comes right out of the box capable of handling your digital images. Unfortunately, older computers may not have this capability, as most cameras today patch to the computer for downloading using a USB or FireWire connection. The same goes for the operating system (OS). If you haven't upgraded for awhile, you might run into some compatibility problems or may need to do workarounds to get the camera software to function in your system. For example, some cameras may not link up with Windows 95 or even upgraded Windows 98. When you get involved with digital anything you are usually confronted with these problems; digital photography is not immune. This is a fast-changing world.

Speed Think of a computer's speed in terms of horsepower in a car. While almost any vehicle will do fine on a straightaway, a low-powered engine may have problems climbing hills or passing on a narrow country road. The same goes with the computer clock speed. If you're doing simple tasks, almost any reasonable speed will do. If you plan to do complex imaging tasks, some digital work can be agonizingly slow. The speed is indicated by the megahertz rating; the higher the number, the faster the speed. Anything above 500 MHz will do fine for most still image processing tasks.

Drive Capacity Hard drive capacity is also important. This is less of an issue today than it was in the past, as 10 GB hard drives are now common. However, if you store your images on your computer, along with a slew of software programs and other files, you might find that capacity wanting. For this reason you should consider alternate forms of storage, such as a CD ROM or DVD ROM. We'll cover storage options shortly and see how to move image files to a CD or DVD in Chapter 5, "Downloading Your Images."

RAM Random access memory (RAM) is the site in your computer where data being processed is temporarily held until it is saved and stored elsewhere, either on the hard drive or another storage device. RAM needs power to hold onto this data, so when the computer is turned off (or crashes!), whatever was in RAM disappears. RAM is used when you are correcting or working creatively on your image, for printing and scanning, and for keeping the image on the screen. In short, RAM is an essential part of working with digital images.

Most computers today ship with a minimum of 64 MB RAM. This is enough to do basic imaging tasks with most software, although some professional image-editing software programs (such as the most current version of Adobe Photoshop) consider 128 MB of RAM a minimum. If you are running other programs while you are working on images (such as a word processing program) you may not have enough RAM to complete your imaging work and might get an "insufficient memory" notice on the screen.

The best advice is to get as much RAM as possible when you purchase a computer, or to upgrade RAM when required. A good place to start is with 128 MB RAM, although people who work with images all the time will customarily get twice or four times that amount.

Storage Devices

When you begin to work with a digital camera, you can safely store many of your photographs on your computer's hard drive. But if there's one golden rule for working with computers, it's "backup," that is, make a copy on some other medium. As you work you'll also find that your image files will begin to accumulate and take up more and more space on your hard drive. This is where alternative forms of storage come into play.

New storage devices are always being introduced, with each new generation offering more storage space in smaller sizes. CD ROMs and DVD storage are the most popular as of this writing; other devices and storage media surely will continue to be developed. You might also con-

As you gather more and more images on your computer, you might find yourself running out of hard drive space. The best bet is to move your images to another media, such as a CD ROM or DVD ROM. This also acts as insurance should anything happen to your computer's drive. Many computers now come with CD or DVD "burners" (recorders) built in; you can also buy a separate drive and install it or use it as a desktop item.

sider a backup hard drive; those with 40 GB are becoming more affordable. Moving images onto these media is a simple matter. Individual image files or folders filled with similar or themed images can be "dragged and dropped" from the hard drive, or images can be saved directly to the medium of choice right from your image-editing software.

Printers and Paper

Photo-quality printers are available in a wide range of prices and sizes. Don't expect to use a word processing printer for photographs, however, as they cannot deliver the same level of color and tone as printers made specifically for photography. There are two main types of photo-quality printers—ink-jet and dye sublimation. An ink-jet printer lays down color by spraying ink through ultra-fine nozzles. A dye sublimation printer mixes transparent colors via ribbons and overlays them onto a receiving sheet. Ink-jet printers can work with a wide variety of paper surfaces and stocks (thickness). A dye sublimation printer can work only with the paper specifically made for it.

Dye sublimation printers produce prints that have the look and feel of traditional photographic prints. The largest size in the price range most digital photographers can afford is 8 x 10 inches, although some printers of this type only produce snapshot-size prints. Ink-jet printers for the digital photographer can produce prints of any size up to 13 x 19 inches. Larger, commercial printers are available in both types. If you want larger prints you can work with a digital lab that offers such services.

Ink-jet printers use ink in cartridges that must be replaced after a certain number of prints are done. Dye sublimation printers use replaceable ribbon sets. If you do a lot of printing you should always keep spare ribbons or

ink cartridges around, as you might find that you are running out in the middle of a printing session.

There are many papers available for ink-jet printers. In fact, if the paper is coated you can print on just about any stock. They range from economy papers for quick snapshot prints to art papers that have the look and feel of watercolor paper, canvas, or even fabric. The stability of any ink-jet print (how long it will last after printing) depends in large part on the ink and paper used. Some prints simply last longer than others. Check the Resources page at the end of this book for a website that tests for the archival stability of various inks and papers.

Monitor

Most monitors that come out of the box are fine for digital imaging work, with the proper graphics card already installed in the computer. The most important aspect is size. In order to properly view an image on the screen, especially when you have software toolbars showing, you'll need at least a 15-inch monitor. If you can work with a larger viewing area, so much the better. Many monitors allow you to adjust screen resolution—see the instruction book that comes with the monitor and/or computer.

Software

There are two important pieces of software that you'll use whenever you use your digital camera or when you work on your images. The first is the download software that comes with the camera. This creates a "handshake" between the camera and computer and allows you to bring images from the camera to the computer quickly and easily. You can download images to a desktop or laptop computer. Without this software, your computer usually won't recognize the camera as a drive, so install this before you begin taking pictures. Keep in mind, however, that card readers, which we'll cover shortly, are perhaps the simplest means of transferring images from the memory card to the computer. They act as separate drives that can easily be sourced (accessed) for information and images.

Image-editing software allows you to correct certain flaws in a digital image, change the brightness and color values, and crop the picture (change the framing) for a more effective composition. In addition to these corrective procedures, this type of software allows you to do many creative things with your pictures, such as combine images, add special effects or text, and even to "stitch" a number of pictures together to make a panoramic view.

Your choice of image-editing programs determines how "deep" you can get into playing with your images. Programs that come with your camera, called "bundled" software, are often good to start with and use for practice. Professional level programs, such as Adobe Photoshop, offer an extensive set of tools and special effects that allow an almost endless variety of ways you can work with your images (left). Perhaps the best way to begin is by practicing with your camera's software until you're ready to step up to this high-end program. There are many other imaging-editing and manipulation programs that can help you get the most out of your digital photography experience. To organize your images, you should consider a browser-type program that lets you look into your image folders and files. (Below) This screen shows the cataloging of a file folder from ACDSee, one of the more popular programs of this type. The tools in this software package allow you to edit and organize, send e-mail of individual images and groups of images, print out contact sheets (sets of images in a folder), and even create slide shows and HTML album pages for the web and more.

Memory Cards

The memory card, often called "digital film," that comes with your camera is dedicated to the model and brand of camera you have. There are a number of memory card formats; the main types include CompactFlash and Smart-Media, mini-CD ROMs, Memory Stick, Microdrive, and SD. New formats are always being introduced, the x-D card being the latest as we went to press. Some cameras allow you to use two different types of memory cards in different slots, but usually you have to stick with the one type of card your camera uses. Cards come in various storage capacities and once the card is filled you either have to download the images and clear the card or swap another card into the camera. It is a good idea to keep a number of extra cards with you, especially when you're on a trip and don't have a download location at hand. There's nothing worse than running out of picture space during a photographic session. Of course, you can delete images as you go, but this is not always practical or desirable. It's also a good idea to work with the largest capacity card you can, as you can photograph with higher resolutions when you choose.

Card Readers

Although you can patch your camera directly to a computer to download images, there are times when this can be awkward or impractical. You can bypass this procedure by using a memory card reader, a drive that plugs directly into the computer. All you need to do is slip the memory card out of the camera and into the reader. The reader can be opened like any other drive or may download directly into your image-editing software. Card readers are made for every type of memory card available.

Batteries

Digital cameras tend to be power hungry. All internal functions rely on battery power to operate. Probably the biggest consumer of power is the LCD monitor. It's best to photograph using the viewfinder with the monitor turned off, but who cannot yield to the temptation to see a picture right after it is made, or to show off the images to others after a shooting session? LCD monitors are also where many of the camera settings are made, so you will have to use it to set up the shooting and playback operations. That's why having spare batteries is important.

Some digital cameras come with rechargeable AAs, which is a good thing, as you can always buy disposable AAs as backups in a pinch. Many are now being made with dedicated rechargeable battery packs that use a specific recharger. These rechargeables are either nickel

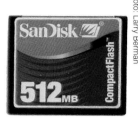

A memory card is the digital film on which you record your images. The capacity of the card packaged with your camera may limit the number of pictures you can take. It's a good idea to get extra memory cards or to get one with a higher capacity. Shown here are three types of cards—Memory Stick, SmartMedia, and CompactFlash. Each camera uses a specific type. Note the 512 MB count on the SanDisk CompactFlash Card. This should be enough for a few days of photographs when you travel and is a better choice when you are working with a high-megapixel camera.

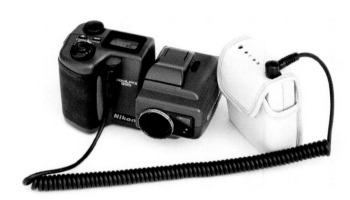

Power supply is a major issue in digital photography. If you use the monitor a lot when you photograph, or play back the images often, there's a good chance that the batteries that came with the camera will run down fairly quickly. One option is to use a portable power supply. This one, made by Maha Energy, can be looped on your belt and used as the main or backup power source.

metal hydride (NiMh) or lithium ion types. Both provide for extra power run times, but you must have a charger at the ready if you see the battery power indicator running low. Some cameras even show you the time remaining on the battery, much like camcorders.

My advice is to work with rechargeables, whatever the type. This makes economic sense, as you will be going through batteries rather quickly. It's also important to keep a spare, charged battery with you, as it is very disappointing to have your power run out in the middle of a vacation day or job. Another option is a battery pack, worn on your belt or carried over your shoulder, from which the camera draws power. This usually provides longer run times and can be used as the main supply or a backup.

Portable Storage Devices

One option for storing images on the go is a laptop computer. You can download images right from the camera or use a card reader. Portable, battery, or AC-powered hard drives are also available, some as small as a Palm PDA or MP3 player, that can take memory cards directly or patch to a digital camera. These are available in capacities as big as 1–10 GB, and larger. These make sense when you are traveling and anticipate making lots of digital images. Once you download the pictures you can clear the memory card and fill it again and again. Then you download the images from the portable to your home base computer upon return.

Now that we've covered some digital basics, let's turn our attention to the digital camera itself. We'll explore how to access and use the many creative controls and start to put our understanding of this type of photography into play.

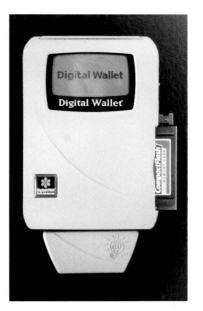

If you run out of room on your memory card and don't have a backup, you're out of luck and you can't take any more pictures. One option is to use a portable storage device, such as the Digital Wallet shown here, which can be recruited as temporary storage as you go. To use it, insert the memory card from the camera and download the images from the card to the external drive. You can then "clear"—that is, erase or reformat the card—in the camera and start recording pictures on it again. The portable storage device can be patched to your main computer to download the images from it to your hard drive.

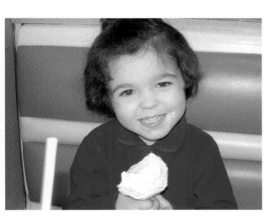
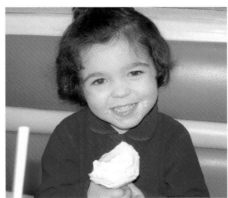

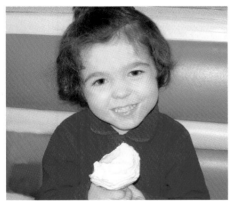
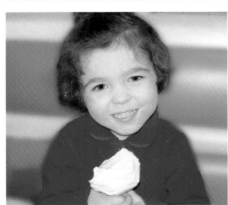

Even with the most basic image-manipulation program you can perform some magical feats with your pictures. This set of images was created using Adobe Photoshop Elements. The causal snapshot of Emma enjoying an ice cream cone was made with a 2-megapixel digital camera (top left). The first step is cropping the image (choosing a smaller portion of the frame (top center). The straw gets in the way, so it is erased and replaced with a texture and pattern similar to the background (top right). Emma's face is cleaned up using a basic retouch tool (lower left). To finish off the photograph the background is made "soft" (out of focus), so there's more of a feeling of dimension in the final print (lower right). When you get involved with digital photography you can have lots of fun with the pictures you take. Many programs will guide you through activities every step of the way.

3 Picture Controls

Capturing What You See

- **The Camera**
 - How Light Travels
 - Lenses and Accessories
 - Advance (Drive) Modes
 - Exposure Systems
- **Understanding Exposure**
 - Exposure Factors
 - Balancing Exposure Factors
 - Exposure and Picture Modes
 - Metering Patterns
 - Overrides: Exposure Values
 - Exposure Bracketing
 - ISO Settings
 - Long Exposures
- **Focusing**
 - Close-up Focusing
 - Focal Length
- **Flash Photography**
 - Fully Automatic
 - Red-eye Reduction
 - Fill
 - Flash On
 - Slow Synchro
- **The Digital Side**
 - Digital "Film"
 - Digital Zoom
 - Image Preview and Immediate Edit
 - Image Playback
 - White Balance
 - Digital ISO
 - Sharpness
 - Color
 - Contrast
 - Movies
 - Panorama
 - DPOF
 - Image Organization
 - Camera Customization

DIGITAL AND FILM CAMERAS share many of the same features. The differences lie in how you set up the camera to make pictures and what happens after the shutter is pressed. In this chapter we'll explore the picture control features of digital cameras. Your camera may have some or all of the controls we cover. As you read through this chapter, relate the topics covered to your camera. Many of these controls may be familiar to those who have worked with a film camera, but there are quite a few unique to the digital realm.

Keep in mind that even if you have a digital camera with the most advanced automatic metering systems, the balance between light control and light interpretation remains in the hand and eye of the photographer. The human visual system is a miraculous thing. Vision is how we understand much of what this world has to teach. It is the sense through which we can express our feelings about ourselves and the world around us. Making the transition from technique to visual expression in a photograph is perhaps the greatest challenge. As you read the following chapters, keep in mind that photography, whether it be with film or digital camera, is all about expression through light. Once you have mastered technique, apply it to making images that are both descriptive and expressive in nature. That's the magic of photography and why it is such an exciting field of study.

The Camera

Any photographic system consists of a camera, lens, way of controlling light, and method of focusing the light onto a light-sensitive material. A camera is a light-tight box that keeps stray light from affecting the light-sensitive recording material. It has a viewing system that allows you to frame the subject you wish to photograph. It also contains various meters and sensors that read the light and camera-to-subject distance, allowing you to get sharp focus and an exposure that faithfully records the light in the scene. Once the scene is composed and the focus and exposure are right, you take the picture by pressing the camera's shutter release button.

Today's digital cameras have operating systems similar to modern film cameras. They also echo the two main types of 35mm camera systems, the single lens reflex (SLR) and the point-and-shoot, or lens/shutter, camera. The main differences between the two types are the way light travels from the lens to the viewfinder and the accessories and lenses you can use with each.

How Light Travels

In an SLR film camera, light enters the lens and is reflected up through the camera body via a mirror assembly (thus the "reflex" in the name) to the viewfinder. When the photograph is made the mirror pops up out of the way; the shutter, which is located behind the lens, opens; and light travels onto the light-sensitive material. In a point-and-shoot film camera, light travels through the lens, inside of or directly behind which sits the shutter assembly. You frame and view the picture through a separate optical system. Some digital cameras have an electronic viewing system, similar to a camcorder. This is a "live" picture that is projected onto the viewfinder screen.

Digital cameras may or may not have a shutter mechanism similar to a film camera. In many cases the digital camera shutter is electronic, which means that the sensor is turned on for the set shutter speed and then turns off after the exposure is made. Whatever the type of shutter mechanism—electronic or mechanical—the shutter controls the length of time light is allowed to strike the sensor.

You see exactly what you frame in the viewfinder with an SLR camera. With point-and-shoot cameras you look at the scene through a viewfinder that is slightly offset from the path of light. This means, when shooting close to your subject, that the image recorded might not line up with what you see in the viewfinder, resulting in a loss of the top and sometimes sides of the scene. When you shoot close with a point-and-shoot digital camera either use the LCD as a viewfinder (if available) or make sure you compensate for this effect in your framing. Some point-and-shoot digital cameras have lines inscribed on the viewfinder that should be used as a framing guide in close-up photography.

Photo by Grace Schaub

With a digital SLR, you see through the viewfinder what will record on the sensor. With point-and-shoot digital cameras you view the scene through a finder that is slightly offset from the lens, so there may be some parallax error (where what you see through the finder is not exactly what will record) when photographing close-up subjects. This flower was photographed with a digital SLR so the framing is exactly what was desired. If your digital point-and-shoot camera has inscribed close-up lines in the viewfinder, follow them. If it does not, learn how the offset will occur and compensate for it when composing.

Lenses and Accessories

There are many more accessories available for a digital SLR camera. You can change lenses, use different types of flash equipment, add filters to the front of the lens easily, and work with close-up equipment. This is partly due to the fact that many SLR digital cameras are built onto the same chassis (including lens mount and flash connections) as their film counterparts. If you already own a Canon autofocus SLR film camera, for example, many of the same lenses and flash equipment can be used on a Canon digital SLR.

The lens on a point-and-shoot camera is integral to the body and cannot be interchanged. This limits the focal length choices—the ability to shoot with other telephoto or specialty lenses—to the range of the lens on the camera body. Some point-and-shoot digital cameras allow you to use add-on lenses that give you a wider angle or more telephoto view. These mount on the front of the lens and increase your shooting options. Some point-and-shoot digital cameras have a separate contact or plug in that you can use to attach a more powerful flash. In many cases, however, you are limited to the power of the flash that is built into the camera.

Advance (Drive) Modes

Virtually all modern film cameras, and all digital cameras, do not require you to physically ready the next frame once an exposure is made. In film cameras, a motor moves the film forward while you're shooting and rewinds it when finished. In digital cameras, the image information is transferred from the sensor to the analog/digital converter and then to memory storage (either a memory card or a storage buffer in the camera.) Drive modes tell you what will happen when you press the shutter release button.

With single-frame advance, one image will be made when you press the shutter release. In continuous drive, a succession of images will be made if you maintain pressure on the shutter release. If you are photographing with high-resolution images on a digital camera, there may be a delay between exposures when shooting in continuous advance mode. This is caused by the time it takes for the system to process the first image and clear the information from the sensor. This delay can be anywhere from a fraction of a second to several seconds, depending on the image size and the camera's capabilities. In most cases, digital SLRs rather than point-and-shoot cameras are the best choice when you photograph with continuous drive modes. They usually have more processing power, and may contain an on-board buffer that holds this information prior to image processing, thus enabling you to make one image after another quickly.

Another drive mode is the self-timer. When you activate this mode the shutter release is delayed for a few seconds or for up to approximately ten seconds. This can be used to allow yourself time to get within the frame (with the camera mounted on a tripod) or to help insure picture steadiness when working with long-range telephoto lenses or a slow shutter speed.

Some cameras also have an "interval" timer. Once set, this takes a series of pictures over a predetermined period of time. The sequence is halted with a second press on the shutter release or when the number of shots in the sequence you have programmed is complete—or when the memory card runs out of space. You can use this to record a flower opening, the progression of a sunrise, or when you want to take pictures of a subject or location without having to stand there and make the pictures yourself. When doing interval photography, mount the camera on a tripod and frame the scene before snapping the first frame.

Exposure Systems

Exposure is the amount of light that reaches the sensor. A good exposure is one that records the light and color as you saw it in the scene and allows you to reproduce it on a print or as a screen image. Exposure is both objective and subjective. The objective part is light measurement and how the exposure system reads the light. The subjective part is what you might add to the scene by changing the "proper" exposure to one that reflects your feelings about the subject or scene.

For example, say you are photographing a sunset over water. If you let the camera meter take full control, it will do what it is programmed to do and attempt to record all the colors and light values. However, to enhance the color you might want to record the sunset darker than it appears in the scene. The camera will deliver an objective measurement of the light; your choice to enhance that color through underexposure is subjective. There are lighting conditions that can cause the meter to expose in ways that are contrary to your needs. That's when exposure overrides, a topic we'll cover shortly, come into play.

Understanding Exposure

One advantage to digital photography is that it's easy to add your own personal touch to every picture you make, and to see the effect of those changes right after you snap the shutter. You can also add these touches later by working with image-manipulation programs once you have the picture in your computer.

This is part of the reason why digital photography is so fun and exciting. It is set up to allow you to interpret the subject and scene when you take the picture and when you "process" it later using image-editing software. But in order to do this you need to get the initial exposure right. Exposure is a key element for in-camera interpretation and creative picture taking. Interpretation of objective exposure is one of the more creative aspects of photography, and digital photography allows us to do this with greater ease than ever before.

Exposure Factors

An exposure system in any photographic system works with four factors: the brightness of the scene, the speed of the light-sensitive material in the camera, and the aperture and shutter speed settings. They all work together to obtain a picture that represents what you saw when you snapped the shutter.

Scene Brightness This is the level of light in the overall scene or particular parts of the scene. It is expressed as exposure value (EV), a relative number that can represent dark or light subjects and scenes. Exposure value is the readout of the exposure meter and is what is used by the exposure system to insure that the right amount of light reaches the light-sensitive material.

Speed Expressed as ISO, this number represents the relative sensitivity to light of the sensor. Higher ISO numbers correspond to more sensitivity to light; they are usually expressed in steps that represent twice as much or half as much light sensitivity. For example, an ISO 200 sensor is twice as light sensitive than an ISO 100 sensor and half as sensitive as an ISO 400 sensor. You can shoot in dimmer light without using flash when working with higher ISO ratings or settings.

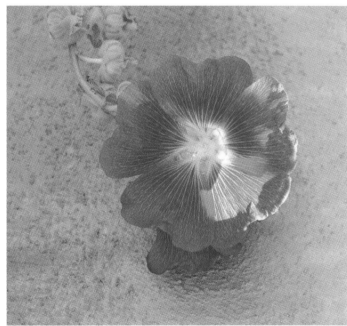

The difference between an objective and subjective exposure is what your eye sees and what the camera records. As you master your digital camera you will be able to make judgments about your images and apply effects built into the camera that express just what you want when you make the picture. In this scene, the camera's exposure system does a good job of recording all the colors and tones (left), but the eye and mind see the scene in a lighter fashion. This is easily accomplished with the camera by using +1 exposure compensation when the picture is made (right). The beauty of digital photography is that you can see the image right after you make it. This allows you to add your personal touch to every subject and scene.

Aperture Inside a camera lens sits a variable opening called an aperture. When the aperture is opened wider, more light passes through; when it is narrower, less light comes in. The setting number increases as the aperture narrows (e.g., $f/8 – f/16$). This is one of the ways by which the amount of light coming through the lens is controlled. The aperture also controls how light at various distances from the subject focuses onto the sensor. Narrower apertures focus light in greater ranges of distance than do wider apertures.

Scene brightness is defined as the amount of light available in a scene. It determines what you can photograph with and without flash, what ISO speed setting you might require to capture the scene, and how you might have to change the way you shoot to make sure you get a steady picture. As you move around during a day's photography session, the light and how you have to deal with it change all the time. Outdoors you will have little trouble with settings and getting a good exposure. (Left) This scene was made in daylight, using fully automatic exposure control. A walk from Times Square in New York to the interior of Grand Central Station changed matters. The low light of the new scene made for an underexposed picture when automatic exposure was set (top right). After seeing this in playback mode, the camera settings were changed from ISO 100 to 400 (a gain of two stops of light) with +1 EV added to the interior light that was recorded (bottom right). This is what the eye saw. Knowing when to change settings is important to picture success. Realizing that the eye and camera see differently is the key to this understanding. Use the picture review feature of your digital camera, understand problems and learn how to overcome them, and you'll make better pictures every time you go out to photograph.

Digital SLRs and some advanced digital point-and-shoot cameras allow you to set precise focusing ranges so that you can determine what will be sharp and "soft" in your pictures. The exposure mode for this is called aperture priority, often identified as AV on the control dial on your camera or in your LCD recording menu. Apertures are identified as f-stops, or numbers. Higher numbers (such as f/16) yield more range of sharpness than lower (such as f/5.6). To get sharpness from the first tree trunk all the way to the back of the stand in this scene, an aperture of f/16 was set on a digital SLR. Focus was set on the tree in the foreground by placing the focusing target on it and then using autofocus lock (AFL) to keep that as the foreground focusing point when the frame was recomposed.

Shutter speed This variable setting controls the amount of time light is allowed to strike the sensor. Shutter speeds in digital cameras can range from a few seconds to thousandths of a second. Faster shutter speeds let in less light and also catch shorter cuts of continuous motion. Slower shutter speeds allow in more light and record longer cuts of action. For example, say you are photographing someone diving off a board into a pool. A fast shutter speed (such as 1/500 second and faster) will record the diver in mid-motion and will freeze him or her in space. A slower

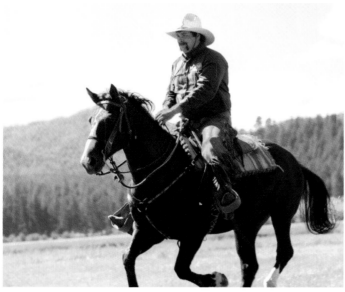
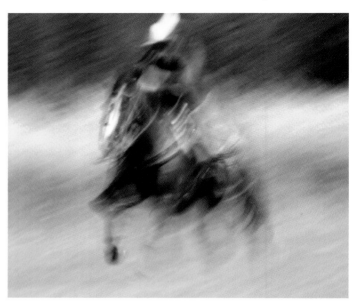
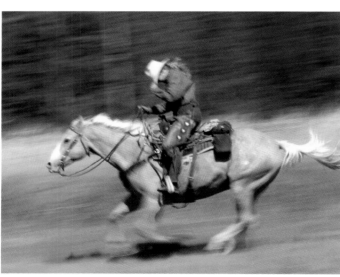

The speed at which you set the shutter determines how motion will be depicted. You can use a fast shutter speed to freeze action and a slow one for intentional blurs. To access shutter speed settings, use the command dial on your digital SLR or the LCD recording menu on your digital point-and-shoot camera. You can also choose the shutter speed using your camera's shutter-priority (TV) exposure mode. Your camera might not have a shutter speed option, but it might have an action or sports picture mode, which yields the fastest shutter speed the camera or light allow. To shoot with a slow shutter speed, use the bulb or long exposure setting on your lens shutter camera. (Top left) This rider was photographed at 1/500 second; the motion is frozen. When photographed at 1/8 second the whole picture is blurred, due to camera shake (top right). A blur and "frozen" effect can be combined with a technique known as panning. With the camera steadied on a tripod, this rider was photographed at 1/8 second while the camera was swiveled to follow the motion of the rider as she galloped past (bottom left). You can use slow shutter speeds for creative effects as well. These horses were photographed at 1/15 second as they galloped past. The form and motion combine for a hopefully Impressionistic effect (bottom right).

shutter speed (such as 1/30 second or slower) will record the diver as a blur. Think of the shutter speed as a knife that cuts slices of time from its continuous arc. A faster speed cuts thinner slices of time.

Shutter speed can also affect the steadiness of a picture. Slower speeds may cause something called camera shake, resulting in a blurred picture because the photographer was not able to hold the camera steady during exposure. This is something that cannot be corrected after the exposure is made. Some digital cameras will warn you when this might occur, usually at shutter speeds of 1/30 second or slower. If you use the telephoto setting of the zoom lens the camera shake speed might be as fast as 1/125 second. Steady the camera as best as you can to prevent this picture-debilitating effect.

Balancing Exposure Factors

Exposure is a balance between all these factors. The ISO is the foundation—it determines how much exposure is required to record the light in a scene. If the ISO changes, then either the aperture or shutter speed, or both, will have to change. If the EV (light level) of the scene changes, then the aperture and shutter speed for a certain ISO will have to change to make a correct exposure. Aperture and shutter speed always work together in an inverse relationship. If the shutter speed is increased, the aperture must open wider to get the same exposure. The converse is also true.

Aperture and shutter speed work in stops. Each stop is equal to a change of 1 EV. A stop is an increase or decrease of exposure that doubles or halves the amount of light in the exposure. If, for example, the exposure changes from 1/250 to 1/125 second, you have a change of 1 stop. If it changes from $f/5.6$ to $f/4$, then twice the amount of light reaches the sensor and it's also one stop.

Exposure does not change if both aperture and shutter speed change in opposite directions in equal stops. If, for example, an exposure changes from 1/125 second and $f/8$ to 1/250 second and $f/5.6$, the same amount of light gets through. What changes are the way action is expressed (with 1/250 second freezing more action than 1/125 second) and the range of focus ($f/5.6$ yielding less range of sharpness than $f/8$). The juggling of these numbers is what allows for different image effects in equivalent amounts of light. The term for this is equivalent exposure.

This may seem strange to you if you have not worked with an advanced film camera, and in fact may not ever come into play if you work with a point-and-shoot digital camera. However, understanding how this works will allow you to have more control of how your pictures turn out, especially if you use a digital camera that allows you to make aperture and shutter speed settings. It also gives you very good control over picture effects. If and when you decide to photograph using these controls, you'll be able to exercise more creative control over your pictures.

Don't worry if your digital camera does not allow you to make distinct aperture and shutter speed settings. You can have a good deal of control by using automatic picture and exposure modes.

Exposure and Picture Modes

An exposure or picture mode is a setting used to define how your camera automatically balances the aperture and shutter speed settings to yield different image effects. As mentioned above, shutter speed defines how you capture motion while aperture determines the range of focus in the scene. Exposure modes use the equivalent exposure method of balancing the two. You set exposure modes either with a dial on the camera body or via the LCD menu. Many cameras display these modes with icons. Keep in mind that these are programmed setups and that what they deliver might not always be what you actually want to have happen in a photograph. They can be helpful in that they let you explore different ways to take a picture. The following are some of the exposure modes available in today's digital cameras.

Portrait This mode assumes that you want to have your subject stand out from the background, so it favors a faster shutter speed and wider aperture. This has the effect of throwing the background out of focus. It assumes that you will lock focus on your main subject, a technique we'll cover with focusing modes and controls. You can use portrait mode for more than just making portraits. It's the way you set up the camera to give you a sharp foreground subject with a "soft" or unfocused background. This can be used, for example, to remove distracting elements from the background of any subject or scene.

Sports (Action) Because action is stopped when faster shutter speeds are used, this mode favors the fastest shutter speed that light and the shutter will allow. It can be used for sports or any subject that moves quickly (like children). This mode also helps you get steadier pictures when using long telephoto lenses or digital zoom. Using a fast shutter speed helps insure that the picture will be steady.

Equivalent exposure means that the same amount of light is used for exposure but the balance between aperture (the size of the lens opening) and shutter speed (the duration of exposure) is changed. As you open the lens wider the shutter speed increases; as you decrease shutter speed the opening in the lens gets wider. Each balance yields different effects. These sunflowers were photographed under the same light with the same total exposure. When a wide aperture was used the effect of the wind is muted, stopping motion but yielding sharpness in a narrow range (top). When a narrow aperture is used there is more range of sharpness (you see sharpness deeper into the distance) but the effect of the wind is more noticeable (bottom).

Landscape When photographing landscapes, you might want to make sure that you have the deepest range of focus the lens affords. This mode sets the aperture at the narrowest diameter it can, depending, of course, on light levels. With some cameras, this mode might indicate that the lens focus defaults to the infinity setting; in fact, it is sometimes referred to as "infinity" mode. This might be needed when photographing through glass or when the lens cannot "lock" focus. This will be discussed further when we

cover focusing techniques. Use landscape mode when you want to get as much of the scene as possible sharp.

Night Scene When light is low, a longer exposure time is needed. This mode may extend the shutter speed beyond its automatic limits. For example, the shutter may normally operate in a 1/8 – 1/1000 second range, while night scene mode might set the shutter speed to 1 or 2 seconds. Or, it just may set the camera at its longest possible shutter

Exposure modes allow you to automatically match the subject matter to programmed camera settings. Depending on your camera model, you set them either on a dial on the camera body or via the LCD recording menu. In landscape mode (above) the programmed exposure is set to maximize sharpness from near to far, in this case to maintain sharp focus from the lily pads to the horizon. In macro mode (top right) the lens can be set up to focus closer than is usually available in normal operation. Here the "solarize" option was used to add an extra touch of design to these flowers (Chapter 4, "Image Menus," explains this feature). Some advanced point-and-shoot and all digital SLRs have a mode known as aperture-priority (AV), in which you set the aperture for a certain range of sharpness from near to far. You can use this mode to determine precise ranges of sharpness. To obtain sharpness from the foreground to background in this scene (middle right), an aperture of f/16 was chosen to maximize the depth of field. Some modes serve special picture situations. Night scene, or slow synchro, mode combines flash with a slow shutter speed. This allows you to capture dimly lit subjects and their surroundings without making special exposure settings. This outdoor café in Istanbul was lit with fairly dim spotlights. Setting night scene mode caught the action of the Sufi dancers as well as the overall scene (bottom right).

speed; check your camera's specs to be sure. In certain cameras, night scene mode also fires the flash to illuminate foreground subjects while it exposes for the darker background.

Some cameras, especially digital SLRs, have a B setting. This stands for bulb, an arcane reference to the time when shutters were activated with air by squeezing a large rubber bulb. When you use bulb, the shutter stays open for as long as you maintain pressure on the shutter release. This can be used to record fireworks or very dark scenes that cannot be read by the camera meter. Both these modes require that you steady the camera on a tripod or other device.

Macro This is more a focusing than exposure mode, but it is listed here because it often appears on the mode dial or menu along with exposure modes. Most lenses focus in a range of distances referred to as minimum and maximum focusing distance. The latter is infinity, or as far as the eye can see. The former might be anywhere from 6 inches to 3 feet. When you set macro mode, you change the optics so that the lens focuses closer than the usual minimum focusing distance. This allows you to focus as close as 2 inches, depending on the camera and the lens, and is great for photographing stamps, details on antiques, and flowers.

Aperture Priority Aperture-priority (AV) mode is common on SLRs and rather rare with point-and-shoot cameras. As mentioned, the variable opening in the lens—the aperture—performs two major functions. It controls the amount of light coming through the lens and affects how that light is focused onto the sensor. You set this mode when you want to control what is sharp and out of focus in your picture. A narrower opening focuses points of light through a greater range of distance from the camera to the scene than does a wider opening. In aperture-priority mode, you set the aperture opening and the exposure system automatically sets the shutter speed for the correct exposure.

For example, say you are photographing a scene where you want everything from near to far sharply focused. In fully automatic mode you may or may not get both the foreground and background sharp. Switch to aperture priority, focus on the foreground subject, and set a narrow aperture—your chances of getting both foreground and background in sharp focus are increased. Conversely, say you want to make an outdoor portrait and the background is filled with distracting lines and shapes. Here you can set a wide aperture and eliminate the background clutter by making it go out of focus. In both instances, having

control over the range of sharpness helps you make a better photograph.

Many SLRs have a depth-of-field (the technical term for the sharpness range in a photograph) preview feature that allows you to see the effect of your selected aperture right in the viewfinder. This is an invaluable creative aid.

Shutter Priority Shutter-priority (TV) mode is also a regular feature of SLRs. When you choose this mode you select the shutter speed and the automatic exposure system makes an aperture selection for you. Shutter priority is appropriate when you want to define how motion is portrayed; faster shutter speeds freeze motion while slower speeds blur it. You can use shutter priority mode to set a higher shutter speed when using a telephoto lens or when you have zoomed the lens out to its longest telephoto range. This helps insure that the picture will be steadier than if you use a slower speed. You can also use shutter priority with a slow shutter speed to create blur effects or use a technique known as panning, which yields a steady main subject and blurred background.

Manual Exposure This mode is usually available only on digital SLR cameras. In manual exposure mode you make all the aperture and shutter speed settings. When you raise the camera to your eye the exposure system will recommend settings for what the meter considers the best exposure for the scene. You can follow those recommendations and change the shutter speed dial or aperture setting to match them, or you can change them to suit your needs.

For example, let's say you are photographing a sunset. Experience has taught you that using less exposure than your camera recommends yields richer colors. You note the camera settings in the finder and then intentionally raise the shutter speed or narrow the aperture, both of which result in less exposure. There are other ways to do this in an automatic mode, but they may involve making settings from a menu rather than right on the camera body—a slower process that might get in the way of catching just the moment you want. We'll cover exposure overrides after we close our discussion on exposure modes by covering metering patterns.

Metering Patterns

The light-metering pattern defines the area in the viewfinder used by the exposure system to take a light reading. When you put the camera to your eye and frame a picture, you are defining the area of light that will be reflected back into the camera through the lens. The

meter analyzes this light and an exposure calculation is made. Not every part of the scene, however, is necessarily "looked at" by the exposure system. In general, most cameras take their exposure readings from the central portion of the viewfinder. The thinking of designers is that the majority of people will place the subject of most interest to them in the center of the frame, so this usually works out fine for most pictures.

When you set a metering pattern, you define where in the viewfinder the exposure system will read the incoming light. Some digital cameras, and all digital SLRs, have an "intelligent" metering pattern that actually analyzes the light from the entire frame and usually comes up with an excellent exposure. This might be called matrix, evaluative, or intelligent metering. (Left) This dark locomotive might cause some exposure system problems, but the evaluative pattern came up with a perfect exposure that revealed every detail. Many point-and-shoot digital cameras have a center-weighted pattern, which reads most of the information from a fairly broad pattern that sits in the center of the viewfinder. It does well in most situations, like this picture of a flower (lower left), but might require you to use autoexposure lock in certain situations. When there's high contrast or tricky backlighting, use the spot metering option, if available, to take readings from select portions of the scene. (Below right) These sunlit plants sat in front of a dark background. To insure proper exposure, a spot reading was made from one of the leaves and the exposure was locked. If spot reading was not used, the background likely would have become lighter and the leaves overexposed.

Using the spot meter or center-weighted metering pattern with autoexposure lock is the way to solve what otherwise would be a difficult exposure problem. (Right) In this image, the camera was pointed straight ahead without any adjustment to the metering pattern. The meter read information from the entire scene, but the expanse of the dark sky fooled the system into "thinking" that it needed a lot more light for a good exposure. The result is that the main subjects are very highly overexposed. This would be a difficult image to print well. To correct the problem, the spot meter is pointed right at the main subjects and the exposure locked; then the frame is recomposed (below right). This exposure lock procedure would work with a center-weighted pattern as well, and results in a much better exposure the first time out.

Composition and light patterns, however, do not always agree with this ideal situation; indeed, many compositions are improved by moving the main subject slightly to the side, top, or bottom of center. But modern camera designers have covered this contingency. They have come up with a segmented metering pattern that analyzes many parts of the light in the viewfinder and calculates exposure by a complex series of steps that takes off-center subject placement into account. They work surprisingly well, for the most part. This type of metering system has different names depending on the manufacturer: matrix, evaluative, and honeycomb are just a few.

There may be other metering pattern options available in your camera. One is known as spot metering, which reads light only from the very center portion of the viewfinder frame. This comes in handy when you want to read a very specific area of a scene. For example, say you are making a picture of bright leaves floating in a pond. If you rely on the automatic meter, it will take all of the light in the scene into consideration and, even if it adjusts for the subject, may "see" the scene as darker than the light falling on the leaves. The result is that the subject will receive too much exposure and become overexposed, a problem in any photographic system and especially so with digital. The best approach to a scene such as this is to switch to spot reading and read just for the surface of the leaves.

Another option might be a center-weighted averaging pattern. Here, the spot reading area is enlarged to encompass more of the center of the viewfinder. In general, center-weighted patterns do take some of the sides of the frame into consideration, but the center receives the most "weight," or consideration in calculations. "Averaging" means that the meter takes all the light values reaching it and averages bright and dark to arrive at a compromise exposure between the different values.

This is a good pattern to use for scenes where light is coming from the side or where the centered subject is lit from the back and fills a fairly large part of the picture frame. It also comes in handy when one part of the scene is considerably brighter than the others and you want to make an interpretive exposure that places emphasis on the subject and darkens the other areas. When working with spot and center-weighted patterns you will also use a feature known as "exposure lock," or AEL. This holds the light reading you make even if you recompose, such as in the spot meter example cited above, allowing you to compose in any way you like without always keeping the main subject in the center of the frame. The AEL may be a sep-arate button or built into the shutter release, in which case light pressure on the button maintains the reading.

In most instances the automatic meter will deliver a usable exposure. Just pay attention when the subject is lit from behind or when the light is very bright and the scene is full of contrast. That's when you might want to use an optional metering pattern for your shots.

Overrides: Exposure Values

Many cameras allow you to override the exposure for creative or remedial purposes. Overrides are expressed as EVs, or exposure values, and add or subtract light from the exposure indicated and set by the metering system. Let's cover the remedial purposes first.

A camera meter is calibrated to deliver an exposure that will insure that the light values in the scene are recorded properly. This requires the meter to sort out the bright and dark light and then arrive at an exposure that will spread the light over the recording range of the sensor. It does this by arriving at one exposure that "sorts" the light so that the metering system places those light values at about the middle of that recording range. Then bright and darker values find their proper place.

There are a few instances when this procedure causes problems. For example, if an exposure is made of a bright field of white (such as white clapboard on a house or a field of snow on a sunny day), the meter reads that brightness and places it in the center of the recording range. This causes the white to go darker and any subjects darker than white go quite dark. The cure is to add exposure by using the exposure compensation feature. It might seem odd to add exposure to a bright scene, but you do this to aid the metering system and overcome potential underexposure. A +1EV or +1.5 EV will solve this dilemma.

The same problem can occur with very dark scenes. Say you are photographing a foggy morning where the mood is deep and blue. You make an exposure and the resultant picture looks too light and loses all its drama. What the meter has done is place the dominant dark tones in the middle of the sensor's recording range, making the scene lighter than you might like. The solution is to take away exposure by using a -1 EV exposure compensation.

Another instance when you might apply minus compensation is when using flash. If you are too close to your subject, there is a danger that the flash will give off too much light. This is called overexposure, and is a real problem with some digital cameras. If experience shows that your camera's flash pumps out too much light, just routinely set the flash exposure compensation to -1EV or more.

Exposure compensation can be used for remedial and creative purposes. On the remedial side, use it to add or subtract light when making photographs in scenes dominated by either dark or bright fields of light. Freshly fallen snow in bright sunlight can cause a problem for exposure systems. Because the meter is calibrated to handle scenes with a range of light to dark values it often underexposes when confronted with bright light on white. The way to compensate for this is to add 1 EV or more exposure compensation, such as was done here (right). You can also use the exposure compensation feature to interpret the light in a scene and create an in-camera exposure that matches what you want to express about a subject or scene. Photographed on programmed exposure mode, this set of buildings makes for a study in forms (center right). By setting -1EV on the exposure compensation dial, the delineation of forms is even more enhanced (bottom right).

The benefit of using exposure compensation for bright white values can be seen in these two images made of white clapboard siding on this old house. (Left) This image was photographed with the normal metering pattern in program (fully automatic) exposure mode. Note how the bright white becomes gray. Adding +1 exposure compensation instantly yields an image that matches what the eye sees (right). This will work the same way with any digital or film camera; it's just how metering systems read light.

When a scene is dominated by dark values you can get the light right without doing fixes in the computer by working with exposure compensation. The exposure meter will often overexpose such scenes. (Left) Here, the dark surface of the pond causes the meter to add exposure, resulting in an image that does not capture the feeling of the actual scene. By using a -1 EV setting the pond and reflections are recorded as seen by the eye (right).

Exposure Bracketing

Some cameras have a feature known as exposure bracketing. This comes in very handy when lighting conditions are very contrasty (that is, there's a broad range between light and dark values) or when you are not sure which exposure setup to use. It's also a fail-safe technique to use when the subject and light is fleeting and you only have a brief time to make the picture. The bracketing sequence is usually three shots—one that adds light, one that uses the camera's recommended reading, and one that takes away light. Once you set up exposure bracketing you press the shutter three times in a row. Each frame will have a different exposure.

Alternatively, you can bracket with exposure compensation so you can have three shots that range, for example, from -2EV to -1 EV and the camera's autoexposure system reading. For example, say you're photographing a fleeting rainbow and want to make sure the exposure is right. Set exposure bracketing and shoot away; odds are you'll get one of the exposures right. Exposure bracketing is also a great way to learn how to set the camera under different lighting conditions. After exposure check the bracketing sequence to see which compensation worked best, and use that for future pictures under similar conditions.

ISO Settings

The sensitivity of the sensor to light is measured by the ISO setting. As discussed, this is one of the foundations of arriving at a proper exposure. When you load a roll of film into a camera you are setting that foundation for every picture you take on that roll. Most digital cameras have an ISO of about 100, but a number of models allow you to change that ISO on every frame you take (see "Digital ISO" on page 64). This is like swapping film speed to match every scene.

Long Exposures

Most cameras have a shutter speed range that will automatically be set by the exposure system. This range may be, for example, 1 to 1/1000 second. If you need to use a longer exposure time, say 2 seconds and slower, you may be able to access the long exposure time function for exposures as long as 30 seconds. Although the need for this may be rare, photographs of fireworks, cityscapes at

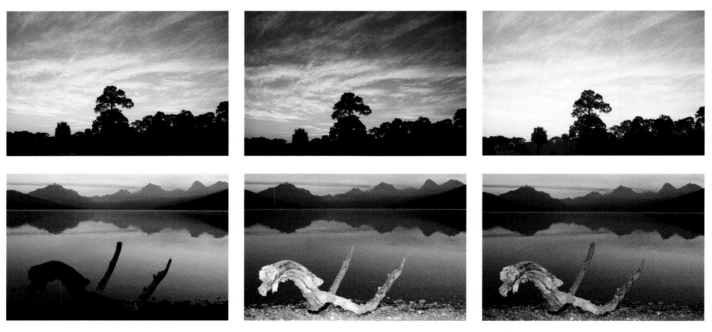

Bracketing exposure is a good technique for insuring that you get the exposure just right. Use it when you are unsure about exposure or if you want to check on slight variations of exposure to see the best of the set. With some digital cameras you can bracket both regular and flash exposures. To bracket, set the bracketing feature on your menu and take three pictures. Sunsets are a good subject for bracketing, as each exposure will yield a different rendition of the light and color in the scene. This sunset series was made with normal (top left), -1 EV (top center), and +1 EV (top right) settings. If your camera allows you to bracket flash exposure as well, use it for both fill flash and when the lighting is tricky. To illustrate the effect, this image has been made with no flash (bottom left), normal flash (bottom center), and -1 EV flash (bottom right). The plus flash bracket can be used to add to the distance a flash covers, but would not be suitable for this type of scene, where a more subtle flash effect is desired.

night, or effects like the streaking taillights of cars or a spinning carnival ride may need such long exposures. When using these slow speeds it is essential to mount the camera on a tripod. As mentioned earlier, some cameras have a bulb setting. When you use this, the shutter is activated as long as pressure is kept on the shutter release. This is a strictly manual affair, so you have to count down while the sensor is exposed.

To capture the burst and trail of fireworks, you will have to set the camera at long exposure or bulb (B). Long exposures are usually found in the LCD menu on cameras that offer this feature. The shutter speed for this picture was 2 seconds. If your camera has a B setting the shutter will stay open for as long as you maintain pressure on the shutter release button. For either setting keep the camera steady by placing it on a tripod; if you don't have a tripod with you, brace it against a surface like a tree or sit on a bench or rock.

Focusing

All digital cameras have automatic focusing. This might seem to remove any focusing decisions, but there are a few techniques that will insure that your pictures are sharp. There may also be times when the focusing system cannot lock in focus on certain subjects. That's when you have to take control of focusing yourself.

There are two types of automatic focusing systems. The one found in many digital point-and-shoot cameras is called an "active" autofocus while that found in most digital SLRs is referred to as "passive." Some cameras use a system that is a hybrid of the two.

The types refer to how the system works rather than their efficiency. In an active system, when the shutter release is pressed lightly an infrared beam is emitted from the camera. This reflects off the subject and back into the camera's autofocusing (AF) sensor. The time it takes for this reflection sets the distance, and the camera's microprocessor sets the lens for that distance. In a passive system, focus is set by an array of sensors that sit inside the camera body. These sensors compare the contrast of the light that strikes them and compute distance when they detect an edge or a difference in contrast in various parts of the scene.

In both types of AF systems you have to select the target, or subject, for the sensor. Digital point-and-shoot cameras usually place that target dead center in the viewfinder, so whatever distance the subject in the center of the finder might be is the distance the system sets. If the main subject of your photograph happens to be at the edge of the frame, the focusing distance may not be correctly set. To overcome this potential problem, you can use a function known as autofocus lock (AFL), which may or may not be available on your digital camera.

To use AFL, first move the viewfinder so the target—usually indicated by a box or crosshair in the center of the finder—sits over the subject. Lightly press the shutter release and confirm that focus has been achieved. Many cameras have a focus confirmation signal LED (light-emitting diode) that lights in the viewfinder. Keeping light pressure on the shutter release, recompose the frame as you prefer. This insures that focus stays on your intended subject. If you release the pressure at all the focus will shift to whatever sits in the center of the viewfinder.

This takes some practice but it should be easy to master with one or two attempts. Just keep your eye on the focus confirmation signal when you shift the viewfinder to another subject. Some cameras have an AFL button on the body itself, which eliminates the need for the shutter pressure method. In either case, the focus confirmation signal in the viewfinder is your key. If it blinks or changes color (from green to orange, for example) focus has not been set. This means that you are either too close (back away until the light stays on steadily) or that the sensor can't lock in focus.

While the active focusing system usually works well, there are a few circumstances that may cause it to fail to find and lock in focus. Because it works with a beam, anything that blocks that beam will throw it off. If, for example, you are photographing through glass, the beam will be stopped by the surface of the glass and focus on the glass itself, not on the actual subject that's further away. To overcome this potential problem use the camera's infinity setting. This turns off autofocus and defaults the focus setting to the far distance. The infinity setting may be indicated by an icon of mountains next to a button on the camera.

If the subject that sits behind glass is not far away you can switch to manual focus mode, if available, or focus on a subject at an equal distance, use AFL, and shoot.

Active autofocusing systems do not set "actual" camera-to-subject distances. Rather, they work in distance zones, each of which defines a certain camera-to-subject distance. If you are considering two digital cameras of this type, find out the number of zones the focusing system allows. Some have as few as 3, while others can offer many more discrete zones. The more zones, the more likely you'll get sharper pictures in a greater variety of subjects and scenes.

Passive autofocusing systems do set actual camera-to-subject distances. But, as with the active type, they also work with targets that you define. Some work with the same centered target as the point-and-shoot models, so the procedure for composing off-center subjects remains the same. Others offer a choice of focusing targets spread around the frame and will either lock in focus on the one closest to the camera (this is called "closest focus priority") or allow you to choose one of the targets with a toggle switch on the camera so that you don't have to use autofocus lock on off-center subjects. As you move the toggle the different focus areas light up; when it "lands" on your main subject you have focus confirmed.

In some cases, the passive system will not be able to lock in focus. As mentioned, the system works by finding contrast within the focusing target. Because the focusing sensor works by judging contrast, subjects and scenes with

The autofocus lock feature (AFL) available on many digital cameras comes in handy when photographing scenes where very little contrast exists, or where the contrast that does exist does not sit in the center of the viewfinder frame. (Top left) The autofocus target, shown by the brackets superimposed over this scene, "lands" on blank sky and will not be able to lock in focus. The solution is to shift the view down so that the contrast between the mountain and sky sits on the target, then to use the AFL hold function to set focusing distance. Then you just recompose and release the shutter. When there is little contrast due to an overcast sky (bottom left) or when there is no place to set contrast, such as this distant photo of a shuttle launch (right), set the camera on infinity or landscape mode, which sets the focusing system to a long-distance range. Keep your eye on the focus confirmation signal in the finder to insure that focus has been locked in.

low inherent contrast, like clouds in the sky, a mono-chrome wall, or certain fabrics will cause problems. You will know the sensor is having trouble because the lens racks back and forth seeking a focusing area or the focus confirmation signal blinks. The easiest thing to do in this situation is to switch over to manual focus and do it your-self or to find a subject with more contrast, focus on it, and use AFL. With digital SLRs you have the choice to focus manually, to turn the lens yourself until you see a sharp image in the viewfinder.

Advanced focusing options are available with many digital cameras, especially digital SLRs. You may have a

choice of three focusing modes. Like exposure modes, these are ways to set up the system to match the shooting conditions and subject matter. The two most common modes are single and continuous autofocus. Use single mode for stationary subjects, as the camera will not allow you to make the picture unless focus has been achieved. The advantage of single mode is that it almost always guarantees a sharp picture if the focusing procedure described above is followed.

Continuous mode will allow you to photograph whether focus has been achieved or not. Use this for mov-ing or action subjects. If you have a camera with a single

Close-up Focusing

Any lens has a minimum and maximum focusing distance. The maximum distance is infinity, or as far as your eye can see. The minimum distance is more critical, as it tells you just how close you can get to your subject to make a picture. That distance may vary if you are using the wide angle or telephoto settings. Some lenses allow you to get as close as 3 feet from your subject; with other lenses that distance may be slightly longer or shorter. Take a picture inside the minimum range and it will be out of focus regardless how you operate the lens or what focusing mode you may be using.

As mentioned under "Exposure and Picture Modes" (page 43), some lenses have an additional focusing range often referred to as a macro setting. This may be available only at the telephoto or wide-angle setting, but some lenses offer it throughout their range. Macro shifts the elements in the lens so that you can get quite close—sometimes as close as a few inches. When you shift into macro, however, you limit the maximum focusing distance, which may shrink to as short as a foot or two. Use this mode for making close-ups of flowers or to make abstractions of everyday subjects. It also comes in handy if you use your camera for auction site photos and plan to sell your rare stamp collection in a web auction setting.

Focal Length

Each lens is identified with a focal length that tells you its angle of coverage (angle of view). Think of angle of coverage as an arc that starts at the front of the lens and spreads out to encompass the scene before you. Wide-angle lenses have a wider arc, while telephoto lenses have a narrower one. Telephoto lenses, as their name implies, bring distant subjects closer, while wide-angle lenses tend to make distant subjects seem farther away. Zoom lenses incorporate all the focal lengths within their range; they are often expressed by the ratio between the wide angle and telephoto maximums. A 7–14mm lens is referred to as a 2X lens, for example, while a 7–49mm lens would be a 7X zoom.

If you have worked with 35mm cameras you might be accustomed to focal lengths such as 28mm (wide), 50mm (normal), and 200mm (telephoto). Because the size of the sensor in most digital cameras is smaller than a frame of 35mm film, these numbers do not apply. Often, however, the focal length for a digital camera will be expressed in terms of its 35mm equivalent, or at least as the angle of coverage the lens supplies. The ratio of these expressions depends on the size of the sensor in relation to a 35mm film frame.

Point-and-shoot digital cameras have difficulty focusing through glass, as the beam they project to lock in focus bounces off the surface and can yield a false distance setting. If the subject is far away (such as when you photograph through a car, plane, or train window), use the infinity setting. This cancels autofocus and causes the lens to focus in the distance. If the subject is close, such as this figurine in a shop window, find a subject at an equal distance, use AFL to lock in that particular range, then recompose and press the shutter release.

focusing target, you have to follow the subject and keep it in the center of the viewfinder when you shoot. Cameras with multiple targets may offer a function that in essence hands off the subject from one focusing target to another. This is called predictive or dynamic autofocus in a number of brands. This will kick in automatically and is ideal for sports or any high action photography.

It should be mentioned that some basic digital cameras have what is known as fixed focus. This means that the lens does not move and that the focusing distance is set at one distance. Check your instruction manual to see the focusing range your basic digital camera offers. It might be something like 6 feet to infinity. While useful for some types of photography, fixed-focus models are not recommended and will usually give you disappointing results.

For close-up subjects, switch the camera to macro mode and watch the focus confirmation signal in the viewfinder. Macro mode limits distance focusing but sets the lens so that it can work in the range of, say, 1–3 feet. Remember to switch out of macro mode when you make pictures from other distances later.

When making portraits, try a frame-filling close-up. You might have to switch to macro mode to get this close. At such distances focus becomes critical and you won't have much of a range in which to keep the entire subject sharp. The key is to focus on the eyes, using AFL and watching your focus indicator signal. This type of picture can also be made successfully in portrait mode.

For example, say the area of the digital sensor is 1/4 the size of a 35mm frame. To find the equivalent angle of coverage you would multiply the digital focal length by 4. So, a 6mm lens on a digital camera would give an angle of coverage of a 24mm lens on a 35mm camera, and a 20mm lens on a digital camera would be equivalent to using an 80mm lens on a 35mm camera. Again, this depends on the size of the sensor.

Some digital SLRs have larger sensors, especially those in the professional class. These cameras generally use the lenses found on their film counterparts, so converting angle of coverage is necessary to know the type of coverage you'll get. That coverage factor depends on the size of the sensor you have in the digital camera. If the sensor is 3/4 the size of a 1 x 1.5-inch 35mm frame, for example, you increase coverage by 25%. So if you are working with a 100mm lens on your film SLR you will get the angle of coverage of a 125mm lens when you put that same lens on a digital SLR. In other words, telephoto lenses get longer and wide-angle lenses get less wide. As chip technology improves and prices get lower we'll see less and less need for this equivalency factor. Some newer models already sport chips the same size as a 35mm frame. Your camera instruction book will aid you in all these calculations as most have conversion charts.

COMPARING 35MM AND DIGITAL LENS COVERAGE

For those who have worked with 35mm cameras, figuring out just what the lens on your digital camera will deliver in terms of angle of coverage can be perplexing. This chart compares a typical point-and-shoot digital camera with its 35mm lens equivalent. As the focal length (expressed in millimeters) gets wider the numbers decrease. For example, a 28mm lens covers a wider angle of coverage than a 50mm.

35mm focal length	Point-and-shoot Digital Equivalent
28mm	7mm
50mm	12.5mm
100mm	25mm
200mm	50mm
300mm	75mm
500mm	125mm

Wide angle lenses or wide angle settings on a zoom lens allow you to take in more of the subject in a frame; they also exaggerate the distance between you and faraway subjects. This freight yard photo was made with a wide angle lens. Note how the point of view of the camera emphasizes the distance from near to far by setting up a "vanishing point" in the frame. The aperture was set at ƒ/11 to produce sharpness from near to far. You can also use landscape mode to get the same effect.

The zoom control on your digital camera allows you to make various compositions while standing in the same spot. When you first work with it, try out different ranges and see the effects they have on your pictures. Some cameras offer rather high zoom "ratios," or the range between the widest angle and longest telephoto lens views. This scene of a cruise ship leaving port was made with a 10X zoom, a very high ratio lens. The difference between what you capture with the wide setting (top left) and the maximum telephoto setting (top right) is quite dramatic. Zoom lenses are great compositional aids. This lone tree seems lost when the sky is included in the scene (middle left), but becomes the center of attention when a zoom is used (middle right). Even digital cameras with a more modest zoom lens allow you to make compositional choices. Using a point-and-shoot digital camera with a 2X zoom lens changed the whole feeling of this scene of dragon boats when photographed with wide (bottom left) and telephoto (bottom right) settings.

Telephoto lenses or telephoto settings on your zoom lens are great for bringing distant subjects closer, as they did in this scene of a mountain range taken from across a lake in Glacier Mountain National Park (left). However, when you use a telephoto at a scene where many different subjects are in the field of view at different distances from the camera, the lens tends to make them look as if they are very close to one another even though they are far apart. This visual effect, called "stacking," can yield images that look like the subjects have been collaged together to create an image (right).

Flash Photography

The built-in flash on your camera comes in handy for indoor, night, and even daylight photography. Once activated, the flash fires when you press the shutter release and links up with the automatic exposure system to deliver a well-exposed subject within its range. That range depends on the size and power of the flash; in general, built-in flash tends to cover subjects only up to about 10 feet from the camera. In some digital cameras that range can be as short as 6 feet, especially when the telephoto lens is used. Even with this short range, the flash can be a lifesaver when light is low or when your subject sits in shadows with bright sun behind him or her. There are numerous flash modes that you can adapt to the shooting conditions at hand.

Digital cameras with built-in flash will often have a feature known as autoflash, which will pop up the flash and charge it when the exposure system indicates a low light situation. It takes the guesswork out of when you should use it. This sculpture sat deep underground in a cistern in Istanbul, Turkey. The flash revealed every texture and detail of this treasure.

Red-eye reduction flash mode is intended to cut down on the amount of red-eye that results from photographing people indoors with flash in low light. In truth, it is not always as effective as we might like and can often serve as a distraction to subjects, especially children. Luckily, it is easy to fix in your computer later using a Red-eye Reduction feature or simply by painting over the offending red glow. Red-eye is severe in this photo (left), which was made with a point-and-shoot digital camera with built-in flash. It was touched up easily in the computer later (right).

Fully Automatic

This is the mode to set when you want to rely on the camera to determine when flash is required. This links up with the camera exposure system and will fire when your shutter speed dips below what the camera designers consider the speed where camera shake might occur, usually 1/30 second. You can set this mode when you are photographing indoors at parties and special occasions. Be sure to check the flash range so you'll know at what distance the flash will be effective.

Red-eye Reduction

This mode should be used if the flash picture you take causes your subject's eyes to have that bothersome red dot in the pupils. This is caused by the close location of the flash to the lens and is endemic to most point-and-shoot cameras. It seems to be worse when photographing children in a dark interior. In theory, red-eye reduction works by pre-firing a small burst of light prior to the actual exposure. The problem is that your subject may turn away after the first flash, as they might believe that the actual exposure has been made. In practice, red-eye reduction is less effective than you might like. Thankfully, it's fairly easy to retouch red eye in your subject later when using a computer image-editing program.

Fill

Fill, or flash anytime, is the mode to use when you photograph outdoors and your subject sits in the shade or when a bright background is behind them. The bright background may fool the metering system and consequently your main subject may not get enough exposure. Fill flash adds just enough light to balance foreground and background; most metering systems will read both the flash-lit subject and the background for a balanced exposure. Your photographs will improve markedly if you learn to recognize this lighting situation and use fill flash when required. It can also be used to brighten colors on overcast days.

Fill flash is perhaps the most important optional flash mode, as it can add so much to images that might otherwise lose detail and color richness. Our eyes allow us to see all the detail in scenes with both very bright and quite dark areas. However, without some extra light from the flash, the camera's sensor may fail to record this light due to the extremes in contrast. (Left) This photo was made inside a barn on auto-exposure mode. The bright light from the window causes underexposure of the detail on the barn wall. To overcome this, turn on the fill flash, even though the exposure system indicates no need for flash. This brings details into the recording that might otherwise be lost (center). Note, however, the blue cast of the interior, caused by the flash—some flashes have a definite color cast. This can be overcome by setting the white balance to "flash" mode (which we'll discuss shortly), adding some warmth to the scene and eliminating the blue (right).

You might also consider using fill flash outdoors when subjects sit in the shade, or on overcast days. This sculpture, outside the House of Blues in Orlando, was in heavy shade. Using fill flash illuminated all of its great detail.

Flash On

This is the mode to choose when you want the flash to fire even if the exposure system does not indicate a need for flash. It is very much like fill flash and can be used for creating fill, photographing on overcast days, or just introducing a touch of light to add brightness to any scene, indoors or out.

Slow Synchro

This mode adds a natural look to flash made outdoors at night and even in dark interiors. It sets the exposure system to make a well-exposed picture of the subject illumi- nated by flash and extends the shutter speed to add light from the background as well. In automatic flash the exposure system only reads the light from the flash-illuminated subject. Using slow synchro is a great way to add a more natural look to interior flash pictures. Be aware when using this mode that the shutter speed slows and may result in some blurring of the background, so steady the camera as much as possible. Usually, the flash-illuminated subject will look steady because of the fast burst of light from the flash. This mode may also be called "night synchro" or "night portrait" mode.

Using fill flash at night can be tricky, but it can also help you get a better balance of light and colors. Without flash (left), the exposure meter gives a reading that reveals details in the statues and fountain, but notice how the background is "burnt up," or overexposed. This results from the contrast between the foreground and background levels of illumination. By using night fill-in flash (often called night scene, or slow synchro, mode), the contrast between the two is reduced and the exposure system has a better chance of giving you a well-exposed image (right).

To flash or not to flash? When the light is low, flash is a good option, but there are times when it is inappropriate, not allowed, or, as in this scene, can take away from the character of the light. Made with flash (above), this is a document of a welder at work. Without flash (right) it carries more of the mood of the original scene. Of course, when working in low light without flash, always steady the camera as much as possible.

The Digital Side

Now that we've covered some of the main components that make digital cameras very much like their film counterparts, let's explore some of the uniquely digital aspects. These are what set digital cameras apart from film cameras and allow you to take advantage of the new and exciting photographic opportunities they afford.

Digital "Film"

As mentioned in Chapter 1, the recording medium for digital cameras is in the form of a slim memory storage card that slots into the camera. There are numerous types of memory cards and generally each camera will take only one type. Advanced digital cameras may take more than one type of card; these will have a slot dedicated to each. To load the memory card you open the slot and slip the card in until it sits firmly inside the chamber. Take care to load it in the direction indicated in your instruction book, as a misloaded card will not record. If the card resists loading, do not force it, as this may damage the contacts.

Digital Zoom

The optical lens on your digital camera has a certain focal length or focal length range. If you have a zoom lens you can go from wide angle to telephoto coverage. Many digital cameras add to the range on the telephoto end by offering digital zoom, a "cropping" of the image on the sensor so you can record even longer-distance subjects closer up. For example, say you have a zoom lens that has a maximum telephoto setting of 21mm. A 2X digital zoom

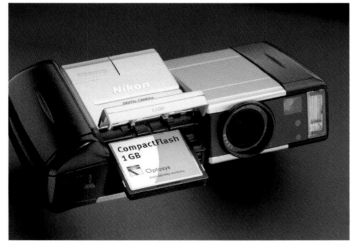

The digital "film" memory card loads into a slot on the camera. Unlike film, it can be taken in and out at any time without fear of image loss. Check your instruction book for the right direction to load it, and never force a card into the slot unless it loads easily.

will extend the range out to the angle of coverage of a 42mm lens. A 4X digital zoom setting makes it 84mm. With many cameras you evoke digital zoom by keeping pressure on the telephoto toggle switch. You will see the digital zoom come into play when the image "jumps" into a closer view. With others you may have to go into the menu and set it, a decidedly less handy way.

There is a limit to the quality that digital zoom delivers. At 2X the image is passable; at 4X and above it can deteriorate considerably. Only use high degrees of digital zoom when absolutely necessary. Keep in mind that the potential for camera shake seems to be greater each time you extend the optical zoom range, and is exponential when you use digital zoom. On most digital cameras, digital zoom just cuts down the area of the sensor used to capture the image. This limits the pixel resolution and contributes further to degrading image quality.

Image Preview and Immediate Edit

One of the chief advantages of digital photography is that you can see the picture immediately after you press the shutter release. This allows you to reshoot if necessary or delete pictures as you go to save room on the memory card. Some cameras have instant preview, a programmable amount of time that holds the picture on the LCD screen for anywhere from 2 to 10 seconds. Others require you to press the monitor display to see the image, or to switch to playback mode to review images.

Image Playback

After you have made a number of images, you can review them one at a time or using a slide show format. To do this you switch the camera from shooting to playback mode and activate the review options. Keep in mind that LCD screens are not always reliable predictors of how the image actually looks. For example, if you make a photograph in a low light situation it may look quite dark on the LCD screen. When you open up the image on your computer later, however, a simple brightness and contrast adjustment reveals a fully detailed image.

The main things to look for on the monitor are whether the picture is sharp and the framing and subject expression are to your liking. Monitors also tend to be obscured by direct sunlight, so you may have to find shade or create shade with your hand to get even a fair idea of what you have on the screen. Accessory hoods are sold that can block the sunlight and aid in viewing.

When the picture calls for it digital zoom can do wonders for getting close. Bird and wildlife photography requires a very long telephoto lens. The top image was made with the "normal" lens on this digital camera. The birds are in there but can hardly be seen. This camera features a 10X optical zoom, which bring you pretty close (middle row). The best of the set is obtained by using a 2X digital zoom over the 10X optical zoom, which brings the birds right into the frame (bottom row). When using the digital zoom steady the camera as well as you can. Don't use digital zoom too much, as optical zoom always yields a better-quality image, as demonstrated by the details beside each zoom shot.

Playback mode can display images as a series one at a time using a toggle switch, or continuously (you set the interval) as a slide show. Some digital cameras have an "info" playback mode that displays the camera settings along with each picture. This lets you see what you did when you made the picture. If you're unhappy with the results, use the information to help correct the image. A few digital cameras can display a "histogram," a graphic representation of the scene that shows you if the image is under- or overexposed. You can use this to correct problems in your next exposure (see pages 75–76).

White Balance

White light is composed of all the colors in the spectrum. When a light source is deficient in certain colors, or when there is a color cast in the scene, that lack of or preponderance of color will affect how it is recorded. Our eyes and mind adjust for these color casts and deficiencies, but film cannot. Digital cameras allow us to balance color back close to what our eyes see with a tool known as white balance.

Let's say we are using film to photograph someone wearing a white shirt in a room lit by ordinary light bulbs and we don't use flash. If we were to use daylight (normal) film, that shirt would record as yellow/amber because of the lack of blue in the light source. The way to get correct color with a digital camera is to set the white balance on indoors or, in this case, incandescent lighting. This, in effect, biases the color recording so that blue is added to the mix. We can do the same thing with film by placing a blue filter over the lens; it's just that digital photography makes getting correct color so much easier.

Most digital cameras have a choice of white balance settings. The offerings might include daylight, cloudy, incandescent, and fluorescent. Customized settings allow you to play with the white balance and then check the preview to insure that you got it right.

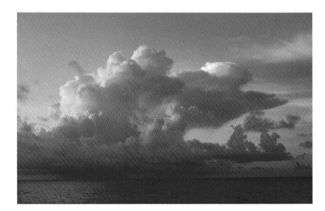

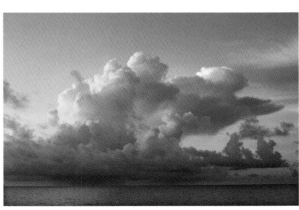

White balance allows you to adjust for any lighting condition to get good color rendition of a scene. When photographed with the default setting, or normal white balance, these clouds are a bit blue and lose the many colors that were in the scene (top left). When the white balance is switched to "cloudy," more of the true colors come through (bottom left). There may be times when you don't want to correct the color cast, as it adds to the visual feeling of the scene. At sunset the long rays of the sun make for a dazzling color display. (Right) If this scene were shifted toward blue to neutralize the color, the entire mood of the scene would be lost. Thus, the white balance here was left on auto, or default.

WHITE BALANCE SETTINGS AND THEIR APPLICATIONS

White Balance Setting	For Color Correction Under These Lighting Conditions
Daylight	Outdoors in good weather
Shade	Outdoors in the shade or under overcast skies
Incandescent	Indoor household bulbs
Fluorescent	Offices, stores, etc. lit by fluorescent light
Tungsten	Concerts, arenas, stage lighting
Automatic	The system chooses for you
Custom	For shoot and review or special effects

You can mix and match the white balance settings with the scene to add a special effect to your photographs. For example, say you are photographing on a foggy morning and want to add a blue mood to the overall scene. Although you might ordinarily use daylight or auto white balance, set it to incandescent and you'll put a blue cast over the scene. Try the shade setting to add a warm, slightly yellow/red bias. You can use shade to photograph a fall foliage scene in daylight to add a warmer color to the leaves.

Digital ISO

In some digital cameras you can raise the sensitivity of the sensor with the ISO control. As discussed, films have a set speed, or sensitivity to light, that applies to the entire roll. This applies even with special chemical processes that can push, or raise, that sensitivity. The range of speeds you can set on the digital camera depends on the model, but usually you can work from the "native" speed of ISO 100 and use ISO 200, 400, and 800 on any frame. This comes in handy when working in varying lighting conditions.

For example, say you are on a city tour. Photographs on the street can be made at the default ISO 100 setting. You go into a museum and the light is lower, so you raise the speed to ISO 400 (and set the white balance as well.) Then you go to a club at night where the light is quite low; that's when ISO 800 comes in handy.

In another example, say you are photographing in the deep woods and notice a camera shake warning or see in

Use the ISO setting to get yourself out of low light difficulties, where using the standard (default) ISO might result in blurry pictures. (Left) This photograph was taken in deep shade at the default ISO 100 setting. Upon review, the shaky image, caused by the low light and a low ISO setting, was obviously not what was wanted. Setting the ISO to 400 yielded two more stops of light (four times as much light overall) and eliminated the camera shake problem (right). Some cameras allow for adding only one ISO increase, while others have no ISO options. In those cases, steady the camera as best you can or use flash in low light.

the viewfinder that the shutter speed is not quite fast enough to be handholdable. You don't have a tripod to steady the camera and don't want to use flash, because you know that it will change the character of light in the picture. The solution is to raise the ISO setting in the camera. Change it to ISO 200 and you get one more stop of light; an ISO of 400 gets you two more stops; while an ISO of 800 gets you three more stops. If your shutter speed is 1/15 second at ISO 100, then it will be 1/30 second at ISO 200, 1/60 second at ISO 400, and 1/125 second at ISO 800. You can usually get away with handholding a camera at 1/30 second, but if you're working with a telephoto lens 1/60 or 1/125 second is recommended.

If you find that low light or night scenes cause blurriness in your images, just set the camera to a higher ISO. You can then make a series of pictures in the same lighting without having to worry about getting a good exposure. While walking around Las Vegas at night, the default setting on the camera (ISO100) was too low to get a steady shot. Every picture looked like it had the "shakes." The solution was to set the ISO at 800, a speed that made handheld shooting easier and resulted in a much better picture (top). But setting a higher ISO does have its price. The higher setting always results in more picture "noise," which can decrease picture quality. In very bright sunlit scenes, such as this boatyard in the Florida sun, always put the ISO at the lowest possible setting; here, ISO 100 was used (bottom).

Raising the speed also extends the flash range. Many point and shoot digital cameras have a rather weak built-in flash with ranges normally topping out at about 10 feet. If you double the ISO you can usually get a flash coverage distance increase approximately 1/3 more than normal. For example, if you can get 10 feet at ISO 100, you probably can get 14 feet with ISO 200. This can sometimes make the difference between getting and losing a picture.

There is, however, some price to pay. The native speed of the sensor does not change. What happens is that the system applies more voltage across the sensor field to increase light sensitivity. This increased charge results in more noise, a visual effect that looks grainier and not as sharp. As you go higher in speed the effect increases. Although the image may be adversely affected, this technique does allow you to get pictures that would otherwise be unobtainable.

Sharpness

The sharpness setting defines how pixel edges are rendered in a scene. There may be three settings—sharpness-plus, normal, and soft. You use normal for most scenes. If you are copying text or want to create a more graphic feel to your images, then add to the sharpness. Soft can be chosen when doing portraits or landscapes. Of course,

The sharpness setting in your digital recording menu is usually used to enhance copies of text documents, but it also can come in handy for certain subjects and scenes. The photograph of these tiles is all about color and design, and it's important that all the detail be recorded. A normal setting yields a good rendition (top), but enhancing the detail by choosing an enhanced sharpness setting works even better (bottom).

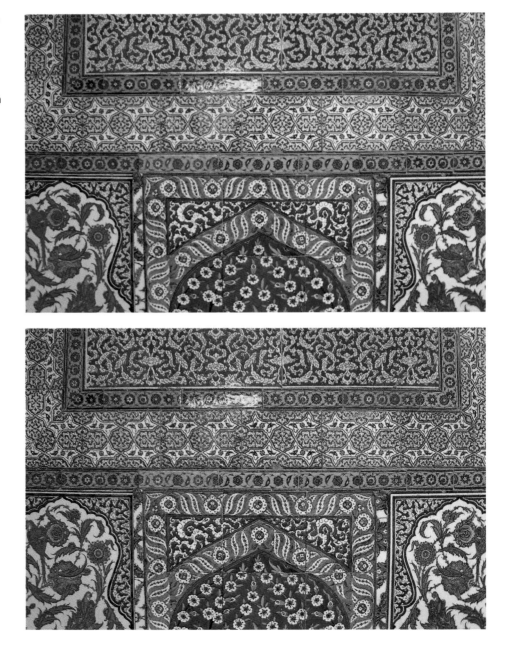

Saturation is the richness or vivid quality of color. This scene is quite color rich (left), but to exaggerate color even more the saturation menu was opened and saturation plus was selected (right).

these effects can be mixed and matched with any scene or subject. Many of these effects can be added later when working with computer image-editing software, too.

Color

Color is composed of its hue and saturation. Hue is the color itself—blue, orange, green, etc.—while saturation is its vividness, or intensity. A highly saturated color would be like a freshly painted wall; an example of low saturation would be a sun-bleached wall with less vibrant color. With some digital cameras you can alter the color saturation as you record it, thus giving it more or less saturation. Note that you can also do this with many digital imaging software programs as well.

Contrast

Contrast is the relationship of light values. Having high contrast means that there is a strong difference between lighter and darker values. With low contrast, the values are more compressed or there is little difference between them. Many digital cameras allow you to affect the scene contrast when you make the picture. You might use high contrast for a more graphic effect or when photographing text. A low contrast setting could be used to tame contrast in a high contrast scene. For example, when photographing in the tropics I often use low contrast to try to control the effect of the bright sun on pictures. You can also tame contrast when working on the image in the computer later, but if an area of the image you deliver to the computer is

You can change contrast in any image-editing program, but there are times when your instinct will tell you to do so in the field. The hot, tropical sun at noon caused this image of a palm frond to have extreme contrast (left). To tame it and bring more color and detail into the scene, the contrast menu was opened and a minus contrast selection made (right). Experience will inform you when to use this option.

very overexposed it will be a difficult task to get it right. Note that very high contrast is a problem with all photographic systems; digital photography is no exception.

Movies

If you look at an actual strip of movie film you soon realize that it is simply a series of still pictures that when photographed at a certain frame rate and played back at a certain speed resembles real live action. The same goes for the digital movies you can make with your camera. Motion sequences made with most digital cameras have a herky-jerky feel due to the lower framing rate. However, the option is fun and allows you to send motion studies across the Internet. Many digital cameras use what is known as Motion JPEG format or AVI (Audio Video Interleave) format, the former being a derivation of the latter. These files require that you have QuickTime installed on your computer for playback. This is usually bundled along with the software you receive with the camera.

The framing rate for Motion JPEG is generally about 10 frames per second, about half of what motion picture and video cameras use. To start recording a movie you set the camera to movie mode and press the shutter release once to start the sequence recording and a second time to stop it. When you begin recording a movie, a timer in the viewfinder or LCD starts, and counts down the remaining time. The duration depends on the capacity of the memory card in the camera. For example, a 16 MB card will allow you to

record about 1.5 minutes of motion using 320 x 240 pixel resolution (the usual resolution used by Motion JPEG format.) Still digital cameras are now being made with higher framing rates that deliver a more natural feeling of motion.

Panorama

Some cameras offer a panorama, or "stitching," option, a useful feature for creating a very wide view of a scene. The camera will guide you in making such scenes by indicating the direction in which you should make a series of pictures. When you do so, overlap the individual frames by about 25%. The image files will be linked and marked as panoramic. Later, you can use the panoramic software bundled with the camera to "stitch" the frames together. The software is easy to use; what takes practice is keeping your horizon lines straight and overlapping enough to blend the images together when you shoot.

DPOF

Digital Print Order Format is a way to preset the number and size of prints you want from a certain image. Increasingly, digital printers allow you to patch the camera directly to the printer or even to put your memory card right into the printer to make computer-less prints. You can set this up when you preview an image right in the camera. We will cover more on DPOF in Chapter 7, "Printing Your Digital Images."

Image Organization

When you record images with a digital camera, the image files are numbered and stored on the memory card in sequence. When you look at them later on a computer you'll see codes such as DSC.0001.jpg—hardly helpful in identifying the subjects. Files should be renamed when they are saved in the computer; we'll cover this later.

You can begin to make sense of image files right from the camera by creating folders into which the pictures are placed right after exposure. For example, you might be able to create a folder in your camera that is titled "Birthday, Brynn, 2002" or "Classic Cars." Before you take pictures you can set the camera to store the images in those select folders. This makes it much easier to edit and organize them later.

You might also have the option of resetting the picture numbers every time you load a fresh or re-formatted memory card into your camera. If you don't do this the numbers will be sequential, starting with the first pictures you take. You can reset the number to "one" if that helps your picture organization. Everyone has a different preference for organizing things, so there's no right or wrong way to set this up.

Camera Customization

Because digital cameras contain microprocessors, you can program them to function according to your preferences. For example, you can change the brightness of the monitor to make it easier to see in varying light conditions. You can program the camera to turn off power in a set period of time—an excellent battery-saving function, especially if you might forget to turn it off after a picture-taking session. The timer can be set anywhere from 30 seconds to 10 minutes. Because the shutter release on a digital camera is silent, most cameras are programmed to beep when a picture is made. You can turn this off (when appropriate) or make it louder according to your taste. You can even set the date and time and have that imprinted on the image itself—a helpful feature for insurance or accident pictures.

We will cover the full gamut of setups in the following chapters and the many options they afford. At times there seem to be too many options, but choosing the ones that will enhance your images and understanding how they affect the way in which you make pictures will have a profound effect on getting the best results. You can always choose the "default" mode—the way the camera is programmed to work right out of the box—and still get good results. But that wouldn't be as much fun!

In the next chapter we'll explore the digital camera imaging menus and how to use them. This goes to the heart of what differentiates digital from film cameras and is your path to making the most of every scene and subject you photograph.

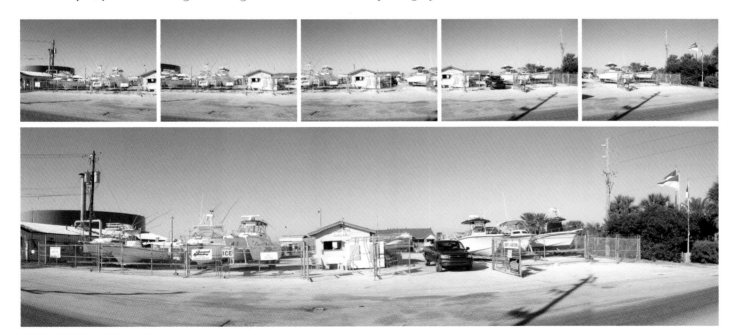

Digital cameras with a panoramic option allow you to make pictures that have a fascinating point of view. These cameras also come with stitching software that makes putting the photographs together easy. The trick is to leave enough overlap in the succession of pictures, something the camera will guide you through when you use the stitch recording option. This panorama (bottom) is composed of five individual frames (top row). As you can see, each one overlaps the other by about 25 percent.

4 Image Menus

The Range of Camera Functions

- **Record Menu**
 - Resolution
 - File Format
 - Compression
 - ISO Speed
 - Drive Modes
 - Digital Zoom
 - Review
 - Contrast
 - Sharpness
 - Saturation
 - Combining Effects
 - Black and White and Sepia
 - Solarize and Posterize

- **Image File Management**
 - File Numbering and Naming
 - Erase: Single and All
 - Formatting Cards

- **Playback Menu**
 - Protect
 - Rotate
 - Slide Show
 - Multiple Views
 - Print Order: DPOF

- **Setup Menu**
 - Sound
 - Monitor Brightness
 - Power Down
 - Date and Time
 - Reset
 - Memory Settings

YOUR **DIGITAL CAMERA** contains circuitry, microprocessors, and software that handle many functions, including converting the recorded image to a digital file; running the focusing, exposure, and viewing systems; and creating paths for moving images from the camera to the computer. In the previous chapter we covered how to use these functions to affect how your pictures are recorded. In this section we'll take a look at the camera menus and how they can be used to record, play back, and connect the camera to the computer. Some menus contain features already covered, while others offer even more extensive controls.

It's a good idea to familiarize yourself with these functions and how to access them, as you want to be able to make decisions as you shoot without having to fumble with the menus and options. Don't expect to learn all of the options and ways to access them right away. The best way to go about it is to understand the basic menu items first and then experiment as you practice in the field. Each time you use your digital camera you'll find another way to solve particular picture problems and make creative choices. This is much like learning any computer program, where creating and completing projects make up the best path.

Record Menu

This is the picture-taking menu you use to set up the camera for different types of pictures and effects and choose the resolution and compression modes for your shots. Putting the camera mode dial on the camera icon setting accesses it. In some cameras you access the record menu by pressing the menu or display button and choosing the camera icon in the LCD display.

Once you are in record mode you might toggle through the choices with a four-direction rocker switch (with left and right pressure bringing you across the submenu selections and up and down pressure scrolling through the main menu selections) or, in some cases, with a knurled command dial that accomplishes the same tasks. Once you've made your choice you might have to push in a confirmation button on the camera (it might be indicated by a "set" switch or "OK" imprinted next to the button), or simply leave the highlighted selection and make a picture. Check your instruction book to see how to navigate through the menu and implement settings.

Resolution

We've already covered the importance of resolution to image quality, but it's worth a quick review. Resolution refers to the number of pixels used to make the image and results in a file size that is then used to determine how large you can make a print and the ease with which it can be sent via e-mail or posted on the web. Choose it according to your end use of the image. Select the highest resolution for making the largest prints your camera can deliver and the lower resolutions for smaller prints and e-mail and web images. The resolution also determines the number of images you can fit on the memory card.

If your digital camera has a movie or video clip mode, you will not have a choice of resolution levels, as the movie mode captures small file sizes only. If you have a choice between a larger and smaller movie clip resolution, choose the larger for better images and the smaller for getting more movie time on your memory card.

To select the resolution, go to the record or camera mode and toggle through the menu until you see those numbers or the names used to identify different resolution choices. Toggle over the number, press the set or OK button, or make the choice in whatever fashion your camera requires.

File Format

Most digital cameras shoot in JPEG file format. Your camera may also offer a TIFF or RAW format. While not

Depending on the camera, you access menus and camera functions using either a command dial and/or the submenus on the monitor. This is the top plate from an HP digital camera. The round dial on the right allows you to access the main menus, which are then selected and edited via the LCD monitor. The camera symbol is the capture/record menu, which you set to take pictures and open the menus on the LCD that relate to this. The symbol next to it is the playback menu, where you can view all the pictures on the memory card. The following symbol opens the organize menu, where you can group images and edit. The PC symbol should be set when you patch the camera to the computer for downloading your images. The push buttons in the center of the camera let you make flash settings, set up the self-timer, and set the camera for infinity or macro (close-up) mode without resorting to the LCD monitor menu. When you set these parameters, the LED readout panel displays them. The number in the LED panel indicates how many images you have remaining on the memory card.

every digital camera offers TIFF mode, this format is probably the best course for preserving every detail in your images. Some cameras have a proprietary RAW mode, which allows you to store images without any changes. This delivers a file that is "lossless" and in many ways equivalent to a TIFF, but takes up less space on the memory card. RAW images can only be opened using the software that comes with the camera and cannot be imported directly into other image-editing software without first running it through the supplied software. RAW also allows you to customize the image after it's recorded.

To choose from these options use the record or camera menu to access them, then press the set or OK button. If you have a choice of all three, match the format with the end use of the image: choose JPEG for getting the most images on your memory card, TIFF for the best possible image quality for prints, and/or RAW. Keep in mind that TIFF and RAW both deliver excellent images for prints and that RAW files take up about one-third less space on the memory card.

When you make an image, you can choose settings for standard size prints, enlargements, or web images. The menu on the right is for JPEG format at a good quality level (sometimes called basic or SQ, for standard quality) with a small amount of compression. This is ideal for small prints or web images. The menu on the far right is changed to indicate a better quality level (also known as normal, fine, or HQ) at 1:4 compression. This would be a good setting for a 5 x 7-inch print.

Compression

JPEG format always results in some image information loss when it is opened, changed, and saved using the image-editing program on your computer. At lower compression ratios (some cameras offer 1:2.7, most offer 1:4), there is not much noticeable loss, but as you compress with higher ratios (such as 1:8 and especially at 1:16), the loss will become apparent. On the other hand, higher compression ratios allow you to save more images per memory card, so balance your need for finer quality images with the quantity of images you need to place on the card.

If the image is filled with fine detail or you want the best possible print, choose a low compression ratio. If the image is simple, does not need to be enlarged too much, or will be used only as a screen shot (e-mail, web images, etc.), higher compression ratios will do. Again, the greater the compression the more the potential loss of detail when you open, change, and save the image on your computer. The greater the compression, however, the more images you can store on a given card size in any resolution.

When you open the image on the computer, you get the original resolution and resultant file size. Thus, even if you compress a 3-megapixel image (the highest resolution) at the highest compression ratio, it will still open up as a 9 MB file. But if you shoot the same image at the lowest compression ratio (1:2.7 or 1:4), that image will have a greater potential for a quality print. TIFF and RAW files cannot be compressed, and thus always take up lots more space on your memory card, but if you use TIFF or RAW format you will have the best possible digital file for making the highest quality print your camera can deliver.

To select a compression ratio, go to the record or camera menu and toggle through until you see compression or the ratios. Choose the ratio you want and hit the set or OK button.

ISO Speed

As you toggle down the menu you might see an option to change the ISO, a topic we introduced in Chapter 3. This sets the sensitivity of the sensor. The default speed (that set in the factory) is the true sensitivity, or speed, of the sensor. If your camera offers this feature, you can change the ISO to make it more sensitive in lower levels of light. Each doubling of the ISO doubles the sensitivity.

As mentioned earlier, the only problem with increasing the ISO to very high speeds is that you also increase the chance of introducing noise into your images. This shows up as glitches in and discoloration of the image, but sometimes it's better to have some noise rather than no picture at all. Some cameras offer a noise-reduction aid. This function takes two images at once and processes them to reduce noise. This is a great feature but it can take up to a minute for the system to process the image, so don't count on taking one image after another if you choose this function.

To select a higher or lower ISO go into the camera or record menu, toggle through to the ISO settings, choose a number, then hit the set or OK button.

Drive Modes

Most digital cameras are set up to take one picture at a time. You press the shutter release, after which the image is recorded, processed, and then transferred to the memory card. Some cameras have a built-in buffer that can hold image information prior to processing. In essence, the information is placed in the buffer until the entire sequence of images is made; then that information is processed and sent to the memory card. You set the number of images and the speed at which the images can be recorded using the drive mode.

In continuous shooting mode the framing rate may be as high as 2 frames per second. Some digital SLR cameras have a high-speed mode by which you can generate 8 frames per second. This is due to the larger buffer where

MAKING SENSE OF IT ALL

Resolution, file format, and compression can be confusing, especially when you first start photographing with your digital camera. Just keep in mind that these three elements, summarized here, are linked and form the foundation of any digital image.

Resolution is the number of pixels used to record the image. If you want to make the largest prints your camera can deliver, choose the highest resolution. Use a lower resolution for smaller prints and the lower resolutions for web images. The number of pixels you select will determine how many images you can get on your memory card.

File format is the way those pixels are organized as an image. Many digital cameras allow you to record only in JPEG mode. If you want to make big prints choose TIFF or RAW format, if available. TIFF and RAW files take up more space per image on your memory card; RAW takes up less space than TIFF but can only be opened using the software that comes with the camera.

Compression is the process by which the camera's microcomputer makes the file size smaller so that more images can be stored on your memory card. It discards some information and then rebuilds it later when the image is opened. Choose the lowest compression for prints and higher compressions for e-mail and web images. Higher compression ratios throw away picture information and you may see a loss in details or color range when they are opened on your computer. TIFF and RAW images are not compressed and lose no image information when they are opened, but they take up the most space on your memory card.

The following chart offers a quick guide to using these image-organizing elements.

Image Use	Resolution	File Format	Compression	Images Per Card
Largest prints	Highest	TIFF or RAW*	Not available	Least
Largest prints (JPEG)	Highest	JPEG	1:2.7 or 1:4	More
Snapshot-size prints	Highest or medium	JPEG	1:2.7, 1:4 or 1:8**	Greater
E-mail and web	Medium or small	JPEG	1:8 or 1:16**	Most

*RAW and TIFF format do not allow for compression.

**Test your camera to see which compression ratio delivers good results for the type of images you photograph. If higher compression ratios deliver satisfactory results, use them, as you will get more images onto your memory card.

Menus may also contain a host of settings for making exposure decisions. The "Photo Assist" menu on the far left lets you set the exposure metering pattern (spot or center weighted), exposure compensation (plus or minus the camera's recommended exposure), and white balance. Many digital cameras allow you to change the ISO, or light sensitivity of the sensor. The menu to the left shows two options. Use the faster sensitivity (and higher ISO) for working in low light. Some cameras have a range of settings from ISO 100 to ISO 1600.

images are held before processing. The larger the buffer (the greater its capacity) the higher the framing rate and burst sequences. You can use these modes to record a sequence of events, such as a sports event, or to make sure you catch the fleeting expression of children. These continuous modes may not work with TIFF or RAW format or, when used with flash, may be slowed down due to the need for the flash to recharge and be ready for firing.

Another drive mode you may have is a self-timer. This delays release of the shutter for a set amount of time after you press the shutter release.

You may also be able to set varying sequences of continuous shutter release for time-lapse photography. In this situation you set the menu item to have the shutter released every few seconds or minutes. This is great for sequences of action over time, such as a sunset or on construction sites.

To set the drive mode choose the camera or record menu, toggle down to the drive submenu, and select a setting. Note that higher resolution levels used in continuous mode may result in longer processing times after shooting.

Digital Zoom

You can usually set digital zoom mode to on or off in the menu. Digital zoom extends the range of the optical zoom by cropping the image in the viewfinder, thus emulating the effect of a zoom lens. If you turn digital zoom on you extend the range by keeping pressure on the telephoto end of the zoom control on the camera. You'll see distant subjects almost leap from the optical range to the enlarged digital image in the LCD. Note that when using digital zoom with a point-and-shoot camera, you must frame using the monitor, not the viewfinder.

Different cameras have varying degrees of digital zoom, ranging from 2X to approximately 10X. To find the equivalent focal length range you multiply the longest focal length of the zoom lens by the digital zoom factor. If you have a 15mm lens at the telephoto end you get a 30mm at 2X, 60mm at 4X, and 150mm at 10X. The coverage this gives you can be amazing, but keep in mind that you are in effect cropping the original image and therefore not working with a prime lens. The picture quality tends to decrease as you digitally zoom further into the scene and the chances of camera shake, even at fairly fast shutter speeds, increase exponentially. However, digital zoom can get you very close to distant subjects. Turning digital zoom off stops the zoom effect at the end of the optical range of the lens you are using.

To turn on digital zoom, start with the camera or record menu and locate the zoom control. There you can turn it on or off. Turning it on means that it will activate with continued pressure on the power zoom control at the telephoto end. In some cameras you must also set the degree of magnification in the zoom menu.

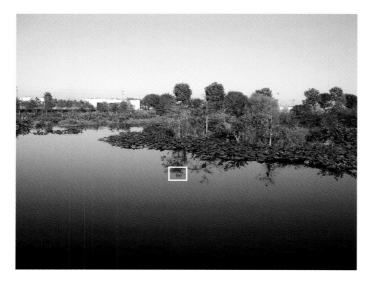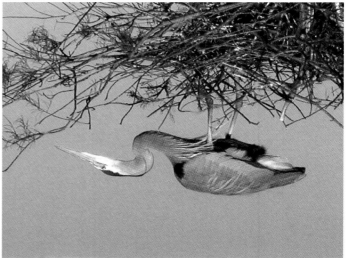

Digital zoom allows you to get extremely close to distant subjects, but must be used with caution when working at extremes. Steady the camera as much as possible and, if the camera allows, always try to shoot at a high shutter speed. To set digital zoom go into the record menu and activate it. With most cameras the digital zoom takes effect when you maintain pressure on the zoom lever at the telephoto end. You'll actually see the magnified subject pop up in the viewfinder. This scene was made with the wide angle setting on a 7mm lens (left). When digital zoom (here 10X) is used, the reflection of the bird in the water fills the frame (right).

Contrast

In photography, contrast is the difference between the lightest and darkest portions of the scene you are recording. High contrast occurs when you have to squint, or when hard shadows are being cast on the ground. It is also subject dependent; highly reflective surfaces, like metal or a body of water, throw off more light due to the angle of reflection of the light striking them. In addition, it can be scene dependent, such as when a subject stands between you and the bright sun. Low contrast occurs when there is little difference between, for example, the sky and ground or the subject and background.

Both film and digital photography have trouble with high contrast subjects. This is because the recording range of the light-sensitive material is often narrower than the light in a high contrast scene. Digital photography lets you control contrast somewhat by applying a contrast control setting before you make the picture on each image you shoot.

To choose a contrast control setting, if available on your camera, go to "C" or contrast control in the recording menu. The control can be set for high, normal, or low, depending on what you want to do. You can use low contrast, for example, if you are shooting on a high contrast day and want to tame the bright light. Or you can use high contrast if you want to add more zip to a low contrast scene, for example, by bringing out the forms on an overcast day. Normal is the camera default and handles most scenes well.

You can also use contrast settings for creative effects, although this can be done later when the image is manipulated in an image-editing program. For example, if you are copying text you should use the high contrast setting to get the sharpest edge and eliminate the chance of a gray background. You can use low contrast when making portraits or photographs of flowers for a smoother transition between colors and tones.

Review

Review allows you to see the image right after exposure and to make any adjustments that might be needed; it also confirms that the picture was recorded. Although you might think that this function belongs with the playback features, it usually resides in the recording menu. You can have the image appear for approximately 2 seconds, up to 10 seconds depending on your camera, or turn review off. A shorter review time saves battery power.

Another type of review that some cameras may offer is the display of a histogram, a graphic representation of the tonal values in the scene (page 76). Often, a histogram can better show you how the exposure fared than the view on the monitor. If you see an even spread on the graph from light to dark, you have achieved success. Too much of a weighting of the values on one end of the graph or the other indicates over- or underexposure, which means either too much or too little light has been recorded, respectively. Some displays might even flash a series of red or blue dots where the scene has been overexposed. This tells you that you may have trouble getting a good print from the image later and that you should try to expose using a minus exposure compensation or take your reading from another part of the picture (usually the brighter areas).

Contrast control comes in handy when a scene is brightly lit and there's high contrast between the brighter and darker parts of it. In this pair of images made in the hot Florida sun at noon, the normal contrast setting is harsh (top). Going into the recording menu and setting low contrast tamed the harshness somewhat (bottom) and makes for a more printable image.

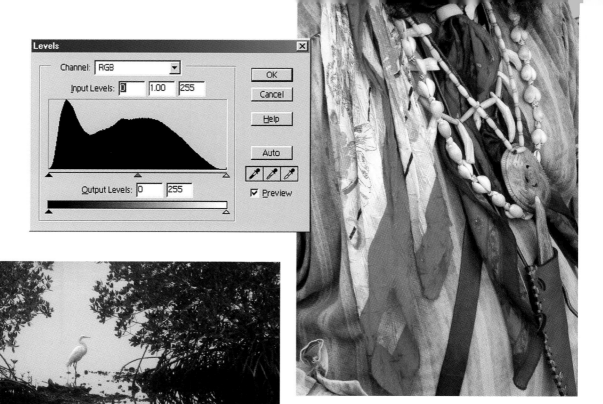

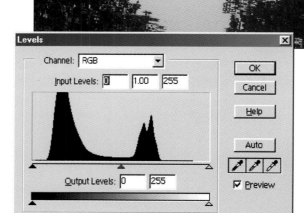

Some digital cameras allow you to view a histogram of an image, a graphic representation of the distribution of tones. This is also available in many image-editing programs. You can use a histogram as another way to check exposure and contrast and to reset your exposure settings if necessary. A full-scale histogram (top grouping) shows that there is a good spread of light and dark values in the recorded scene. (Middle grouping) When the light is low or dull the histogram shows many dark values (see the spike on the left of the graph) and some lighter values, but low contrast. This is echoed in the scene itself. If you see this readout you might want to increase the contrast to add more strength to a scene. You can see how a night scene (bottom grouping) reads out, with a majority of the values on the darker side of the graph.

To turn review on and off, and to put a time limit on the length of the review after an exposure is made, go to the camera or record menu and find the review submenu. There you can set the parameters and confirm them by pressing the set or OK button on your camera.

Sharpness

Sharpness in digital imaging is the definition of edges, or the areas in the image where there is a difference between one brightness value and another. This has nothing to do with focusing, which is the overall sharpness or lack of it in the entire scene or parts of a scene. There are three options in the sharpness recording menu: normal, low (or weak), and strong (or hard). Normal is the camera's default setting.

Strong sharpness is best used when you are copying text and, when combined with high contrast, gives you the best result. The strong setting can also be used when photographing objects that you want to stand out (such as model cars and architectural studies) or when you want to add a graphic, edgy feel to any image. Weak can be used to soften outlines, such as when shooting portraits or photographing nature scenes.

To set sharpness, toggle down the camera or record menu to that area on the recording submenu, and select the setting that suits your subject or scene.

Saturation

Color can be roughly divided into three components. The hue is the color itself, be it red, green, orange, etc. Brightness is the degree of reflectivity of that color, whether it is bright or dull. Saturation is the vividness of the color itself and refines the hue. Thus, a pink can be "hot" (high saturation) or pastel (low saturation). In some digital cameras you can alter the color saturation to match the subject and scene. The choices are normal (which delivers colors close to the original scene), high saturation (which adds more vivid character to the colors), and low saturation (which mutes the colors, regardless of how they appear in the scene).

You might use high saturation to add to the color richness of a dull or overcast scene. You can also use it to add a surreal touch to already brightly colored scenes. Use low saturation when you want to mute colors, such as with a nature scene or portrait.

To change the rendition of color (but not the color itself), choose the camera or record menu, toggle down to the saturation submenu, and make your selection before you shoot.

Combining Effects

The three image effects described above—saturation, contrast, and sharpness—are not mutually exclusive; in other words, you can use them singly or in combination. As mentioned, if you are copying a text document you might want to try high contrast with strong sharpness. If you are doing a portrait try normal contrast, low saturation, and low sharpness. A photograph of a tropical building in the bright sun might benefit from low contrast, normal sharpness, and high color saturation. Experiment with mixing and matching effects and you'll have much to explore with each image you make.

Color saturation describes the vivid quality of a color. To get different degrees of saturation with film you would have to change film types in your camera. With digital you can select saturation levels in the record menu for every frame you take. This colorful statue was photographed at normal (top) and high (bottom) color saturation settings.

Black and White and Sepia

When you load a roll of film in your camera, you have chosen to photograph in black and white or color. True, you can make black-and-white prints from color slides and negatives, but results are marginal at best unless you have a custom lab do the work. Your digital camera may allow you to select monochrome as an option on any frame you desire. The two monochrome choices are black and white and sepia.

The black-and-white option might mean different things in different cameras. In some, it refers to a high-contrast black-and-white image only (without gray shades) and is meant to be used for document copying. In others it refers to the more conventional grayscale image, which contains black, white, and all the shades of gray in between. It's fun to occasionally photograph in black and white, as it makes you see things differently. You might find that you are attracted to texture, tone, and design that would not be as appealing in full color. There is a strong tradition of black-and-white use in photography, and this option allows you to explore all its charms. Note that most image-editing pro-

grams allow you to convert from color images to black and white fairly easily; this might be a better way to go as you have the option with every image you make.

Sepia is a color tone applied to a black-and-white image; it is a warm, golden brown cast that gives an image an "old time" look. This is a great mode to use when copying old photographs, or when you want to add a nostalgic touch to landscape and nature photographs. Find some old shacks with tumbleweed tossed against the boards and you have a natural subject for the sepia effect.

To select either of these options, go to image effects (or similarly named submenu item) on the recording menu and make your choice before you shoot.

Solarize and Posterize

Some digital cameras offer other special effects such as solarization or posterization. This creates hard edges and reverses some of the color or tonal values in a scene, yielding a highly graphic effect. This can be fun, but note that you can usually add this later in most image-editing programs.

Image effect modes are available on some digital cameras and can be selected via the recording submenu. This boatyard was photographed with a Sony digital camera on normal color mode (top left), then with black-and-white mode (top right), sepia mode (bottom left), and a special effects mode known as solarization (bottom right). These effects could be achieved from the normal shot in the computer, but it's easier occasionally to create these effects right in the camera.

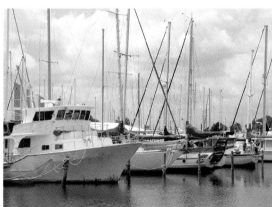
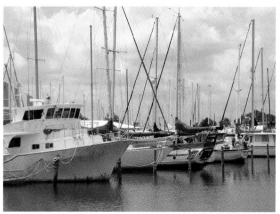
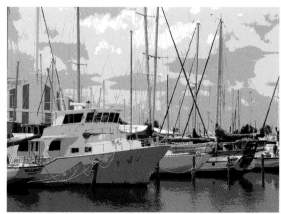

Image File Management

File Numbering and Naming
When you download your images to the computer, you will see that each frame is numbered. You may see something like 100.001.jpg, which is not especially helpful when you want to locate a particular image. As we'll see later in this book, there are archiving programs that allow you to rename individual images and place them in convenient folders once you have downloaded your images to the computer. You can begin the filing and organizing process by insuring that you do not have duplicate numbers when you go from one memory card to another, or when you format a memory card for use after you have downloaded. (We'll discuss formatting next.)

In some cases the file number sequence begins afresh every time you load a memory card into the camera. Thus, each frame number 1 on every card might be 001.100.jpg. The better way to do this is to choose the menu item that creates a sequence of numbers from one card to another, ad infinitum. In essence, this means that if you photograph 20 images on a memory card and then format the card or load another into your camera, the next frame number is 21. At the least, this allows you to sort out pictures later by not having to cope with repeating numbers in different image folders.

Some digital cameras allow you to name file folders for types of pictures you shoot and assign those images to that folder as you shoot them. Or, the software that comes with the camera automatically assigns the date and time to a new folder each time you download the images. This folder then "travels" with the images from that card until you decide to change the name or move the pictures to another folder. This is a very good start to getting organized.

To set up the image numbering sequence, go to image file or other such name in your recording submenu and indicate whether you want to have sequential numbering or renumbering any time you load a new or reformatted card into your camera.

Erase: Single and All
One of the advantages of digital photography is that you get to reuse your digital film—the memory card—over and over again. To do this you have to clear the card of images as you go. This is especially true if you have a lim-ited number of cards or cards with a low file size capacity. As you photograph, you can check your images right after exposure or periodically and erase those that don't make the grade. This is usually done with an erasure button right on the camera body, although some cameras make you go into the playback menu to do so. When you press the erase button (usually indicated by a trash can), the camera will generally prompt you to verify the fact that you want to dump the picture. This might seem bothersome, but it is good insurance just in case you pressed the erase button by mistake. You then toggle to OK or press an OK button on the camera body.

You can choose to erase images one at a time or all the images on the card at once. This is usually indicated by an erase all option in the recording menu, although it might be in the playback submenu as well.

Formatting Cards
Another item that may appear on your recording menu (or elsewhere with some cameras) is format. This can be used to erase all the information on a card or to format one for use in a different camera. Most cards will record when switched from one camera to another, but some software programs that come bundled with the camera for downloading may not recognize the images made by another brand camera. To clear the card of information you format it. Choose format from the menu and a message will appear informing you that all images will be erased if you do so. It may even ask you this twice. Indicate OK, the system will work for a minute, and the card will be clear and ready for the next group of pictures. One word of advice is to insure that the download went well before you format or erase any images from a card. Do this by opening the pictures on your computer before you reformat, if possible.

The edit menus allow you to review what you have taken right in the camera and create groups or categories of images that help organize your digital files. You can also protect some files from erasure or delete select files from this menu.

Playback Menu

Once you have made a series of images, it is only natural to want to see them right away. You can use the review mode in the recording menu to see a quick glimpse of your images, but you may also want to study them more closely on your camera monitor. Be aware of two things: the monitor may not always show you a true picture of what you've captured, and overuse of the monitor is a major drain on batteries. Your monitor is best used to get a sense of what you captured and not to make final decisions about picture quality. When images are made in low light, for example, experience shows that there is usually more in the image than might show on the monitor. And because the monitor screen is fairly small, it might be tough to make critical decisions about focus.

That said, you could use the playback menu to review all your images prior to downloading. If you are tight for space on the memory card, the monitor can help you make decisions about duplicate shots you might have made so that you can delete an image right then and there so more space is available.

To get into the review mode, switch the main dial on the camera to review selection. This will bring up a menu on your monitor from which you can choose various options. Another good use of the review mode is to preview images that you will print directly from the memory card without even downloading to your computer.

Protect

Just as you can lock a floppy disk or CD RW to prevent it from being overwritten, you can protect any images on your card from being erased. This is a good idea if you swap a card out of the camera before you have filled it and want to be sure that the image will not be erased accidentally next time you use the card. It also allows you to use the erase all option without eliminating your keepers. Later, once you download the image, you can remove the protection from this menu to free space up on your memory card. Note that the format command will erase even those images you protected, so when protecting images from removal, "clean" the card using erase all, not the format command.

Rotate

Although the orientation of the camera and your computer screen is what's called "landscape," or wider than tall, there's no reason why you can't make photographs with a vertical orientation. To see them without tilting your head you can rotate them 90 degrees on the playback, and they will be downloaded in the same fashion.

Slide Show

If you want to look at your images without having to toggle through them you can set up an automated slide show using the playback menu. You can play this show on the camera monitor or use the camera as a "projector" by hooking it up to a TV set or computer via the A/V cables usually provided with the camera. If you are showing slides through a TV set, use AC power rather than the batteries. The duration of each image on playback can be varied, usually between 1 and 10 seconds. You can program the system to play back the show once, or as a continuous loop. You can also select certain images and exclude others from the slide show. And, with some cameras, you can even add sound right from the camera as audio captions.

To use this feature, go to the review menu and select slide show, then set the time you want each image to appear on the screen and whether you want a one-time show or a continuous showing of the images.

Multiple Views

Some digital cameras allow you to view sets of images on the monitor. While this will not be a great aid in judging image clarity, it does allow you to review, for example, a number of poses of a portrait and to save the best and eliminate the rest. You can toggle through sets or groups of images (which can range from 4 to 9 images) to get a quick overview of every one on the card. This view is composed of very tiny "thumbnails," although the size is considerably smaller than anyone's thumbnail!

Print Order: DPOF

Usually part of the playback menu, Digital Print Order Format (DPOF) allows you to select individual images for printing, order single or multiple copies, and even have the date and file number printed on an image. For this to work you need to have a DPOF-compliant printer, one that can read and follow DPOF commands. This information travels with the image and can be read via a computer linked to the printer or directly by a printer that can print right off a memory card.

Setup Menu

This menu lets you customize your digital camera with your preferences. It is used to adjust screen brightness, sound, power saving, and other features. One menu item discussed above—format—might appear here in some models.

Sound

One of the early complaints about digital cameras was their silence—when the shutter was pressed there was no reassuring sound that the picture was actually made, as with film cameras. The shutter release sound is programmed into the microprocessor of the camera and is not inherent to its mechanical operation. This might be called "beep" on some menus. You can turn the sound off and on (it's best to keep it on unless you have to be discrete when shooting), and even control its volume. The same goes for confirming the selection of menu items.

Monitor Brightness

You can, to a certain extent, adjust monitor brightness to match the overall lighting conditions of the location you're shooting. The adjustments may be incremental (normal, bright, and dark); some cameras work with a slider to customize brightness from bright to dark. Most digital camera monitors do not allow you to see the image very well in bright sunlight. Some cameras, however, have a monitor that can be rotated so that at least you have a chance of viewing it at an angle that optimizes the image. Accessory hoods are sold that can be used to shade the monitor in bright sunlight.

Power Down

With a digital camera, no power means no pictures. One common way to drain batteries is to forget to turn off the camera when you finish shooting, or for the camera to somehow get turned on while it sits in your camera bag or pocket. A way to prevent this is to set a power down time. This feature automatically turns off the power after a set period of inactivity. Some digital cameras allow you to set the time; others only offer a fixed period. While it may seem that this should always be set to the on position, there may be times when you want to turn this feature off. For example, if you are engaged in photographing a sequence of events and are waiting for the next peak of action, you don't want the camera to turn off right as you are poised to make the next picture. Due to Murphy's Law this will usually happen. Power down is like a sleep function on your computer; some battery drain still occurs. But it's not as bad as having the monitor on while the camera is sitting its bag.

Date and Time

If you want to add the date and time to your pictures you can set this easily enough and turn it off when desired. It might be a good idea to set this for one picture in a set and then turn it off for the rest. As long as you save the image with the information you'll always have a visual reference to when the group of pictures was made. Many digital cameras record the date and time as part of the information that travels along with an image, and do not print the tag on the image itself.

Reset

Because there are so many menu options, there may be times when you are unsure as to just what is set and what is not. Many digital cameras have what is called a reset function, which might be a menu item or accessed by a button on the camera itself. This is the "bailout," the button or item that resets all functions to the camera's default, or factory, settings. You should check what those default positions are, but usually they are set up for point-and-shoot type photography.

Memory Settings

If you arrive at a set of options that delivers just what you want for different types of scenes or subjects you might want to access that setup without always having to go through the menu and make all the selections manually. Some cameras have a memory bank that allows you to save, store, and recall a set of features with the push of a button. This combination might be TIFF, high color saturation, spot metering, and cloudy white balance for nature and landscape scenes, or JPEG, medium resolution, 1:8 compression, and high sharpness for items you are photographing to sell on a web auction site. You assign one of the memory banks to each type of setup and then select it when required. The only matter you have to consider is how you will remember which setup goes with which memory bank number. Some cameras allow you to name these setups.

5 Downloading Your Images

From Camera and Card to Computer

- **Camera Software**
- **Downloading Images**
- **Card Readers**
- **Dockable Cameras**
- **Organizing and the Save As Command**

ONCE YOU'VE MADE your first pictures with your digital camera, you will be eager to get them saved and onto your computer. Taking pictures is fun, but it's only part of the equation. Working with your images— correcting and enhancing color, adding special effects, and e-mailing them to family and friends—is just as exciting. In this chapter we'll explore how to easily move images from your camera to the computer. There are two basic methods for doing this: by attaching the camera directly to the computer; or by using a dedicated card reader or docking device. The first step, however, is making sure that your computer will "recognize" that camera or card reader as a drive. You do this by installing the software that comes with your camera or reader.

Camera Software

Every digital camera sold is accompanied by software that holds any number of programs, including those for downloading images, image editing and archiving, and even adding special effects. In order to connect from the camera to the computer you must first install the downloading software so that it will "see" your camera as a drive and "handshake" with it to bring in images. The two key elements in the software are the driver (the recognition and download pipeline) and the "catcher," or program that will receive the images. If you have not installed the driver software correctly you will not be able to transfer images directly from your camera.

Unfortunately, at least in the sense of convenience, digital camera connectivity and computer operating systems change frequently. You may have Windows 98, Me, 2000, or XP, or one of the various Mac operating systems. By the time this book gets in your hands there may be other operating systems and camera drivers to deal with, making it difficult for this writer to give you one set of instructions that will cover all contingencies. Perhaps standards will eventually be adopted that will eliminate all this mixing and matching, but that's unlikely given the rapid pace of change in this environment.

To avoid problems, the first step should be making sure that your camera and software are compatible with your computer system. In addition, you should make sure that the way your camera connects, be it via a USB, FireWire, or even serial port, is compatible with and available on your computer. Finally, check that the version of the operating system you have installed will work with your camera. Those still working with Windows 95, for example, might not be able to use the latest camera connectivity software; indeed, even those who have upgraded from, say, Windows 95 to 98 might have a similar problem, as some digital cameras require the native (pre-installed) rather than upgraded operating system. Some digital cameras connect only with USB ports, and some only with FireWire. Also, many cameras must be connected directly to the USB ports on the computer and may not work well or at all if you connect through a hub.

You can find this information in the list of camera specs, available on the web or on the camera's box. Buying a new digital camera only to find that it will not work with your operating system or connectors is frustrating. Buying a used digital camera can also be a problem, as it might use a software or connector that will not work with your newer computer setup. The best advice is to educate yourself about this *before* you make a purchase.

That said, installing the software that comes with your camera is easy, a process that is guided by "wizards" (on-screen guides) and dialog boxes that walk you through the steps. Follow the instruction book carefully and make sure that you use the setup designed for your system. With some cameras, when using Windows 98/2000 you must use the USB Twain driver; for Windows Me and XP your choice should be the USB WIA driver. Twain drivers are not standalone and you might have to access images from within a Twain-compliant image-editing program. The WIA driver will usually bring up a wizard upon connection to help you with the process. Sound overwhelming? It can be—that's why making sure that your camera and computer handshake with one another is important.

With some cameras there is a definite advantage to working with Windows programs; others tend to favor the Mac, where downloaded images may go into another program altogether. A number of cameras allow you to use plug-ins with programs like Adobe Photoshop, Adobe Photoshop Elements, or other basic image-editing programs. This means that you can set up your image-editing program to be the direct recipient of your images by using the Import Command, much like the procedure you might use with a scanner. For Windows XP users, many download setups are pre-installed, making it very easy to get images into that operating system.

This may all seem confusing if you have not worked with computers, but for the most part the wizards will take you through the procedure step by step. Although not entirely simple at this point, you can take some comfort in knowing that the procedure has been vastly simplified from what was available in the not-too-distant past.

Downloading Images

Start by placing the CD ROM that comes with the camera into your computer and following the instruction book for your particular operating system. You may have to restart the computer after you load the software. Once you have installed the drivers and image-editing program, connect the camera to the computer via the supplied cable. The first time out you may have to designate or open the download software, although most programs will automatically start the program once the camera and computer are connected.

You can place images into a current folder on your hard drive or a new one you create for each download. Click on that and name it. For example, you may have images from a trip to Colorado and can name that folder "Colorado, 2002." Go to your browser and find the location folder. Then, if you have a "download" button on the image-editing screen, click it and the program will grab whatever images you have on the memory card and place them inside that folder. Some programs will name a folder for you, and may simply identify it as the date on which the images are downloaded. You can accept this and rename the folder later. You can then begin to edit and play with your images.

If after looking at an image on the screen (you can usually see a full screen version by double clicking on a selected image) you decide to delete it, just click on the Delete button on the screen. This is a good way to clear off images before you begin to archive them further. Many programs allow you to make corrections on the image and then save them to another file destination, if you desire, or to a CD ROM or DVD for backup. This is done via the Save As command (see page 88).

You usually can get images directly into an image-editing program from the camera's software or by using the Import menu item on third-party software. Your software instruction book will explain how to do this. You may have to load the plug-in module, if available, directly into the software's Import/Export folder. You can also start the image-editing software and gain access to images on the camera's memory card directly from that program.

When you download images from the camera, it is a good idea to use an AC adapter with the camera. If the camera batteries run down during transfer, the flow of images may be interrupted. You will just be wasting time, as you have to start the process all over again with fresh batteries. And transfer does drain batteries.

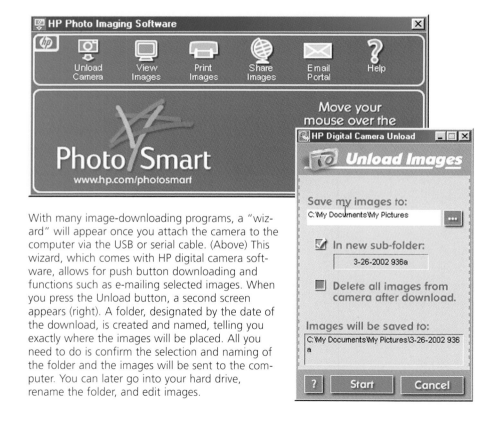

With many image-downloading programs, a "wizard" will appear once you attach the camera to the computer via the USB or serial cable. (Above) This wizard, which comes with HP digital camera software, allows for push button downloading and functions such as e-mailing selected images. When you press the Unload button, a second screen appears (right). A folder, designated by the date of the download, is created and named, telling you exactly where the images will be placed. All you need to do is confirm the selection and naming of the folder and the images will be sent to the computer. You can later go into your hard drive, rename the folder, and edit images.

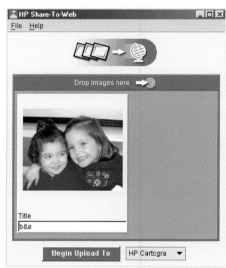

You can also use the wizard to select images for e-mailing or uploading to a sharing site, taking them from the camera or from the folder you have created. Here, clicking on a selected photo brings it into the preview screen of the upload function. All you have to do is send it on its way. The HP Wizard is a good example of an efficient and easy-to-use program.

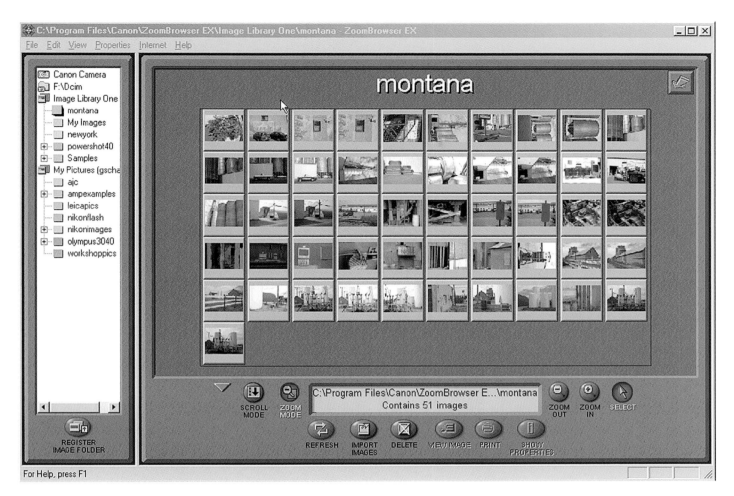

If you use a software program dedicated to the camera to download and sort your images, you get both an image organizer and download setup in one. This is the ZoomBrowser program used with Canon digital cameras. Before downloading, a new "album" can be created that allows you to organize your images according to locations, dates, or themes. Each time you open the program the album sets appear in a browser on the left. Open images from those albums by selecting the album folder; each image in the folder will appear on the screen. You can then click on an image to edit it, save it to another location, e-mail it, and so forth. Note the image information that appears in the window at the base of the album window.

This editing and downloading software, an EXIF viewer, is another example of a folder-type browser. You can print, send, and edit easily when your images are organized in this fashion.

Card Readers

One of the simplest ways to get images from your memory card onto the computer is with a device known as a card reader. This is simply a drive, like a floppy or CD ROM drive, that connects to your computer via a USB or similar cable. Like the USB direct camera connection, it is best not to use this device through a hub. You must install the card reader software first for the computer to recognize it as a drive.

Card readers are made for every type of memory card, including CompactFlash, SmartMedia, Memory Stick, SD, etc. There are also "universal" readers that can take many different types of memory cards, usually with some sort of adapter for each type. You still need an image-editing or archiving program to "catch" the images as they flow to the computer, or an import program that will bring them directly into an image-editing program.

The simplest way to use a card reader is to use it as another drive and just drag and drop images and image folders from the card into whatever folder you create for them on your hard drive. You can then open those images from the folder using your image-editing program.

Card readers are the best way to go because they eliminate the need to have your camera always ready to download images. They also draw power from the computer, so there is no need to use an AC adapter on your camera. You can leave the device plugged into a USB port on the computer, or simply plug it in when you are ready to use it. And the card reader is not camera dedicated, so you can use it with any similar type of memory card from any number of cameras.

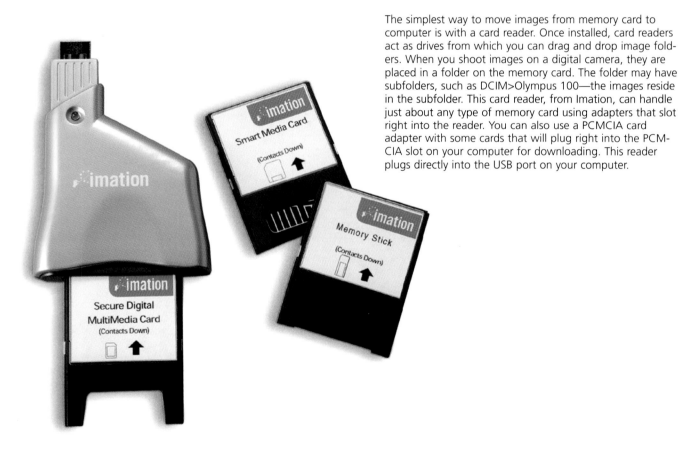

The simplest way to move images from memory card to computer is with a card reader. Once installed, card readers act as drives from which you can drag and drop image folders. When you shoot images on a digital camera, they are placed in a folder on the memory card. The folder may have subfolders, such as DCIM>Olympus 100—the images reside in the subfolder. This card reader, from Imation, can handle just about any type of memory card using adapters that slot right into the reader. You can also use a PCMCIA card adapter with some cards that will plug right into the PCM-CIA slot on your computer for downloading. This reader plugs directly into the USB port on your computer.

Dockable Cameras

Some camera brands and models, most notably from Kodak, Casio, and some from Fuji and other manufacturers, work with a docking system for battery charging and image downloading. These are like card readers in that there is no need to connect the camera itself with the computer via a USB port and cable. The dock itself is cabled, and once the camera software is loaded all you need to do is place the camera into the dock and press the download button. The images then travel from the card in the camera right into the computer software.

There are a few other options for downloading images. In some models you can remove the memory card and use a PCMCIA card adapter to download the images directly into the computer folder of your choice. The adapter slips right into the PCMCIA slot on your computer, if available. Olympus offers a floppy disk adapter for use with Smart-Media cards. You just slip the SmartMedia card into the floppy adapter and then into the floppy disc drive of your computer. You can also download images in the field to a portable hard drive and then plug that into your computer. This then becomes a separate drive from which the images can be brought into your image-editing software.

What's the best way to go? Card readers offer the most convenience, can be used for any number of cameras using the same type of memory card, and remove the need to cable the camera to the computer. They can handle any memory card capacity, from 16 MB to 1 GB, as long as the memory card is of the same type. An investment in a card reader makes the most practical sense. In addition, as mentioned above, certain card readers can work with a multitude of memory card formats. Called "multi-format" readers, they are great for families with different types of digital cameras, or for sharing your computer with other digital camera users in a club or business. These are also a good idea if you change or upgrade your camera, because you won't have to get another card reader.

The only time you must bring images directly into the camera manufacturer's proprietary software is if you shoot in the camera's RAW mode. This mode can be read with advanced versions of Adobe Photoshop, but you will have to install the camera's specific plug in module to handle them. RAW mode delivers an uncompressed file that is actually smaller in size than a TIFF file, but you usually have to convert from RAW to TIFF in order to work on the image in your software.

This Kodak is an example of a dockable camera. The dock serves as both battery charger and card reader. You plug the dock into the computer and leave it set up as a drive. Once the camera is placed in the dock you press the send button and the images go right into the computer.

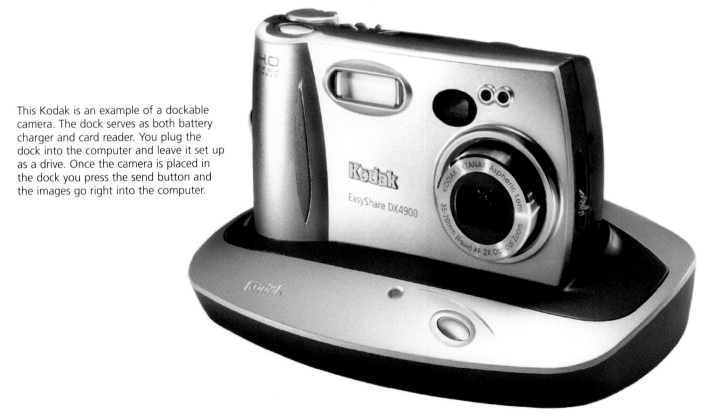

Organizing and the Save As Command

Once you have your downloaded images on the screen, you should begin the process of sorting, deleting, saving, and archiving them. This will help you find those you want later and protect them from accidentally becoming lost or damaged. Unlike film images, where you have the original negative or slide, digital images now reside in electronic form. That's why all this housekeeping is necessary, as anything can happen to information on your computer. Once gone, you may not be able to recover your precious images. Assume that you have to back up your files to protect them; fail to make copies to back them up and you may regret it later. This is not pessimistic; it is just words of advice gained from experience.

Every image-organizing software program is different, but most show all the images from the card in a display folder on the screen. They may start out in a closed folder on the side; click the folder to open it and the images all appear in thumbnail size in the display. You select individual images by clicking on them, or you can select all using the Edit menu. Or you can click and then press Shift/click to select more images, holding down the Shift key as you go from one image to the next.

After you have selected an image in the organizing software, you have any number of options. The best advice is to do rudimentary tasks first and hold off on more complete editing and manipulation until later. In short, your first job is organization, including naming, placing, and making copies of the originals.

The first stage is creating folders on your hard drive and then moving your images from the download software browser to these folders. It is best to do this right after downloading. Next, look at the images full screen by double clicking on the thumbnails. Delete those that are obviously mistakes or bad pictures. You might want to hold off making a decision on images that might appear too dark or light—many times these can be fixed later. Do eliminate those that have camera shake or are out of focus—these cannot be fixed with your image-editing software.

Once an image is acceptable on the screen, you can save it to the folder you have created on your hard drive. You can name images according to the date, subject, event, or even locale. The way you save them to the folder depends on how your software or operating system works. One way is by doing a Save As procedure. This is a good method because you can convert the file format from JPEG to TIFF. You can also name the image at that point. The way you name an image will help you find it later. Use keywords as ways of grouping images (such as Birthdays, Paris trip, etc.). With some image-editing programs, by typing in the keyword, all images associated with that word will pop up on the screen as thumbnails.

As mentioned earlier, the reason you should convert from JPEG to TIFF is that JPEG is a lossy format. Every time you open and work on an image and then save the file as a JPEG it loses some image information. TIFF files, when opened, do not. You can allow the images to sit on your hard drive as JPEGs. It's just that when you open and work on them—even to crop or rotate—you lose information if you save them as JPEGs. This is an important consideration, so please keep it in mind until converting becomes habit.

The reason you name your image files is because each may originally appear as a number such as 001.100.jpg, which most likely will not help you identify it later. As mentioned, you can always rename an image later and even use keywords in your image-editing software to find groups of images that share similar subjects or themes. This, again, is part of the housekeeping that you have to get involved with when you work in digital.

If your browser software has a Save As button, use it; if it does not, go to File on the menu and open the Save As dialog box. The box will allow you to convert the file from JPEG to TIFF, name it (change it from a numbered to a named file), and save it into a designated folder. Do this for each image you want to keep.

Once you have named, saved, and converted the file, the next step is to back it up by burning a CD, ZIP, or DVD of that file. CD ROMs can hold up to 700 MB of information, while DVDs can hold 4 GB or more. Burning software is easy to use. Open the program and drag and drop the image files or folders from your hard drive to the drive that holds the backup media. You then label the CD or DVD and place it in your backup library on the shelf.

This may seem laborious, but once you get into the habit it will become an easy task. If you want, you can keep the images on the hard drive as well, but at one point you will find that the drive begins to fill up. Making backup copies is the best way to archive your images, to free up space on your hard drive, and to protect the

images as well. Many digital photographers keep images on their hard drive for a few months, then copy and delete them after they have made prints or e-mailed them. If you make backups right away you won't have to worry about losing them should your hard drive do what, unfortunately, hard drives sometimes do.

Now that we have our images backed up and in folders on the hard drive we can begin to print, share, and create all sorts of interesting projects with them. We'll begin in the next chapter with some basic image-editing and manipulating tasks and then follow through with printing and other ways to share our images with others.

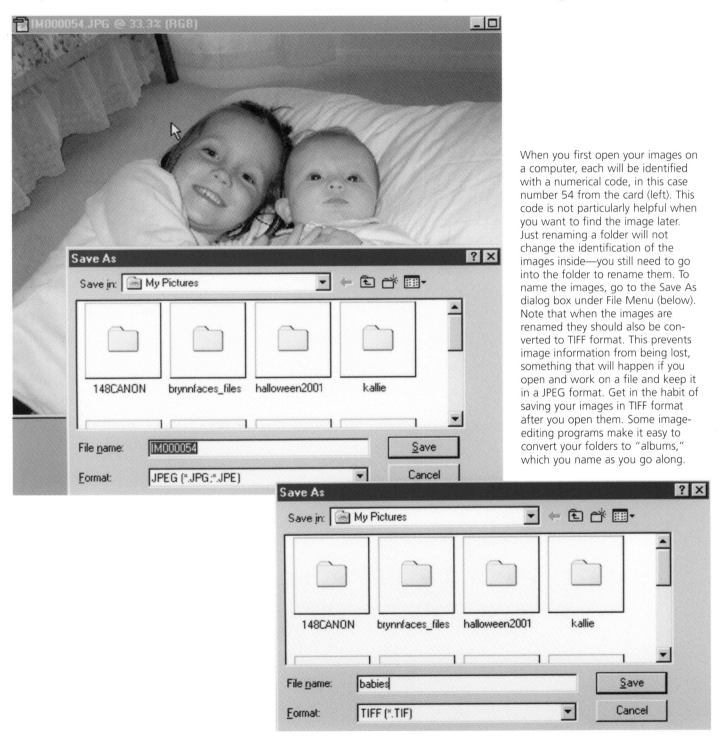

When you first open your images on a computer, each will be identified with a numerical code, in this case number 54 from the card (left). This code is not particularly helpful when you want to find the image later. Just renaming a folder will not change the identification of the images inside—you still need to go into the folder to rename them. To name the images, go to the Save As dialog box under File Menu (below). Note that when the images are renamed they should also be converted to TIFF format. This prevents image information from being lost, something that will happen if you open and work on a file and keep it in a JPEG format. Get in the habit of saving your images in TIFF format after you open them. Some image-editing programs make it easy to convert your folders to "albums," which you name as you go along.

6 Image Editing

Getting Started

- **Image Software**
 - Opening Picture Files
 - Making a Copy
- **Image Edits**
 - Rotate
 - Crop
 - Brightness
 - Contrast
 - Color Balance
 - Sharpness
 - Blur
 - Red-eye Reduction
 - Zoom Controls
 - Undo and Redo
 - Text
 - Paint
 - Advanced Tools

ONCE YOU HAVE AN IMAGE safely stored and saved, it may need some adjustments and enhancements. Just like film, digital images are "sketches" of the final picture that you can refine, correct, and even work with creatively to add your own personal touch. In this chapter we'll cover some of the basic techniques used to make your pictures the best they can be. The tools described here should be available with even the most basic image-editing programs that come with digital cameras or can be purchased off the shelf for a very reasonable price. We'll cover how you can use your pictures—for prints or the Internet—in the chapters that follow, finishing up with special effects and advanced techniques in Chapter 10, "Picture Projects."

Image Software

There is a host of image-editing and -manipulation software programs available. They range from the most basic to highly advanced programs used by picture and graphics professionals. Even basic programs have highly sophisticated features that let you do some amazing things. The best advice is to start with the basics and work your way up to more advanced techniques. Do this by creating projects for yourself and applying them to individual images. Just reading without doing is not a good way to learn—you lose the advantage of being able try out different techniques and see the results right on the screen. Using the editing tools encourages experimentation and many hours of creative fun, all without wasting materials.

Image-editing software is loaded in the same manner as any other program. Wizards and setup screens usually walk you through the process. The program's display screens contain icons for the various tools and applications. Clicking on a tool will either create the effect selected or bring up a dialog box to walk you through the process. Some basic programs combine applications and tutorials in "projects" that help you learn the program while you create. This can be very helpful when starting out.

With so many programs on the market, it is not practical to focus on a single one here. As you read through these sections, compare the tools and techniques described to those in your own software program and refer to the instruction book or on-line help to learn how to apply them. Most of the tools and applications covered here are common to every program. Some of these tools may even be available in your camera's download program. But it's generally best to use the download program for just that and to use the more sophisticated editing program for working on your images.

Opening Picture Files

Once the program is running, you need to bring the picture into the working environment by using the File>Open menu. When you do this the browser "tree," or list of folders and files, will appear. Click on a folder to open it, click again on the individual file, then click Open. If the image resides as an individual file, simply click on that and then click Open—the image will load and appear on the screen. The ease with which you can find and open a file often depends on how well you organized your images when you first downloaded them. Placing them in folders and naming the folders and images makes finding and opening them much easier.

Making a Copy

When you open an image, you have the original file on the screen. Any work you do on that file will alter it. This may be fine for basic work, but usually you will want to experiment with imaging techniques without worrying about making a mistake and possibly "ruining" the original. This is quite different than when you work on a film print, as whatever you might do in the darkroom will not affect the film itself.

To avoid this problem, and to encourage a freewheeling type of play, make a copy of the original file and work with that. You can save the copies in a folder called Image Edits or something to that effect. To make a copy, go to File>Save As, rename the image, and save it into another folder. For example, if your original is named Cactus, simply rename it Cactuscopy and save it. Some software programs may have a Save As button that will initiate this process for you.

The working screen of image-editing software presents you with a host of push button controls for easy editing tasks. This screen is from a program called FotoCanvas. The toolbar across the top of the screen allows you to zoom in and out of the picture, rotate it, crop it, and apply other editing tools. Some tools open up dialog boxes that help you refine the effects, while the main menu items, such as Open, Edit, etc., let you to get to your image files and apply even more image-changing effects.

The opening screen of Adobe Photoshop Elements (right) offers a menu bar, tool palette, and the opportunity to use guided tutorials for your picture projects. The Open icon allows you to access images from your folders and files. The Acquire icon lets you import images from a digital camera or scanner. The Tutorials and Help icons are there to walk you through various picture projects. When you start using any image-editing program, take advantage of the Tutorials to help you learn, and then apply what you've learned to other images and ideas.

To open an image, go to the File menu, click it, then click Open. This brings up the browser window from which you can choose images (below). Here, a folder is open. All you need to do is click on an image file, then click Open. You can also double click on the image file to open it. Once opened, the image appears on your screen (bottom left). From there you can start to perform the magic available in the digital darkroom.

Image Edits

The basics of image editing include adjustments such as rotate, crop, color balance, brightness, contrast, red-eye elimination, and sharpening. Each image-editing program differs in how these changes are applied, but most are fairly intuitive. As you work with these tools, don't hesitate to experiment on a wide range of images, as each subject and scene might call for a different approach.

Rotate

The usual orientation of digital images is horizontal—that's just how the cameras are built. There's nothing odd about shooting vertically; many subjects call for this framing. However, if you shoot vertically the image will show up on the screen lying on its side. To fix this, use the Rotate tool and choose either a clockwise or counterclockwise rotation. In computer-speak, a horizontal composition is often called "landscape" and a vertical called "portrait." When you print, every image is usually changed to portrait orientation to make the most use of the paper size being fed through the printer.

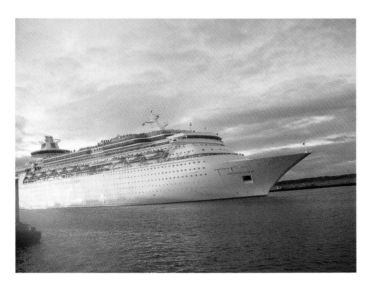

The Rotate tool can help you orient an image for printing to maximize print size and examine images you photographed vertically so they read correctly on the screen. It can also help you straighten out horizon lines. In this image, the horizon line was crooked (above). To straighten the horizon, the Rotate tool was used to tilt it slightly. This made the horizon parallel to the picture borders but resulted in a tilted frame (top right). To justify the frame, the image was cropped to square up the frame edges. Some image information was lost but at least the boat is no longer steaming uphill (right).

Crop

Not every composition you create in the camera viewfinder is perfect. In fact, most images improve through some judicious cropping, or reframing of the subject. Cropping entails cutting away some of the picture. Choose the Crop tool; a frame will appear where you place the cursor. Drag the tool across the image to define the new frame, then click or press the Enter key to effect the crop. If you make a mistake you can usually cancel the action with the Undo key on the Edit menu.

Be aware that when you crop an image you are eliminating picture information, thus reducing the file size. This might limit how large you can print the image later. We will cover this in Chapter 7, "Printing Your Digital Images."

Cropping can be used to eliminate extraneous detail and help focus the viewer's eye on the main subject of the photo. (Top left) This colorful spool of lines was photographed from the dock at the longest telephoto setting on the camera. To focus attention, the image was cropped in the image-editing software (top right). It was also converted to a vertical composition. Even when your lens lets you get very close to distant subjects, you might want a photo of a smaller portion of the frame. (Bottom left) This photo was made from street level and is as close as the lens allowed. The detail in the clock and statue are brought to the center of attention by cropping into the frame (bottom right). There is a limit to cropping and image quality; the larger the image file to begin with the more successfully you can crop.

Brightness

Brightness is a measure of how light or dark your image will be. It is an oddity of digital photography that the picture that first appears on your camera monitor or the computer screen can be quite a bit lighter or darker than how you perceived the scene. You can adjust this easily with the Brightness controls.

Problems with brightness are most noticeable with pictures made in low light. The sensor actually captures more than first meets the eye. The Brightness control "opens it up." The same applies to scenes that appear too bright, although areas of gross overexposure (where the pixels get overwhelmed with light) may be more of a problem.

The Brightness control might be in the form of a simple slider. When a picture is opened, the slider control bar sits at the center. Move it to the left and the image darkens; move it to the right and it brightens.

Contrast

Contrast is the difference between the lightest and darkest areas of a scene. Consider the light that falls on subjects during the day. If the sun is shining at noon, a scene will have more contrast than if clouds gather to diffuse the sunlight later in the day. When working with image-editing software, you can increase or decrease contrast using a slider bar or, in some programs, with a control known as Levels.

The Brightness control allows you to add or subtract light from a picture. The image may appear dark on the camera monitor or computer screen, but it's easy to correct. This image is shown as it appeared right out of the camera (top). A simple slider control brought it back to its original color and light (bottom).

The lighting conditions under which you photograph have a profound effect on your images. You can correct and enhance lighting easily in the digital darkroom. This scene was made on a bright day and the color richness is lost due to the harsh light and exposure (top). All the image needs for color richness is an increase in contrast, which darkens the water and adds vivid color to the lily pads (bottom).

You might want to increase contrast in scenes shot on an overcast day or in the shade, or when you want to add a starker effect in general. Doing this can also increase color richness. For example, say you want to liven up a fall foliage scene. Raise the contrast a notch and the colors become more vivid. Some digital cameras produce colors that are a bit "flat"; raising contrast is a good fix. You can lower contrast if the colors appear too harsh, for example, when you are correcting a portrait. Many pictures of people made in bright light benefit from a slight lowering of contrast.

Contrast and brightness often work hand in hand. If you really want to make colors stand out, raise contrast and lower brightness. If you want to create an abstract scene from a still life, raise both contrast and brightness. Or, if you would like to add a more luminous effect to a landscape, lower contrast and raise brightness. In general, when working with contrast and brightness, you are affecting the

The Sharpness, Contrast, and Brightness controls can be used together to enhance many scenes. This image was made in shadows and is flat and dull (top). To enliven the subject it was first sharpened, then the contrast and brightness were increased slightly (bottom).

entire scene. Some programs allow you to select certain portions of a scene to make lighter or darker without affecting the rest. This comes in handy when you have photographed a scene where the foreground subject is backlit, that is, the light in the background is so bright it causes the foreground subject to record as dark in the image.

Color Balance

Color balance can be used for both corrective and creative purposes. If you failed to set the white balance correctly when you made a picture, or if you were uncertain which setting to use, you can, to a great extent, fix it with the software. For example, while it's best to catch this when you shoot, you can eliminate a yellow cast (created by photographing indoors with daylight balance set) by adding blue and taking away yellow, or get rid of a magenta cast (sometimes caused by photographing with the flash too close to your subject) by adding green and cutting back red and purple. The controls are intuitive, as you see just what you'll get right on the screen.

Another use of color balance controls is for a creative touch. This is where you add mood through color, such as by using more blue on a foggy morning or adding more yellow and/or red to fall foliage scenes. This is also a great way to add more excitement to sunset and sunrise pictures. Again, as you work the controls you'll see the results right away.

Some programs allow you to eliminate color altogether and convert pictures to black and white. Or, you can add a sepia tone—a nice touch when making copies of old photographs. Most programs offer this through a push button control. You can also adjust the tone of converted black-and white-images by working with the color balance controls after the conversion. This way you can add just about any color cast you want to the picture.

Sharpness

Sharpness controls increase the contrast of pixels that sit at the edge of color and tonal borders. This gives the scene a more defined edge on every line and shape. Some digital cameras produce images that, while not out of focus, could use a bit more definition. Be aware that too much sharpening can make an image look stark, so use this control judiciously.

Blur

The opposite of sharpening is blur control. You can use this feature to soften the focus of an image. This is good for certain nature scenes, and especially for portraits. Blur

Color balance and color cast can be controlled to both correct for improper setting of white balance controls and add a personal touch to images. (Top left) This fruit stand was photographed under incandescent light, resulting in a yellow cast. The color balance was shifted in the image-editing software to both remove the cast and allow the true colors to come through (top right). (Bottom left) This boat was photographed right after sunset and has a pleasant blue cast that is reminiscent of the actual color mood of the scene. To make a more fanciful image the color controls were modified to give the light a pastel feel (bottom right). Keep in mind that colors in a digital image are easy to change. That change can make colors seem "right," or can be used to add any mood you desire to a scene.

control is usually done with a slider. As you increase blur, you will see the image soften right on the screen.

Red-eye Reduction

When you photograph people or animals in low light with flash there is a chance that you will get an effect known as red-eye. This results from the flash bouncing off the dilated pupil and reflecting back the blood vessels inside. To remove red-eye you can use a tool that you position over the red area and click. This paints a black spot over the red. While doing this, work with the Zoom tool (covered next) to enlarge the image on the screen so that you can position the Red-eye Reduction tool more accurately.

Zoom Controls

If you want to get a look at details in a scene or subject, use the Zoom tool, usually designated by a magnifying glass icon, to enlarge portions of the image. The Zoom can be clicked as many times as needed. To reduce the size of the image after it is zoomed, look for the magnifying glass icon with a minus in it. Click this to bring the image back to normal size.

Undo and Redo

When you make a change to an image you might have done so to experiment with a look and feel that, after the fact, doesn't seem to work. Most programs allow you to go back a step and eliminate the change. This is called Undo, and is often accessed via a push button control. If you want to look at the change again and reconsider it, just press or click the Redo button. If you want to study a progression of changes you can always perform a Save As on each stage as you work. This creates a new image that can then be opened along with the others in the progression. Contemplating the series of steps you used to arrive at a new image from the original is a great way to learn what you did right, and what you did wrong. Some advanced programs allow you to go back many steps in the progression and automatically make snapshots of each stage as you work.

Text

If you want to add text to an image for a card or caption, use the Text command. Click it, then place the cursor in the image where you want to insert your text. Many programs allow you to manipulate the size and type style of the text, too.

It's easy to add text and to even "shape" the text with basic image-editing software programs. This photo of red rock formations in New Mexico looks like the perfect picture postcard (top). To convert the picture to a postcard, just add type. Select the Type tool and place the cursor where you want the text to be set. You usually have a choice of different type styles and sizes. After type was added a curved shape was applied to it (bottom).

Paint

The Paint tool lets you add colors to your pictures with various tools. When you click it, a color palette pops up. Select a color from the palette, then add it with a Paintbrush, Pencil, or Airbrush tool—each offers a different stroke and size of color application. Some programs allow you to use an Eyedropper tool to select a color right from the image. This lets you match colors closely without having to guess when looking at the palette. Place the Eyedropper over the color you want and click it. This loads the brush with that color—now just paint away. Some paint programs allow you to vary the opacity of the paint application. You can use this to add just a touch of color to an area without obscuring the image details underneath.

Advanced Tools

Numerous other tools are available in both basic and advanced image-editing programs. These allow for more refined ways to control contrast and color and to lift certain sections of your image for placement in another. We'll cover these with other advanced techniques in Chapter 10, "Picture Projects." The tools we've described here will get you on your way and help you make image fixes and apply some creative touches to your work.

In the next chapter we'll cover how to get the best prints from your digital picture files. As you'll see, a number of important factors contribute to making prints, as well as to optimizing your image files when you want to make the prints large.

Painting tools allow you to add color to change or enhance your picture. The color on this amusement park clown was a bit faded (far left). To enliven the colors the Eyedropper tool was used to "pick up" the color from other parts of the subject. You can also choose your own colors from the Paint Palette in most programs. After the color was selected the Paint tool was chosen. In order not to obscure detail under the painting the "exposure" or "opacity" of the paint was kept at 15%. This adds color without blocking what's underneath. Red from the clown's costume at the lower left was "picked" and added to the hat and lips. Yellow from the clown's eyebrows was "picked" and added to its hair (left).

Pictures of children almost have to be spontaneous, as they move around so much and a baby will certainly not pose for you. You can use a variety of tools to enhance these pictures. Here, the Crop and Blur tools were used. (Left) The first step was using the Blur tool to remove distracting elements from the background and to soften the fabric of this baby's jacket and hood. Select the Blur tool and paint with it as you would any brush tool. More advanced programs allow you to select a portion of the scene to add blur to; this protects the other portions from the blur effect. Here, the baby's face was "protected" from the blur effect. After applying blur the frame was cropped so that the baby's face sits more in the center of the frame (right).

7 Printing Your Digital Images

Seeing Your Results

- **Equipment and Materials**
 - Printer Types
 - Paper Surfaces and Inks
 - Ink Choices
 - Matching Paper and Ink with Printer Software
 - Loading Printer Software
 - Preparing an Image for Printing: DPOF
- **Digital Printing**
 - DPOF Printers
 - Printing Without a Computer
 - Print Image Matching (PIM)
 - Printing with a Computer
 - Image Orientation
 - Printer Properties
- **Kiosk and Lab Printing**

FOR MANY YEARS, most film photographers have surrendered the process of making prints from their negatives and slides to photographic laboratories. While convenient, this provides little opportunity for creative control. But home darkrooms require a good deal of space, an investment in equipment, and the use of various chemicals that are not particularly healthy. Although some people still produce great prints in the darkroom, the proportion of those who photograph to those who make their own prints this way is small, and shrinking.

The new digital darkroom has changed all that. Photo-quality printers are available that produce excellent results, going head to head with most photo prints. Inks and papers have been developed that can stand the test of time. More paper surfaces are now available for a wide variety of creative choices. And the fact that you can see how a print will look before it is printed saves on materials and time. The main excitement around the digital darkroom is that it opens the door to creative experimentation and makes printmaking accessible to many more people than ever before.

In this chapter we'll explore ways that you can make prints from your digital image files as well as the equipment and materials required to get good quality prints. We'll cover the different printers and types of paper, as well as the steps you need to take to enhance and maximize every print you make.

Equipment and Materials

Printer Types

There are two types of digital printers that you might use for your digital darkroom—dye sublimation and ink-jet. Dye sublimation printers work with a color-coated ribbon and paper specific to that printer. Color is diffused onto the print by heating heads within the printer. Ink-jet printers work with inks that are sprayed by ultra-fine nozzles onto the paper. They can use a wide range of papers available in a number of different surfaces, from glossy—which resembles a photo print—to canvas, silk, and fine art acid-free stock.

Dye sublimation printers generally pass the paper through the printer three or four times—three for applying color and the fourth for coating the print surface with a protective shield. Ink-jet printers pass the paper once, during which time the ink is laid down line by line. Dye sublimation printers often can be used only with 4 x 6-inch sheets, and you must use the paper supplied by the printer manufacturer. More costly dye sublimation printers are available that can print up to 8 x 10 inches in size. Ink-jet printers that are used by home and business photographers can print onto sheets as large as 13 x 19 inches.

The quality of both systems is excellent, if the image file is prepared properly. The main advantage to dye sublimation printers is that they are quite easy to use. Printers for snapshot-size prints are quite portable, with some small enough to fit into a briefcase. Ink-jet printers have the advantage of accepting a very wide range of paper types and surfaces as well as the larger print size capability. Prices of both have come down considerably in the past few years so that today their cost is certainly not a barrier to making high-quality digital prints.

Paper Surfaces and Inks

Because you must use the manufacturer's paper with dye sublimation printers, there is little to discuss in terms of selection. Some dye sublimation printers offer more than one paper surface, but generally you're limited to glossy (shiny) or matte (flat) paper types.

It's a whole different ballgame with ink-jet printers. Manufacturers have brought out papers that cover the gamut—from glossy photo to silk fabric and watercolor surfaces. The choices are wide ranging and allow you to print on just about any surface available to artists and printmakers in all the graphic arts. The only limitation is insuring that your printer can handle the paper, since some printers do better than others with certain paper types. Companies that manufacture printers will do their best to convince you that only their branded papers work well with their printers. This is not necessarily the case, and mixing and matching can yield some interesting results.

Papers are classified according to their best end use. There is no standardization of paper types, but there are some generic guidelines for selecting the most appropriate type of paper for your work (see chart below).

The thickness of the paper and the way it receives ink have a lot to do with the resultant image quality. If you are in doubt about which paper to use, many manufacturers offer a sampler pack that will allow you to test different types of papers with various subjects and scenes.

Ink Choices

When it comes to choosing ink for an ink-jet printer, it is usually best to stick with the one made specifically by the printer's manufacturer. Various third-party manufacturers

PAPER TYPES AND BEST USES

Type of Paper	End Use
Photo paper	Snapshot prints, medium quality enlargements
Premium gloss	Best sharpness, best quality, shiny surface enlargements
Heavyweight matte	Fine flat surface art enlargements, nature scenes
Premium semi gloss	Best quality portraits, enlargements, scenics
Photo quality	Medium quality glossy surface enlargements
Sticker paper	Photo stickers
Acid-free rag	Fine art; best for black and white
Transparent film	Overhead transparencies for presentations
Fabric, canvas	Special projects

also offer inks for printers, but any cartridge you use must fit in your specific printer. Inks are made with a certain viscosity, and using poor quality or the wrong ink may clog the ink-jet nozzles. This can lead to costly repairs or necessitate a cleaning that you want to avoid. There is no doubt that some ink and paper combinations work better than others, but you can only judge this by testing one against the other. The differences can be profound, so don't be discouraged if your prints don't come out the way you expect. It might simply be a matter of changing your paper. This is especially true when using photo paper versus premium gloss paper; the more costly paper usually yields better results.

Matching Paper and Ink with Printer Software

We're jumping the gun on this topic, but since it applies to print and ink combinations we'll mention it here. Perhaps the most important step toward getting quality prints is matching the paper you use with the correct media type

An index print shows you all the images you have on a memory card and is essential to choosing images to print when using a direct card printer or printing from your camera. You can "order" an index print using the DPOF function in your camera, if available, or when working with printers that have index print capability. Here, 53 images from one card are shown on one sheet of 8 x 10-inch paper.

in the Printer Software dialog box. This box appears when you choose Print from the File menu and displays a button called Properties. Click on it to display a menu called Media Type. Click and scroll on this box and select the paper you are using by matching the type of paper with the list. You may see Plain Paper (for documents), Photo Quality, Premium Glossy, etc. Matching the paper correctly means that the ink will be distributed properly. Don't match it and results will be poor. If you get poor results always check that the paper type has been matched, as this is the chief cause of problems. We'll cover other settings when we get to the actual printing of an image.

Loading Printer Software

Once you unpack and set up your printer, you should install the printer software. You cannot print without installing it. This creates a handshake between the printer and the computer as well as a basic foundation for what's known as color management—the way image color is read and translated by the printer. Follow the wizards for installing the software and then hook up your printer.

Preparing an Image for Printing: DPOF

Digital Print Order Format (DPOF) allows you to set up your print order right in the camera. You need a camera that offers this feature as well as a compatible printer. You can print all the pictures, single images, or even an index print—a single sheet of thumbnail-size images of everything on the card. The index print is a proof sheet that you can file to help you keep a record of images you made at a specific time and place, or at least of every picture you took on that card.

DPOF setup is slightly different on each camera, so check your instruction book for directions to access this feature from the menu. In general, you select DPOF mode (sometimes called Print Order or Print Reserve), then select or highlight the images you want to print when they appear on the camera monitor. Once selected, you choose the number of copies you want printed by working the arrow or toggle keys. Index prints are created in a similar fashion. This information then travels with the images when you download them to the computer or directly to the DPOF printer.

Digital Printing

DPOF Printers

Once you have set your print order on the card, you can insert it directly into a DPOF-compatible printer or, with some cameras, patch the camera with the card loaded right into the printer. Check your camera instruction book to see how this works with your model. Some work only from JPEG files, may have a limitation on pixel size (for example, 160 x 160 up to 3200 x 3200), and/or are able to handle only a set number of images from a card. If you are plugging the card right into the printer, you might have to use an adapter to insert your type of memory card into the printer. Make sure that when you first buy a printer you have the right adapter for your type of card.

Some DPOF printers start right up and print snapshot-size prints of your images or an index print. Most have a control panel that allows you to make selections as to size and type of paper used. After the card has been inserted, the printer software will walk you through the steps. In general, for DPOF-formatted cards, the printer recognizes the print order and all you have to do is press the Print button. If you want to override the DPOF settings you can do so as well.

Printing Without a Computer

In order to print without a computer you should have an index print of all the images on your memory card. If you have made one via DPOF, use it to guide your choices, as you do not get a preview on the printer control panel (though some printers do have an accessory LCD monitor that allows you to preview your image before printing). Some direct printers provide an index print option. You just insert the card and choose Index Print. Either way, having an index print of everything on your card is essential and is your only guide to selecting the images you want to print. Once you have your index print, insert the card as described above and work with the control panel.

Various settings on the control panel let you choose which image to print, along with paper, size, and image quality. Paper type as well as size should be matched with the paper loaded into the printer. You might be able to choose a page layout, and the number of copies of an image you want printed on a single sheet of paper. You have the option of printing with a border or borderless (that is, a print where the image goes right to the edge of

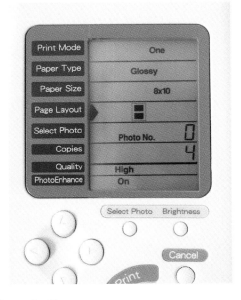

When printing directly from memory card to printer, you need to match the image number on the card with the image itself. The best way to do this is by making an index print of all of the card's images. (Left) This panel from an Epson 785EPX printer allows you to select Index Print, the type of paper you will be printing on, and paper size. Insert the card into the printer with an adapter and press the Print button. (Middle) This adapter lets you insert the card into the printer for direct printing. Adapters are made for virtually all types of memory cards, including CompactFlash (shown), SmartMedia, Memory Stick, SD and Type II cards, among others. You can also make enlargements when direct printing, as long as you have an index print to match the image and number. (Right) This setup on the Epson 785EPX keypad illustrates how you can select four copies of two prints on an 8 x 10-inch sheet of glossy paper. Toggle through the selections with the buttons below and to the right of the panel, then press the Print button to start printing.

the paper). Some printers allow you to get up to 20 prints on one sheet. Of course, the more images per sheet, the smaller the picture size. Select the image number (as shown on the index print) or images you want to print as well as the number of copies of each. You might have a choice of quality settings: choose the highest for enlargements and a lower quality when making a quick proof.

Some printers offer enhancement settings for your image. When you first use your printer, experiment with them to see how they affect different subjects and scenes. Enhancements might include the ability to make a print lighter or darker, soften the image, increase color saturation or contrast, or use any combination you desire. When you use these features, you do not change the original image file; the printer software adds the information when it processes the image.

Use these enhancements on the first go-around or add them after you have made your first print and want to change something about it. For example, say you have a picture of a sunset and want to make the colors richer. You might make the print darker and add color saturation. If you have a picture of a snowy field that comes out a bit dark, you can lighten it. You can also soften a portrait. Play with these enhancements and you'll be amazed at the control you can have over your prints even without using a computer.

Print Image Matching (PIM)

Many digital cameras support a protocol known as Print Image Matching. This is a type of data that travels with the pictures to the printer and is made to match the way the camera "sees" with how the printer performs. Ideally, it eliminates the need to perform specific color, brightness, and tonal corrections to get a good print the first time out. These matchups work only if you used your camera with a specific picture mode. For example, if you photographed using the camera's close-up or macro mode, the data might include commands to enhance sharpness and clarity. Or, if you have photographed using portrait mode the commands might bias the print to emphasize a bit softer focusing and enhanced skin tones. PIM commands do not work if you made your pictures using shutter- or aperture-priority or manual exposure modes. You can turn PIM on or off, depending on your success with it and whether it delivers the "look" you want in your prints.

Printing with a Computer

There are times when printing with the aid of your computer has distinct advantages. If you want to do extra creative or corrective work on your image file, or if you save your printing work for a free weekend and don't want to

When you make prints you can choose from any number of paper sizes, from postcard to 8 x 10 to 13 x 19 inches. Using software, both in your image-editing program and that which might be built into your printer, you can also print multiple copies of an image on the same sheet of paper. Of course, the more copies you have on one sheet the smaller the images will be. These prints on an 8 x 10-inch sheet show a four-up (above) and two-up (right) print selection.

When you go to File>Print on the menu, you should set up the printer for the paper and ink you plan to use. Begin the process with Page Setup on the menu. Your printer should appear after you have installed the software (drivers) for it. If you have a Mac, go to Chooser on the Apple menu to confirm that your printer is selected. Once this is set up you usually don't have to check again. Page Setup tells you how the printer is connected (here, via USB1). It also allows you to select a background color (for the print borders) and set borders. If you select Borders you can determine how much inset the print will have from the edge of the paper. The next step is to click the Properties button to set up the ink and paper.

keep your images on your memory card, then printing with the computer is the way to go. Many printers do not have a direct memory card interface, so the computer route is the only path.

After you have worked on your image, there are a few things you must do to prepare it for printing. The main task is setting the print size. Do this by opening Image>Size (or Resize). A dialog box will appear with a number of items in it. Look at the resolution first. This probably reads 72 or 96 dpi. This is the screen (monitor) resolution and is the setting in force unless you change it, which you must if you want to obtain a decent print. For most ink-jet printers you should set this number between 240 and 300 dpi to create the best results.

The next step is to look at the image size. This tells you how big the print will be. If the size is smaller than you'd like, change the resolution, but don't go below 200 dpi. If your image-editing program has a "resample" box, you can check it, increase the size, and maintain the resolution. Resampling adds image information by sampling pixels and then building in more pixels. This can be helpful, but don't exceed a 20% sampling rate, as the image

information, particularly in fine details, may begin to deteriorate if you do.

All these numbers work together. When you change the resolution, you will see the image size change. If you type in the image size first then your resolution changes. The file size (the pixel dimensions at which you first photographed the image) remains constant unless you resample. If you resample up then the file size increases.

This brings us back to the beginning of this book, when we discussed the importance of photographing with a resolution to match the desired end use of an image. If your aim is big prints, then always shoot at the largest file size you can. If small prints are your goal, then you can shoot at a medium pixel resolution. As we'll see, if you plan just to use the images on the Internet, as part of an e-mail attachment, or on a web page, then even smaller resolution sizes can be used. But the resolution chickens come home to roost when you go to print. If you shot at too small a resolution, you'll be limited to small prints.

What happens if you have a large file size and want to make a small print? This is no problem, as you can always just change the image size settings without much loss of color richness or sharpness. The resolution settings will go up, but this does no harm when printing.

Image Orientation

Once you have the size you want, the next step is to orient the image so that you make full use of the paper size. Almost every printer feeds paper vertically, with the long end of the paper up. If you have a horizontal image on the screen it will print horizontally on the paper, thus losing the advantage of the paper's height. Some printers allow you to orient this in the Printer Setup dialog box; otherwise, you can rotate the image before you print by using the Rotate command in your software. It doesn't matter if the print is sideways on the screen—it will print out fine.

Printer Properties

Once you have the correct size and orientation, the next step is to open the Print dialog box. When you do this, you will see the name of the printer and a box called Properties. Click on this box, and you'll see a number of tabs and pull down menus. The first option might be Media Type. Scroll down the menu to see the various types of paper selections. Match the paper type with the paper you have loaded; check the packaging of the paper to insure you've made the correct choice. Next, click on the Paper Size menu and do the same. Check off Color for the ink and

Automatic for the mode. If you want to make the color richer, check off PhotoEnhance, if available. Then select Quality or Speed. Always use Quality for the best results by sliding the bar on the Quality setting. Once you have done all this, click OK. The dialog box will close and you can click the Print button.

Some printers may have different settings and properties, or a different way to choose settings. You should be aware of how to select these settings with each printer. You can experiment with the settings to see the difference they make, but rest assured that you will get the best results with the course outlined above.

Your Properties menu may be different from what is shown here but it contains many of the same features. This screen shows the paper size and number of copies you want to print, as well as the orientation and printing area. It is important that you select the paper size, as printing with the wrong size may result in loss of some image area or getting an error message that tells you that the image you want to print is too large for the paper selected. To change the paper size, click on the Paper Size arrow and select from the options. For Orientation, always choose Portrait, as this will maximize use of the paper area for the print—it's also the usual way paper is fed through a printer. For Printable Area you can select a standard print type, a centered print. This can be used when making a 5 x 7-inch print on an 8 x 10-inch sheet, for example, that will sit in the middle of the paper and not at the edge, thus eliminating the need to trim the paper when fitting it into standard frame sizes.

The Main Properties menu is where you select the ink, type of paper you are using, and quality level of the print. Matching the paper here to what you have loaded in the printer is essential—a mismatch is one of the main causes of poor print quality. Check the packaging that came with your paper to insure that you have this set correctly. You can also choose whether to print in color or black ink. If you use your printer for text and photographs, use black ink for text, as this will save on the use of color ink. The Quality/Speed slider should always be set as shown here, to maximum quality, for printing pictures. You can choose Speed for a quick proof print and draft text documents, but avoid this in most cases. Choose Automatic for the majority of your work, though note that the Custom settings do allow you to tweak the print on a second run if it is, for example, too blue or yellow. In most cases the printer driver will work in conjunction with your computer to deliver excellent quality when set on Automatic.

When you print you must work with a dialog box known as Image Size or Resize. This sets up the printer resolution and is very important for quality results. It may be found in different parts of your toolbar menu, depending on the software. In most cases it will be found in either the Print or Image submenu. You quickly see the effect that original image resolution has on the size of the print you can make. When loaded, an image is in screen resolution, either 72 or 96 ppi. You must change this to printer resolution to get a decent print. The printer used for this book is the Epson 785EPX; it has an ideal resolution setting of 240 dpi. This is the case for many ink-jet printers; your printer manual will recommend output settings for your work. When opened, this 4 MB image is at 72 ppi and the document (print size) is over 14 x 21 inches (top left). This is both too large to print and, at 72 ppi, would result in a very out-of-focus picture. When reset to printer resolution (top right), the maximum print size is about 4 x 6 inches, or snapshot size. At a bit over 8 MB, the original image can yield a slightly larger print (bottom left). At screen resolution the image would yield a very poor 20 x 27-inch print. When resized for printing we get a 6 x 8-inch print (bottom right). A process known as resampling, or interpolation, can help you gain a bit more print size from images. Generally, a resampling of 20% is about as far as you can go while maintaining print quality. Experiment with your images and printer to see how much latitude you have. To resample, check the Resample box in the Image Size dialog box, then type in the desired print size. When you do so, watch how the image file size grows.

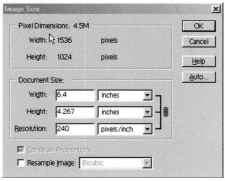
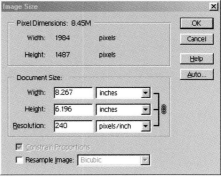

exposuretrain fillflash flamingodof

flashonwelder lowlight macro

rainbow scan stitch

welder2noflash whitebalauto whitebalinca...

Another option for printing images in a folder is a contact sheet. You can make contact sheets using any number of image-editing programs. In Photoshop Elements, for example, work from the File>Automate menu by choosing Contact Sheet. Select the folder from the browser and the program will organize the images for you. This program prints the name or number of each image under its frame. You can also select how many images will appear on each sheet. Select fewer images per sheet and they will print larger.

PRINTING PROBLEMS AND SOLUTIONS

There may be times when despite your best efforts you might get a print that does not meet your expectations. Listed below are some common printing problems and possible solutions.

Printer Problem	Most Likely Cause	Solution
Dots or lines are missing. Bands are running through the print. Some colors seem "off."	Clogged nozzles on your ink-jet printer or dirty heads on your dye sublimation printer.	Run a Cleaning Utility, found in your printer software. This unclogs nozzles for ink-jets and helps clean the thermal heads in dye sublimation printers. Some dye sublimation printers might require cleaning with compressed air or a lint-free cloth. Check the printer's instruction book for the proper cleaning procedure and tests. Note that if you do not use your printer for a month or two, ink or ribbons can deteriorate and cause problems. Either run a print through at least once a month or use the Cleaning Utility to refresh the printer.
You get a "can't find printer" message.	Printer software not loaded; lack of a good connection between the printer and computer.	Make sure you have loaded the printer software, then check your cables. If you use a computer with a Chooser (Mac), make sure that the correct printer is in the Chooser panel.
Lights blink on the printer and it won't print.	Printer is too low on ink to run a print through.	Replace the ink cartridges or ribbon.
Paper error.	Paper not correctly loaded in the tray.	Cancel printing and replace the paper.
Colors are dull or smeared.	Incorrect printer and ink settings.	Make sure that you have used the right printer and ink combination in the Properties box. Recheck the Media Type setting.
Prints are grainy. Prints look blurry and display pixels.	Incorrect media type; resolution too low in Image Size (Resize) dialog box.	If you see a number below 100 when you open the Image Size dialog box, you have not reset the resolution to printer resolution. Reset the number to at least 240 for ink-jet printers and 300 for dye sublimation printers.
Image is too big for page or clips at the edges.	Not choosing the right media size in the Properties dialog box.	Some printer software will tell you that the image might be "clipped" if you print with the settings you selected. If you change paper size often keep an eye out for this.
The color is off.	Monitor setup could be too bright or have a color cast.	Use the controls on your monitor to correct this. Some advanced software programs have built-in monitor adjustments that help you calibrate the monitor with the printer. There are also third-party color calibration software packages that help you set up your color correctly.

Kiosk and Lab Printing

As the use of digital cameras has grown, so have the options for making prints using outside services. One of the latest developments is the digital print kiosk, found in photo stores, labs, copy shops, and even supermarkets. These self-service units have slots for various types of memory cards and even CD ROMs, and allow you to make print orders using a touch screen type of system. Once you insert your media you can order an index print or view all the images on the media. You then place an order and the unit's self-contained printer does the rest. Costs are similar to ordering prints from film negatives.

Another option is the digital minilab, a unit that makes prints on photographic paper from digital image files. Here, you bring in your media to the store counter and order prints just as if you're doing so from film. Many labs will offer a variety of services, including making enlargements and even burning a CD ROM of the images for you. This is very convenient if you don't have the time or equipment to do it yourself. You can also work with an online lab, such as the one available at www.kodak.com. Here you upload your images, maintain albums, and order prints for yourself or to have sent to others. It's quite convenient and offers digital services that were unheard of a few short years ago. Of course, printing yourself is fun, but these services make digital imaging more mainstream and accessible to everyone.

In the next chapter we'll explore another type of output—making images ready for e-mail attachments and for use on the web. Much of the same procedure used for creating screen images can be applied to making prints, except that we work with much smaller file sizes.

Getting prints from digital cameras, CDs, and memory cards is now just as easy as ordering prints from a roll of film. Many locations have walk-up, self-service kiosks that allow you to make prints, burn CDs, and e-mail and upload images to various websites. You can even order gift items, such as T-shirts, mugs, and calendars, right from your memory card. This walk-up kiosk from Kodak has a self-contained printer, with slots for various types of memory cards and even Picture CDs. You'll begin to see these digital printing stations in tourist spots, malls, and photo stores, along with copy shop and drug stores. A real advantage is that you can burn a backup CD of images from your memory card when you're traveling and run out of room on your card.

8 Internet Images

Mailing, Sharing, and Posting Web Pages

- **E-mail**
- **Picture-sharing Services**
 - **Prints and Image Gifts**
 - **Editing On-line**
 - **Community Websites**
 - **On-line Viewing Options**
- **Building Your Own Website**

ONE OF THE WAYS that digital cameras have changed our lives is the means by which we share our images. Of course, you can always make prints to show family and friends, but the Internet allows us to share images with people we rarely see or perhaps have never met. Anyone with a computer and Internet connection can be part of your sharing community.

The appeal of sharing images in this new way has spawned many easy-to-use programs and systems for getting your images onto the web. New cameras have features that allow you to make e-mail–ready images from any resolution size with the touch of a button. This makes a small file copy of any image on your memory card right in the camera. There are even e-mail functions built into the camera that, when patched to a computer hooked to the Internet, send an e-mail right from your inserted memory card. And new cell picture phones can be used as cameras and e-mailing systems in one. Whatever method you use, part of the reason you might have bought a digital camera is to share your images electronically. The simplicity and ease of sharing will continue to grow.

Showing your pictures on the Internet is usually done by one of three methods. The simplest is e-mail, where you attach your image to a message and send it. You can also join a picture-sharing website, where you post images for invited guests and everyone else to see. Or, you can create a website to show off your images and possibly even sell prints.

E-mail

Electronic mail has become an important form of communication. Some reports claim that more e-mail messages are sent today than letters through the post office. All this has occurred in the past few years, drastically changing the way we keep in touch. Sending pictures through e-mail is as easy as sending a text message. All you need to do is attach your picture to the e-mail message, send it, and you're done. The only thing you have to be aware of is the size of the image file you are attaching.

If you recall our discussion on resolution, we noted that the smaller resolution mode choices on your digital camera are best for Internet pictures. Larger files take a longer time to upload to the Internet and, more importantly, download to your recipient's computer. Indeed, some Internet Service Providers (ISPs) block very large files (some as small as 2 MB, others anything over 6 MB). This may change as broadband technology improves, but we may not see this in any but urban centers for a while.

The ideal resolution choice for e-mail pictures is 640 x 480, also known as VGA resolution. If this takes a long time to download because the recipient has a slow modem, you can lower the file size further. You will surely need to lower the size if you used a larger resolution mode when you made the picture you now want to send. Ideally, your file size should be between 100 and 500 K, the smaller size preferential.

The first step is to make sure that your images are in JPEG format. When you saved your images from your digital camera we recommended that you convert them all to TIFF files to prevent the loss of image information when opening each file again. However, to put images on the web you have to convert them back to JPEG format—this is the web's standard picture file format.

Convert your image by making a copy or using the Save As command. You can also find a Save to Web command in some image-editing programs. These guide you through the steps, show a preview of an image as it will appear when compressed, and even tell you the time it will take to transmit to different types of modems on the receiving end. When you do the JPEG conversion you might be asked by your software program to indicate a Quality setting. Place the setting between 5 and 7 and follow the instructions for best performance. If you photographed in JPEG format you still might have to lower the file size.

Some digital cameras have a built-in e-mail function. This takes a picture at the resolution you have chosen and at the same time makes an e-mail-size copy. Thus, you get two of the same image with one push of the shutter release: one at the taking resolution and one primed for e-mailing. Some cameras allow you to do the same thing in review mode. When you are scrolling through your pictures on the camera monitor, pushing the "small picture"

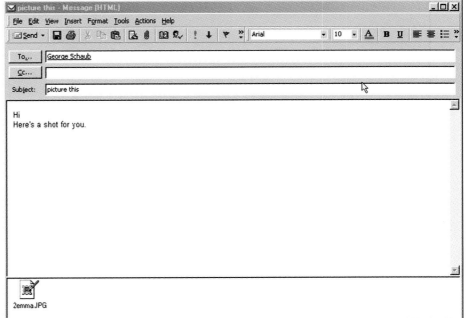

E-mailing photos is as easy as sending an attached document. When you write an e-mail message, simply find the Attach button and click it. Next, click the Browse button and your Browser will appear on the screen. Scroll through the folders and files and choose the image you want to send (above). Once you select the image and click Open, it will appear as an attachment on your e-mail. In this screen it appears at the bottom of the window (right). All you need to do then is click Send.

button or a similar function instructs the camera to make an e-mail copy for you. This is a clever idea that more and more camera makers are incorporating.

Some e-mail and image-editing software programs will shrink the size automatically for you when you press the E-mail this Picture icon on the toolbar. This handy feature resizes the image file for you.

Once you have arrived at the correct file size, all you need to do is attach the file to your e-mail document. When you open your e-mail program you will see a paper clip, Attach button, or similar function. Click the Attach-

ment command and a window will open that shows all your files. Browse through until you find the correct image, click Open or Attach, and an icon with the file name will appear in your mail window. Some programs allow you to send more than one image with a single e-mail, but be sure that the sum of the image sizes does not exceed the total file size permitted by your ISP. In addition, be aware that certain ISP providers may have trouble receiving more than one picture per message. You can compress the images using a "zip" program, but your recipient may not be able to open them once received.

When the recipient receives your e-mail it will alert him or her that a photo or document is attached. (Left) On this AOL screen, the attachment is accessed by clicking the Download button. When the recipient does this, a dialog box entitled File Download appears (above). Choices include Open and Save. If the recipient wants to save the image to a file folder, he or she selects Save and the file is downloaded to that folder for later viewing. Alternatively, the file can be opened right away and then saved after viewing. (Left) This 1 MB file was downloaded through a cable modem connection in about 10 seconds.

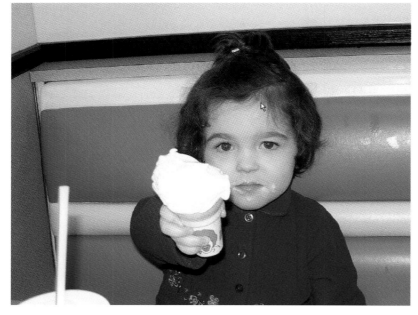

Picture-sharing Services

If you have trouble attaching images to e-mail, or if your recipients have difficulty opening them, there's another way to share your images. Most ISPs offer "sharing" web-sites, sometimes in the form of personal album pages that are free with membership in the sharing site. To get your pictures onto those sites you must upload them from your camera or computer. The photos are then stored on a web server, which becomes a resource for sharing on the Internet. You can upload individual photos or create albums that store groups of photos. Once you have established these folders you can send e-mail directly from them or give their web address to the people you want to see them.

When you sign up with an albuming service provider, you will be given the tools necessary to upload images to your personal site. Some will place an Upload Tool in your computer. Start by simply moving images from your files into the Upload Tool, where you can arrange them in albums or folders. The images will appear as thumbnails in your albums. You can then open the albums and use the various functions provided by the Upload Tool. One is to upload to the server site. Another is to e-mail right from the Upload Tool to individuals or groups of family and friends. Those people who you want to view the on-line albums can do so from an address you supply; you can also require a password to enter the site.

The number of images you can store on these sites or the total memory space the albums take up on a server might be limited. Some sites provide a meter that will tell you when you are about to reach capacity, allowing you to remove pictures or possibly buy extra space on the server to accommodate them.

Just as resolution determines how large you can make prints at home, the size of the image files you store on these servers will determine what you and others can do with them. If you upload small file sizes you will be limited in your choices. Upload larger files and you can do more. The time it takes to upload will be determined by how large the image file sizes are and the type of connection you have. A cable modem will certainly speed things along faster than a dial-up connection. Consider all this when you upload and download images.

Sharing sites allow you to store images and folders (or albums) that can be sent to family and friends, used for printing or purchasing gifts, and serve as a way to easily move images from one place to another. Getting pictures on the sites is easy. You select a picture from your Browser and click Upload. Once the photo reaches your personal site you have a host of options (left). You can share it, order prints, create gifts, and even edit and correct it. (Right) This screen is from MSN Photos; if you choose to share a photo you get this screen. It is constructed like an e-mail and allows you to type in single or multiple addresses. You can use an address book for a particular circle of family and friends to easily insert multiple recipients.

Prints and Image Gifts

Image-sharing sites allow you and your recipients to order prints and image gifts on-line. This is one of the reasons why "albuming" sites are usually cost-free. The larger an image's file size, the more you can do with it. Some sites actually give you an indication of how you can use the image. MSN Photos, for example, provides a Picture Meter to make the judgment call. This uses a set of bars in a meter graph.

Editing On-line

As sharing sites become more sophisticated, you should be able to do basic editing functions on your stored images. This alters the stored image file and affects the files in your computer as well. Alternatively, you can edit pictures offline using Upload Tools, and send them to the site later. You can often adjust brightness and contrast, remove red-eye, and even apply some special effects—such as making your image look like a painting—without ever going into an image-editing software program. You can also crop, rotate, and delete images from these files. Templates for calendars, greeting cards, and personal invitations are available as well.

ON-LINE GIFT OPTIONS BASED ON FILE SIZE

Resolution	Gift Options*
Low (one bar in MSN Photos)	Postcards, magnets, e-mail
Low–medium	Snapshot-size print, coasters, business cards, baby t-shirt
Medium	Greeting card, photo clock, 5 x 7-inch print
Medium–high	8 x 10-inch print, 11 x 14-inch poster, sweatshirt
High	Large posters

*As you go higher in resolution all the items in the lower resolutions can be ordered as well.

If you choose the Gift option, you can order posters, t-shirts, mugs, and all sorts of other gear with a photo printed right on them. (Near right) This is MSN Photo's option for ordering posters. A Photo Meter notice appears on the screen, indicating whether or not the image resolution will be sufficient for the product selected. In this case, the resolution is too low for a good quality poster print. (Far right) The Photo Meter also indicates which products will yield quality results based on an image's resolution. This is a great tool that both teaches you the importance of resolution and avoids disappointment when you get your gift in the mail. If you want a poster, you have to hit the four or five mark on the meter.

Community Websites

The premise behind a community website is quite similar to the album-sharing sites discussed above. The difference is that your albuming site has a unique web address, one that you can share with others. Community sites are often built around a common theme. You build your picture portfolio on these site albums in a manner similar to how you build your personal sharing site, filling them with images identified by a particular subject, event, or scene. Many basic image-editing programs now offer website building templates. All you need to do is move pictures and type in text; the program performs all the coding for you. Just as with a sharing site, you should make your picture sizes small enough to be carried with the pages. These sites might be built around themes such as travel locations, dog breeds, or even tips for image-editing techniques. You join the sites as a member and make your own personal contribution, somewhat like an image-driven chat room. Many professionals also use these sites for gen-erating business. There are, for example, many wedding photographers who use these sites to show off their work and to solicit clients.

On-line Viewing Options

Aside from looking through individual pictures and albums, other options are available for on-line viewing. One is a slide show, an automatic loop of images that plays through an entire album or folder. You can set it up for a single viewing, or for a continuous loop of all the images. A second is to load a set of thumbnails that when clicked on make the images appear full screen.

Another option is known as an e-book. This recreates the feeling of flipping through an album or book on the screen. You can add type, captions, and all sorts of special effects to help tell the story. Some programs allow for ani-mations (GIFs that move) and a music or sound track. One company, E Book Systems, offers many such pro-grams.

Toolbar Annotation Bookmark

Background Music Flipping Page Full Page Layout

This image illustrates an e-book created with E Book Systems software. Pictures, type, and graphics are all easily loaded into this flip-through virtual book. You can even add a sound track.

Building Your Own Website

The web is a major showcase of photography for hobbyists and professionals alike. It is used for conducting business, displaying fine artwork, and building family photographic trees; it's also a great way to keep in touch with the world beyond your town and country. In the past, web pages were difficult to build, as you needed to know all sorts of code and lingo. That's no longer the case. Web page building programs offer templates and tutorials for creating sites and links. Most offer drag-and-drop ease. As you gain experience, you can customize your pages to your taste.

Building a web page can be as easy or complex as you want to make it. Simple web page editors can be found in programs such as ACDSee and Photoshop Elements. The first step is creating a folder that contains all the prepared images. This becomes the source folder that you open when asked to load your pictures. When you choose Source, the Browser opens, you click on the folder, and all the pictures in it are loaded (top left). A variety of album styles are available when working with your web page builder. (Top right) This style sheet is from the Namo webeditor 5 program. Here, all the pictures in the album are shown horizontally; the selected picture is enlarged at the bottom. You can also choose styles, colors, and typefaces for your page. A wizard (bottom left) will guide you through every step of the process. This style sheet is from Adobe Elements. If you are interested in building a complete website, you can work with a blank page to start or choose from any number of templates provided with the building software. (Bottom right) This selection is one of many available in the various programs on the market.

Some image-editing programs come with HTML page builders. These are simple programs that you can use to create a page of thumbnails that, when clicked on, enlarge to full-screen images.

The basis for image work with web pages is similar to on-line album creation and e-mail preparation discussed above. First choose the images you want to show, resize them, and place them in a folder. You then use the images from that folder as your source for your web pages. You can also add type and artwork from any source, your own or the web template folder.

When you have finished your work, you have to "publish" the site. This means contacting your ISP and finding out their fees, maximum size, etc. Check with your provider to see how this is done. When you've come to an arrangement you simply upload the pages in the site as you would any image or document.

In the next chapter we'll cover other sources for digital images—including digital files you can get along with your processed film—and scanning your own film and prints to bring them into the digital environment.

(Top) This basic web album was created in three minutes using Adobe Photoshop Elements, which creates all the necessary code for you. The album pages allow the viewer to see thumbnails of every picture in the album. If a viewer wants to see the picture enlarged, all he or she needs to do is click on one of the thumbnails, which will then replace the picture on the main screen. (Center) Here, the picture selected for the opening shot is shown as the main image. Clicking on one of the thumbnails brings another image to the fore (bottom).

9 Supplementing Your Digital Library

Other Sources of Digital Images

- **Doing It Yourself**
 - Scanners
 - Scanner Software
 - Scanning Old Photos

- **Picture CD and Scanning Services**

ALTHOUGH THIS BOOK is written for digital photographers, omitting reference to other ways to obtain digital images would be remiss. Those of us who have dived into digital from a photographic base have plenty of prints, negatives, and slides that we'd like to work with in the digital realm. In addition, photographing with a digital camera does not mean we have abandoned the use of our film cameras. With that in mind, this chapter is dedicated to exploring ways to bring prints and film into the digital fold. We can easily translate images into binary code, making them workable in our digital darkroom and available for printing, sharing via e-mail, and creating websites.

Doing It Yourself

Scanners

The way that we convert prints and film to digital information is with a device known as a scanner. Like digital cameras, scanners contain sensors that read visual information and pass it electronically to a digital converter, where it is changed to bits and bytes. In film scanners, the charge-coupled device (CCD) is fixed and a stepper engine passes the film before it; the CCD reads the film line by line. In print, or flatbed, scanners, the paper is fixed and the CCD itself moves to read it. Some print scanners have film adapters so you can use them for both film and print scanning. If you plan to scan a lot of film and want to make big enlargements, then a dedicated film scanner is best. More affordable, flatbed scanners with film adapters do a pretty good job with negatives and slides, but might limit the size to which you can enlarge a film image.

Scanner Software

Like most digital devices, scanners are powered by software. You load the software before using the scanner and use it to control the settings. You either create a file and save it onto your hard drive, or have the scanned image feed directly into your image-editing software, where you then make final corrections before you print or send the file.

Just as with digital cameras, the higher the resolution of the scanned image the larger the print you can make. Inexpensive scanners offer lower maximum resolution, thus allowing only a limited print or file size. More expensive scanners let you make very large prints. When scanning an image, select the resolution depending on what type of result you want, as with a digital camera. Choose the maximum resolution the scanner affords for large prints, a medium resolution for smaller prints, and a small resolution for e-mail and screen images.

These numbers are selected in the scanner software. When you place a piece of film or print in the scanner and start the process, a work area appears on the screen. The first step is to choose the type of image you are scanning, whether positive (slide) or negative. Prints are often called "reflective."

You'll see boxes that include references to items such as dpi, output size, or scale. Most scanner software is fairly easy to use and eliminates the need for elaborate calculations. For example, say you are scanning an 8 x 10-inch print on a print scanner and your intended use is another 8 x 10-inch print. Locate the output box and type in or select 8 x 10 inches. The software calculates the rest, including resolution and scale. If you're scanning for an e-mail image you might want to type in the resolution, such as 640 x 480. The scanner will then calculate the file size, which should be below 500 K. Finally, if you are scanning a slide on a film scanner for a print, you might want to type in the desired file or print size and have the software make the calculations for you.

After making these selections, click the Preview button to perform a quick scan of the image. This places the image inside the work area. Scanner software packages differ among manufacturers, but all allow you to make certain adjustments to the image after you create a preview. For example, you can crop the image right in the scanner. This is helpful because it eliminates unnecessary use of memory and file size. You can also adjust brightness and contrast, rotate the image, and perhaps make some preliminary color adjustments.

 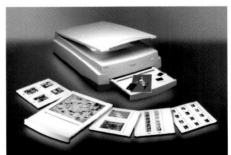

Photos, Courtesy Polaroid Corp., Microtek Lab Inc.

Two main types of scanners are used to digitize film and prints. A print, or flatbed, scanner is employed primarily for prints and documents (left). You open the top plate, place the picture or document face-down on the glass plate, close the cover, and make the scan. A film scanner is best if you work primarily with negatives and slides (middle). The scanner shown here is for 35mm format film. You can also get scanners with Advanced Photo System (APS) film format adapters and larger format film sizes, like those for medium format cameras. A hybrid scanner (right) can handle both film and flat prints. The film goes into a tray on the bottom. Some scanners have film adapters that you place onto the top plate.

Scanner software may provide a tonal curve, allowing you a simple way to adjust contrast and brightness. The tonal curve starts out as a straight 45-degree diagonal on a graph. You can play with this to change the contrast of the image, but keep your adjustments minimal. This tool is needed if the image being scanned is very bright or very dark, as the scanner might not be able to read the values properly without your input. Moving the lower part of the line changes the darker areas, while moving the upper part affects the brighter areas (highlights).

After you have typed in or selected the size or resolution of the scanned image, completed some basic adjustments, and cropped the image to its final proportions, press the Final or Full Scan button. If you have linked the scanner to your image-editing program, the program can acquire the image directly. With some scanner/software linkages, this is done via the Import or Acquire command for that software, which may start the scanning setup for you. Once you have the original file stored, create a copy before you make any changes to it; you can then make further adjustments and create whatever image affects you desire.

Scanning Old Photos

Perhaps one of the most interesting and meaningful projects you can do with a scanner is copy old family photographs. Many of these images might have been damaged by poor storage conditions or just plain old time. Photos are memories that do fade; scanners give us a way to protect, preserve, and pass these images on to future generations. They can be used to build family tree web pages or given as gifts of fresh prints once they have been restored.

Most family pictures survive as prints, so a print scanner is the best tool to use. If the print is mounted in a mat you can crop the mat out when you scan—you don't have to remove the print to scan it. You can also scan prints mounted in album pages as well as old glass plate negatives or tintypes.

Some prints have already begun to fade, but your scanner and image-editing software can do wonders toward restoring them to their original look. If a print is faded, for example, you can increase contrast by using the curve adjustment in the scanner or the contrast adjustment in the editing software. Some scanners come with a dust and scratch "filter" built in. This helps restore images during the scan itself.

Scanner software allows you to make basic adjustments to an image before you scan it into your image-editing program. Start by bringing the image into the computer using the Preview button. The image opens up on a Preview screen (left). Tabs on the page indicate adjustments you can make. (Right) This window lets you adjust the contrast of the image before final scanning. Slider bars on the right side of the window make the job easy, and the image adjusts right before your eyes as you move them. Some scanners also use tonal curve adjustment controls.

Picture CD and Scanning Services

If you or family members still photograph with a film camera, you can get digital image files without scanning the pictures yourself. Most photo labs offer photo/picture CD services that deliver a fairly low resolution scan of all the images on a CD, along with prints and negatives. There is an extra charge for this, but it allows you to easily access the scans for e-mailing, web page building, and making snapshot-size prints at home. Many services include software on the CD for creating greeting cards and other projects as well as links to e-mail and sharing websites.

Using a scanning service is similar to getting reprints from your film negatives or slides. Most advanced image-editing programs can read from photo CDs. Some lab services allow you to put up to 100 images on a CD. The scans made on a Kodak Photo CD system come in five resolution levels for each image, letting you choose the proper resolution for any project—from making web images to 11 x 14-inch prints. This is a handy way to scan a group of images that you might want for a variety of uses. Costs vary, but average out to about $3.00 per scan.

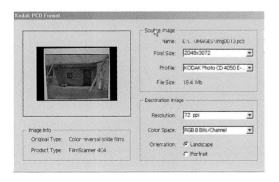

One way to get digitized images from film is to order a Picture CD. (This is Kodak's name for the product; other companies have similar products under different brand names.) When you order a Picture CD you also get back prints and negatives from your film. The Picture CD offers many options, including basic image editing and e-mailing, all accessed via the Features menu (top left). You can edit brightness, contrast, and color cast (top right), and even create special effects (bottom left). One of the best functions is the ability to e-mail images right from the CD. When you choose a picture and press the E-mail function button your e-mail program automatically opens and the image is attached to a message (bottom right).

For higher resolution digitized images, you can have an outside service to do the scans for you. One such service provides a photo CD. Different from the Picture CD, you order scans just as you would reprints from your negatives and slides. Once created, a Photo CD offers a hierarchy of different image resolutions, which you can use for a wide variety of image functions. Examples include building web pages, where you choose a lower resolution (left), or prints, where you would select a higher resolution (right).

10 Picture Projects

Applying Your New Skills

- **Exploring with Your Camera**
- **Project 1: Composition**
- **Project 2: Light, Color, and Exposure Controls**
- **Project 3: White Balance Customization**
- **Project 4: Camera Plus Computer**
- **Project 5: Stitching**
- **Project 6: Pixellate It**
- **Project 7: Swapping Color**
- **Project 8: Specialty Prints**
- **Project 9: Scan, Retouch, and Print**
- **Project 10: Color Variations**
- **Project 11: Adding Color**
- **Project 12: Plug-ins and Filters**
- **Project 13: Color Moods**
- **Project 14: Black and White**
- **Project 15: Line Drawings**

DIGITAL PHOTOGRAPHY places creative control in your hands, and what you do with your images is limited only by your imagination and what you want to express. There are certainly enough opportunities for this, both before and after the shutter is released. As mentioned earlier, for example, you can create various effects in the camera itself when making the exposure. These effects are part of the camera's software, and allow you to take the first step toward interpreting scenes and subjects and not just recording events.

Once an image is in the computer, you can stylize it, correct for backgrounds and exposure mistakes, and apply a wide range of effects. There are a variety of software programs to choose from. Using these programs can be as simple or as complicated as you want to make them. Some offer push button effects, while others can take you down long roads of a process that takes up nights and weekends of creative work. The beauty here is that the digital darkroom allows for a great deal of experimentation and play.

We'll start with a few photographic projects, follow up with some in-camera and software combinations, and end with some purely computer-generated effects.

Exploring with Your Camera

Working with a digital camera does not mean that we are not engaged in that essential photographic endeavor—seeing and making pictures. The question for some photographers becomes one of subject matter, and how to develop a photographic eye. Seeing and making pictures is a combination of aesthetics and science, of applying the rules of the photographic road to best express the subject and scene before you. You can develop this eye by randomly taking pictures as you go, or by selecting a scene or subject and developing it into a project or theme. Your digital camera is a great tool for learning about the science side of this equation. As you photograph, you can get instant feedback on your results and change settings or point of view for more effective images. You can alter exposure, ISO, lens focal length, and even color balance on every subject to experiment right in the field. This feedback is unique to digital photography and is what makes it both a creative and learning process.

One of the best ways to develop a photograph eye and hone your photographic technique is to select a subject and spend time working with light and composition. A classic teaching technique is to ask students to develop a theme or set of pictures in a small area—to walk around and make pictures within an acre of ground. Indeed, one teacher I studied with many years ago took students into her backyard and told them to spend the afternoon making pictures. The diversity and different points of view of the images were amazing. The point of the lesson is that you can find photographs virtually anywhere if you let your imagination run free.

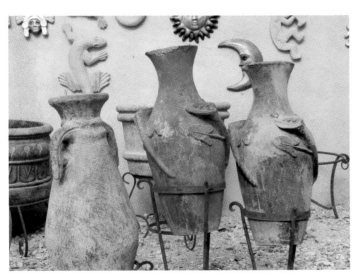

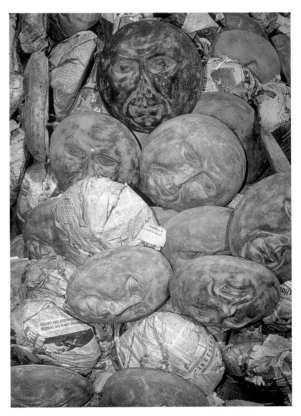

One way to develop a photographic eye is to work with themes, similar subjects, sights, or even color and design moods. Your choice of theme is of course personal, but you can get ideas from looking at articles in photo magazines and in books that cover one subject or area intimately. These photographs were all made in and around curio and antique stores in northern New Mexico. The arrays of forms, patterns, and colors in those shops are a constant source of photographic interest.

Composition

Your point of view—where you stand, how you point the camera—and use of different focal length settings on the lens (from wide angle to telephoto) have a profound effect on your pictures. Change any of these factors and the light, relationship of the subjects, and impact of the image can be completely different. How you frame a subject—where the picture begins and ends—also speaks to your sense of balance and composition. When looking at a potential photograph, see the forms it contains as building blocks that can be assembled in various ways. Consider the shapes, angles, and lines as objects to be spread around on a grid. A composition can be harmonious or chaotic, depending on your feelings for the subject. See each image you make in a sequence as a rough draft, one that becomes refined with each subsequent picture in the series.

This series of photographs shows how a subject can be considered and refined. The first image was taken from approximately 30 feet away using a wide-angle lens (top left). The elements are cylinders and rectangles formed by the grain silos, along with the truck and building. The parking area in the foreground is empty space and does not serve the photo in any way. To tighten up the composition, the lens was zoomed to the telephoto setting, eliminating the empty space and more effectively balancing the shapes (top right). Finally, the camera was pointed to the left and the composition shifted from vertical to horizontal, incorporating more rectangular shapes and giving a sense of depth and scale to the shapes (bottom). The back fender of the foreground truck touches the end of the building and the size of the foreground truck set against the one in the background yields a more interesting visual play.

Continuing this compositional exercise, we went around to the back of the silos to see what was available there. Under the shade of the building sat this arrangement of shapes. One thing you'll find with your digital camera is that it is able to record every detail in shade where there is little or no contrast, especially if you give it some help. To boost the contrast here the recording menu was accessed and a +1 contrast setting made (top).

A freight depot across the tracks was covered with peeling paint, making for a study in texture and design. Rather than photograph the entire building, the shapes formed by this door and boarded-up window were isolated in the viewfinder. Often, showing only the details of a subject can tell the whole story and focus the viewer's eye on just what you want him or her to see (middle).

Across from the freight depot sat these interesting chemical storage tanks. This photograph took some time to compose and many variations were made. The final image is a visual play of form and light (below). Exposure here was critical. To record the white values correctly, the camera's metering pattern was switched to spot metering and a reading made from the white tanks. A +1 exposure compensation was applied. This kept the whites bright but maintained the other values in the scene. If the reading had been made off the white without compensating for the background, the other areas would go too dark.

Exposure compensation was also used for this shot of a freight shed and silos. The first exposure (left) was checked in the camera after it was made. Because the meter read much of the shadow area it added more light and overexposed the sunlit area in the shade. An exposure compensation of -1 EV (right) yielded a much better exposure of all the values in the scene. The lesson here is to check exposure as you work, using the review feature to help you learn about the effects of exposure compensation and control for future pictures.

Light, Color, and Exposure Controls

Capturing the right mood in your pictures results from working with the exposure controls, metering patterns, and color balance settings in your camera. This is a process that takes time to learn. If you have already worked with a film camera that offers these features, you are a step ahead of the game, as the same rules apply. If not, don't worry; a digital camera is an excellent learning tool. This project illustrates a number of techniques that will help improve your basic images.

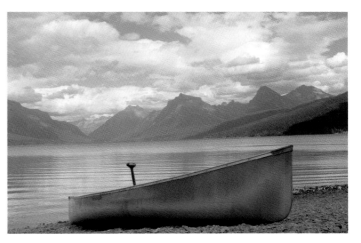

In many instances you can simply turn on your camera, put everything on automatic, and make great shots. But the light and color of the scene must play along. If the light is coming from over your shoulder or falls evenly over the scene, "program," or fully automatic shooting, will do fine. (Top) This scene was made in just that way.

Metering patterns determine where in the viewfinder the exposure system gets its information. Many cameras have a choice of patterned, center-weighted, or spot metering. You can choose center-weighted or spot metering, point the camera where you want the light information to be read, then use exposure lock and recompose if necessary. (Middle) This seemingly complex lighting situation was read by the patterned meter and, because the light values were varied, it made a good exposure call.

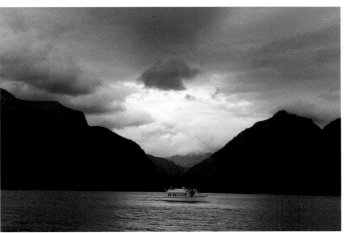

Use spot or center-weighted metering when you want to control the exact location where the camera reads the light. (Bottom) This early morning, foggy sunrise photograph was the second in a set. The first was made on automatic but turned out too light and lacked the mood and feeling of the scene. To darken the in-camera image, the metering pattern was switched to center weighted and the camera pointed toward the sun. This forced the meter to compensate for the extra light, yielding an exposure that was more expressive of the moment.

To maximize the picture right out of the camera, set the internal software to help you get the type of picture you want. For example, mood is a very important aspect of an effective photograph, and is often determined by the color cast in a scene. One of the best tools for controlling mood is white balance. In this set of sunset pictures, the white balance was set to enhance the light in the scene. (Top left) For this first image, the white balance was set on tungsten, giving the image a blue color cast. The opposite was done with the second (top right). The white balance was set on cloudy, adding red to an already blazing sky and creating an even more vivid scene.

Some scenes are just loaded with color. (Bottom) This house with sunflowers is a study in yellow. To enhance the subjects further, the color saturation control in the camera was set to +2 EV.

Photo by Grace Schaub

Exposure compensation can be thought of as a light enhancer, since the amount of light falling on any object affects its rendition. (Above) This deep forest scene was first photographed on fully automatic exposure mode, but lacked the mysterious feeling of the woods. An exposure compensation of -1EV gave it just the right touch.

There are some subjects and scenes that just look better in black and white. "Converting," or removing the color, can be done easily enough in an image-editing program, but here it was captured right in the camera by setting the picture control at "sepia." Working in monochrome helps you see the world differently. Try some subjects and scenes in this mode to get a sense of how it makes you more alert to texture and design (left).

White Balance Customization

White balance controls allow you to compensate for any unusual lighting conditions and obtain true colors in virtually every scene. They act like filters that you might place over the lens to accomplish the same task. If you set white balance for cloudy, for example, the camera adds a warm, amber cast to your image; if you select tungsten, a blue cast will be added to a scene. This is all done with the camera's built-in software.

Another option found on several digital cameras is the custom setting. The way you usually use this feature is by placing a white card under the light you are shooting and pressing the custom key; the software will choose the filtration necessary to give you the proper color under that specific lighting condition. However, you can also use this function for special image effects. Custom works by adding a cast that is complementary to (the opposite of)

the color it detects. If you think of a color wheel used by artists, you can see the complementary color directly across the circle from any chosen color. In this scheme the opposite of blue is yellow and the opposite of magenta is green.

(Upper left) This photograph was made by setting the white balance on cloudy. To change the color, the white balance was set on custom and a piece of blue paper used as the basis for the next image (upper right). The scene was then photographed. Notice how the scene takes on a yellow cast. The same procedure was followed with a sheet of purple paper (bottom left) for a green cast and a yellow sheet of paper (bottom right) for a blue cast. The papers used were from an art set that cost under $5 for 50 different color sheets. While this might seem like a complicated way to get color casts, it shows you how versatile digital cameras can be.

Camera Plus Computer

You can combine effects in your camera with those in your image-editing software. In essence, the software becomes an extension of your camera controls and adds an extra touch to the images you begin to make in your camera. Think of the captured image as a sketch that you refine later. (Top left) This dockside photo was made in standard color mode. The digital camera used to make the picture had a setting for text (identified as black-and-white mode); by switching to this mode, the image becomes more like a drawing than a photograph

(bottom left). (Note that black-and-white mode usually yields a grayscale image. This particular camera produces a strictly black-and-white image—with no gray in between. It is intended for copying documents, but can also be used to convert scenes to resemble pen-and-ink drawings.) The image was then downloaded to a computer, where a color background was added using Add Color (Fill>Color in some programs) with the color opacity (the degree of color intensity) set at 15%. The result looks like a line drawing on colored paper (right).

Stitching

Many digital cameras let you create panoramic pictures with a recording option known as stitching. Once selected, this mode will guide you in making overlapping images that move from one side of the frame to the other. To complete the process, open the pictures on your computer in the camera's stitching software program. Select each picture in order and the program joins them together. Once you save the stitched image, the program crops the side, top, and bottom of any disjointed frames to create a rectangular, panoramic picture, which you can then print or save as a screen image. You can stitch together landscapes, photos of architecture, and even interior rooms. In this Times Square scene, another sort of panoramic has been

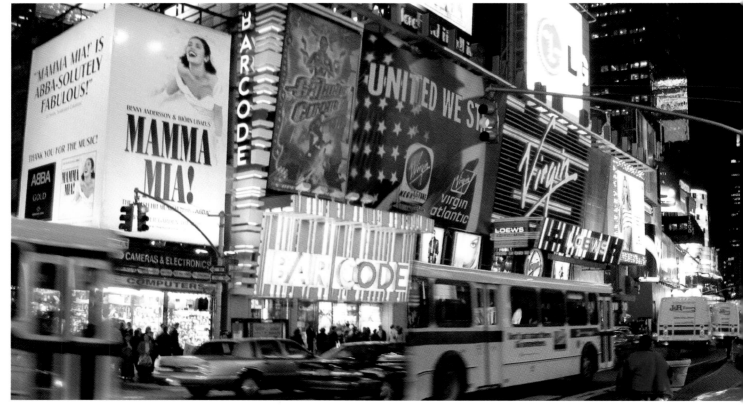

created; one with moving subjects. As the individual frames were recorded (top row), buses and taxis passed by. When the pictures are stitched, something odd happens—we see the same vehicles at different sizes as they move through space (bottom). This rather strange result speaks to the physics of motion and seems to be more a collage than a "straight" panorama.

Pixellate It

Digital images are made up of pixels, each one with its own unique character. A fun thing to do when you first start working with them is to see just what a pixel looks like. You can do this easily enough by opening an image and clicking on it with the zoom key until the picture starts revealing its component parts. (Right) This image was converted to black and white. As a print, it looks all the world like a film-based photograph. However, if you enlarge a film-based photograph greatly you will begin to see the image break down into a salt-and-pepper-like grain pattern. Not so with digital pictures. The next image (bottom left) is made from a very low-resolution copy of the original file. You can see the pattern of boxes emerging. A portion of the image was then selected and the zoom key pressed four times (bottom right). You can now see how all those tiny boxes sit at the heart of a digital image.

Swapping Color

Ten years ago the capability shown in this project was available only on a computerized graphics workstation that cost half a million dollars. Today, you can buy software that accomplishes the same task for under $100. Back then, the computer was used to change colors on products like cars that could be shot once then shown in a catalog with all the available colors. Now it can be used for anything from changing the color of a friend's shirt to adding deeper blue to the sky. This set of images began with a simple shot of chairs on a lawn (top left). Using the Replace Color command, a color was selected and then switched to another of the millions available in every hue, saturation, and tone. The color can be enhanced with higher contrast, darkened or lightened, or eliminated altogether. The variations shown here were accomplished in 5 minutes. This process could be used by a catalog house to show off all their different colors in a brochure, or by you to figure out which color combination would work best in your living room or backyard. Or just for fun.

Specialty Prints

Numerous software programs are dedicated to providing you with templates—predesigned graphic pieces—that you can use for printing your own calendars, postcards, and greeting cards. These are extremely simple to use. Guided tutorials take you every step of the way. Pick an occasion or project (such as a birthday card), choose a design, then add a picture from one of the folders on your hard drive—or from a scanner or digital camera directly. Many programs also link directly to a website that will print your project for you. This involves uploading the image and a credit card order. The projects shown here were made on Microsoft Picture Publisher.

(Below) This calendar page is one of several dozen offered in the program. After the design was chosen, the picture was inserted into the blank space above the dates. You can set the calendar for any year and the program adjusts the days of the week accordingly.

2003

April

S	M	T	W	T	F	S
		1	2	3	4	5
6	7	8	9	10	11	12
13	14	15	16	17	18	19
20	21	22	23	24	25	26
27	28	29	30			

Cards and invitations are also easy to create. You can buy special card stock or print on standard paper. (Left) The front of this card uses a preset design; you can also work with a blank card and fill in your own pictures and type. After printing as a flat sheet, the card is folded into quarters for mailing (below). Folding is perhaps the hardest part of this process—technology has yet to produce a printer that can do this chore for you.

It's A
Birthday
Party!

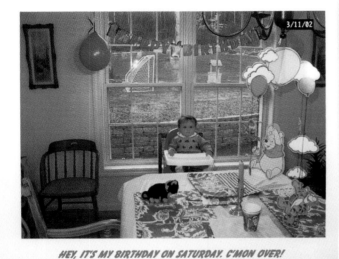

HEY, IT'S MY BIRTHDAY ON SATURDAY. C'MON OVER!

It's A
Birthday
Party!

Some of the fun projects allow you to place images into all sorts of folders, mats, and surroundings Here, Emma graces the inside of a billion-dollar bill.

Scan, Retouch, and Print

Once you have your digital darkroom set up, you can begin to consider projects that use photographs already taken with film or prints from the family album. One worthwhile project is to take the old family album in hand and begin to preserve those precious photographic memories using digital techniques. Old pictures often lack a negative. Many have faded, or show other ravages of time. So pull out that shoebox and start taking on the role of family archivist. Many "family tree" programs allow you to insert pictures and captions about people in the photographs. This is one project that will be cherished by your family, now and in the future.

(Below left) This photograph shows cracks and deterioration. It was scanned into the computer and opened in Photoshop Elements. Using the Rubber Stamp (Clone Stamp) tool, retouching begins. Use Rubber Stamp by picking up areas where there is no damage and pasting them over cracks and lines, working with the zoom tool for accuracy (below right). Once the repairs are done on the face, the background needs attention. Rather than retouch every small nick and crack, the foreground subject was selected using Magnetic Lasso and the selection reversed. This tool allows you to grab onto lines and shapes without resorting to freehand selection, which can be tricky. The reversed selection means that the background can now be changed. This was done with the Gaussian Blur filter (found under Filters>Blur). When you choose this filter, you are presented with a dialog box that allows you to select the degree of blur. The slider was moved until the scratches dissolved (opposite, top left).

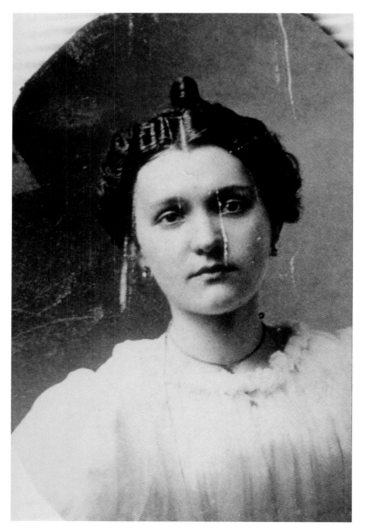

The picture was then cropped with the Crop tool and rotated to correct the tilted position of the original (left). For a final touch, a warm brown tone was added using Edit>Fill with an opacity of 15% (above). The color was chosen from the Color Selection guide, available when you double click on the foreground color box. This image color gives the photograph that old-time feeling.

Color Variations

(Top left) This photograph of colorful umbrellas was made at a flea market. To enliven the scene further the colors were converted using the Replace Color command. With this tool, you can select a color and then easily replace it with another. Keep in mind that all pixels have an address (a color, brightness, and intensity) and that address can be changed (top right). These colors can be altered to any hue and intensity you like. The next variation involves converting the color picture to black and white. This is done with a command known as Desaturate, which eliminates the color but keeps the image file as a color (RGB) record (bottom left). The next stage is adding a sepia tone to the picture. This is accomplished using the Color>Hue/Saturation sliders. Click and

hold the mouse and slide until you get the color you want (bottom right). The picture seems a bit bright, so it is darkened using the Brightness/Contrast control. Click on this tool and use the slider as just described (opposite, top left). Now a special effect filter—a push button control that can be modified—is used. Open the Filter dialog box and play with the options. The Find Edges filter is used here (opposite, top right). The final step is to play with the brightness and contrast, using the controls of the same name, to get the tone and contrast you want (opposite, bottom). As you can see, your ability to play is limitless, and you can spend many hours exploring the multitude of options. This complete set of images was done in approximately 10 minutes.

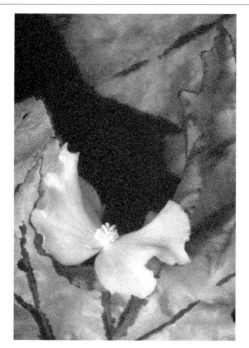

Adding Color

Any tool or technique used in conventional photography can be emulated in the digital darkroom. One of the more personal techniques is adding color to black-and-white photos, a craft that goes back to the first years after the invention of photography. To hand color a photographic print the picture would have to be printed on a matte or textured paper, then colors would be added using special photo oils and pencils. The digital darkroom makes this process easier, as adding colors is simply a matter of defining where you want to place the color, choosing the color, then pushing a button to fill it in. (Top left) This image started as a black-and-white negative that was scanned as a color (RGB) file using a film scanner. To create a warmer look, the Hue/Saturation color controls were chosen and a sepia tone was selected (top right). Some editing programs have a push button for Sepia, which yields the same effect. Three colors were added next: yellow (for the center of the flower), green, and purple (bottom). Each area was highlighted using a Selection tool, which identifies the area on which you want to work and protects the rest of the image from application of the chosen effect. In this case a Lasso tool was used and the selected area drawn freehand. Once each area was highlighted, a color was chosen. To fill in the area, you can use Paintbrush or a function known as Edit>Fill. However the color is added, the opacity is kept low (about 15%) to insure that the color does not obscure the details beneath it. This method lets you add color that is almost transparent. The three colors were added via Selection, Color Pick, and Add Color. This resulted in thinly veiled color on the picture, with some areas left open and without color. Often, when adding color to a black-and white-photo, leaving some areas black and white can be quite effective. To make the photo more vibrant, the entire picture was selected and the Brightness/Contrast controls adjusted (opposite page).

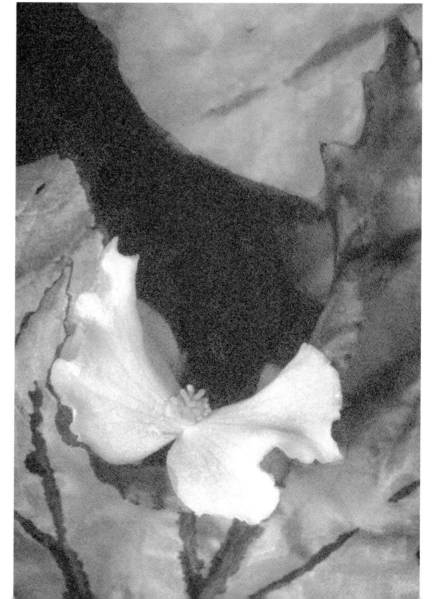

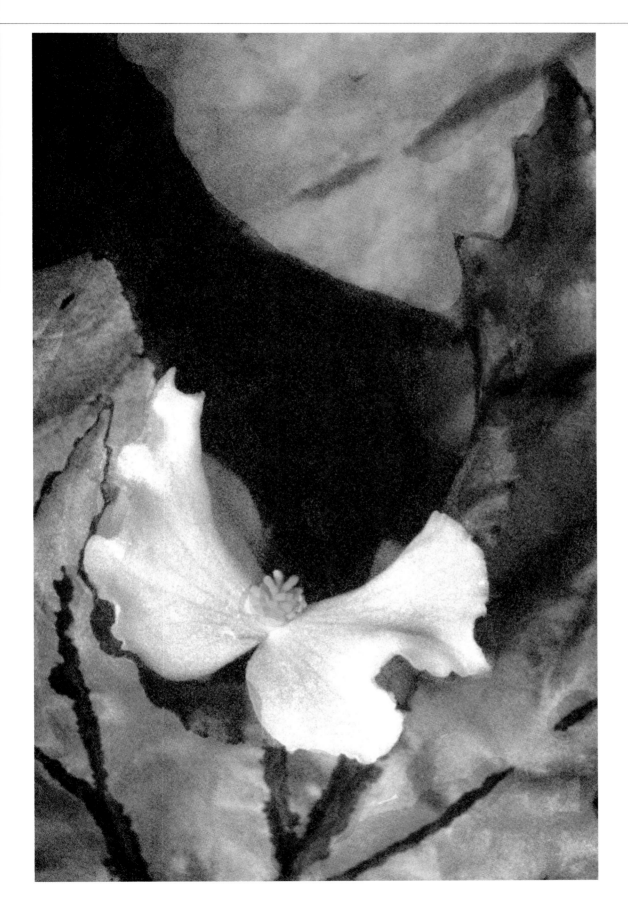

Plug-ins and Filters

Image editing is made easier with items known as filters and plug-ins. These offer everything from sharpening an image to emulating the effect of placing filters over the lens when photographing or adding wild special effects. Filters appear under the Filter menu in Adobe Photoshop products or may be identified via an Effect button or Project in other image software programs. Plug-ins are add-ons to the filters available in the image-editing program. They are called plug-ins because they attach to the Filter menu and supplement those already offered in the program itself. Some filter and plug-in programs can also be used as standalone effects with their own menus.

(Top left) This candid portrait was made with bright light in the background and the subject in the shade of a passing cloud. To brighten the subject, the Fill Flash (Adjust Backlighting) filter was chosen from the Enhance menu in Adobe Photoshop Elements (top right). The background and foreground are still somewhat unbalanced, so two filters from the nik Multimedia Classic Camera set were used: a warming filter (which adds yellow to the scene) and a polarizer (which deepens the sky) (bottom). When the two nik Multimedia Filters are chosen, a dialog box opens that allows you to adjust the degree of each filter's effect (for example, Warm, Polarizer).

Photographs made at high altitude often exhibit a blue cast due to the effect of UV rays and aerial haze. You can correct this to a certain extent by placing a UV haze filter and a slight warming (yellow) filter over the camera lens, or you can fix it later using a filter. (Top) This unfiltered photograph shows a typical result at such heights. Adding a Warm filter from nik Multimedia's Plug-In set solved the problem (bottom).

Graduated density filters are often used by landscape photographers to alleviate the contrast between the sky and ground. The lens filter holds back the light from the sky yet is clear on the bottom. When you use a Graduated Filter plug-in (in this case, from nik Multimedia's Plug-In set) you can control the intensity and area of coverage of this digital darkroom filter. (Left) This sunrise photograph benefits from the addition of a graduated yellow filter (right).

There is a host of special effects filters for every trick, including converting photos to line drawings, creating instant "Impressionist" paintings, and making images appear as if they were drawn with pastels instead of photographed with a camera. Not every subject or scene will benefit from application of these special effects, and when overdone they can ruin an otherwise good photograph. But some subjects, such as this colorful truck (above) seem made for transformation. The Pop Filter from nik Multimedia created this amazing rendition with just a click of the mouse (right).

Color Moods

Color has a great effect on how we perceive the subject and scene in our photographs. A warm color can evoke a friendly feeling, one that can be tinged with nostalgia. Cooler colors can be peaceful and evoke the more somber feelings of dawn or dusk. Think of the colors you might have painted different rooms in your home and how they affect your mood when you're in each space. Some photographs are made in just the right color light, and the prevailing color cast enhances the subject. But many photographs are made in a more neutral light, and it is only in retrospect that you know that a different color atmosphere will complete the picture.

Changing the overall color of any digital image is easy. All you need to do is go to the Color controls in your image-editing program and move a slider or push a button. The beauty of digital imaging is that you can experiment with many different color moods until you find just the right one for your picture. (Right) This photograph was made on a foggy morning just north

of Sacramento, California. To try out the visual effect of different color casts, the Color controls (Hue/Saturation or similar) were used to make both a cooler (bottom left) and warmer (bottom right) rendition. Which one would you choose as your final image?

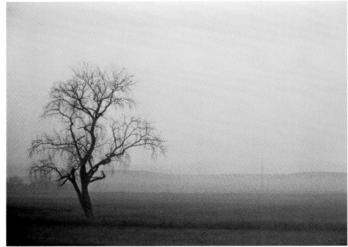

Black and White

Black and white is an exciting form of photographic expression. You can change any picture from color to black and white with ease, even those you get by scanning from film or prints. This is done by using Mode>Grayscale or by Desaturating or the Eliminate Color command. (Left) This photo started out as a color slide that was scanned. It was then converted to black and white. Once the conversion was made, the contrast and brightness were changed to yield a richer value (bottom left). The image was then "toned" to give it a sepia effect (bottom right). This can be done with a Sepia command on some image-editing programs; others allow you to Colorize the picture and use the Hue>Saturation or Replace Color command.

Line Drawings

The graphic capabilities of even the most basic image-editing software programs are astounding. With a few simple steps, you can produce abstractions of subjects that would have taken many hours to accomplish in the conventional darkroom. (Top left) This close-up photograph of an old watch casing is one example. The first step is to eliminate the continuous tone and convert the image to a line drawing. This is done with the Filter menu under an item called Find Edges (top right), available in Photoshop Elements or under a similar name in other programs. The next stage is to get rid of the circle formed by the watch casing edge and clean up the details with a Paintbrush tool loaded with opaque white paint. This blends the details into the white background of the image canvas (bottom left). To complete the pen-and-ink effect, color is eliminated with the Desaturate control (bottom right), or by converting to black and white. Any subject can be given this special treatment to achieve exciting graphic effects.

Glossary

A/D Converter: Analog-to-digital converter, which converts electrical signals or impulses to binary, or digital, form. The component of the image-processing system in digital cameras that translates information from the CCD to the memory card or buffer.

Algorithm: A mathematical process that solves a problem or defines a set of procedures for image file compression or color management.

Aliasing: The visual effect of "stair stepping" of edges that occurs in a too–low-resolution image. This can be caused by using a low-resolution image file to make a print or screen image that is larger than can yield sharp and defined edges.

Ambient Light: The light in the scene, as opposed to the light provided by the photographer with flash, photofloods, etc.

Analog: As opposed to digital; often used to describe film or video tape images.

Angle of View: The maximum angle a lens covers in the field. Measured in degrees, and qualified by terms such as wide-angle, normal, and telephoto. A wide-angle lens has a wider angle of view than a telephoto lens.

Anti-aliasing: Smoothing the edges or tonal areas in an image. Various blending or softening techniques can be used to soften jagged (aliased) edges.

Aperture: The opening of a lens, the size of which is controlled by a diaphragm. The term is commonly used to designate f-stops, such as $f/4$, $f/5.6$, etc. The wider the opening, the lower the f-number—and more light is let through the lens. Each step in aperture represents a halving or doubling of light. Thus, $f/8$ allows in half as much light as $f/5.6$, and twice as much as $f/11$.

Aperture Priority: An autoexposure mode in which, after the photographer selects the aperture, the exposure system selects the appropriate shutter speed for a correct exposure. Sometimes referred to as AV or simply A on exposure mode controls.

Archival: Long lasting. In processing, those procedures that help insure stability of an image. Also, storage materials that will not damage prints or image files.

Archive: In computer imaging, storing the image file off the hard drive for easy access and retrieval when needed.

Artificial Light: Any light not directly produced by the sun. Can be tungsten, flash, household bulb, sodium vapor street lamp, etc. In many cases, the color produced by artificial light is deficient in the blue end of the spectrum, thus white balance settings are required to render "true" or perceived color.

Aspect Ratio: The relationship of height to width.

Autoexposure: A method of exposure where aperture and shutter speed settings are first read, and then set, by the camera's exposure system. Various autoexposure modes allow for customizing or biasing the readings.

Autoexposure (AE) Lock: A push button, switch, or lever that locks in exposure after the initial reading has been made, regardless of a change in camera position or light conditions after the lock is activated. Release of the lock button returns the exposure system to normal. Useful for making highlight or shadow readings of select portions of the frame, and an essential feature for critical exposure control with automated cameras.

Autofocus (AF): A method of focusing where focusing distances are set automatically. A passive phase detection system compares contrast and edge of subjects within the confines of the autofocus brackets in the viewfinder and automatically sets focusing distance on the lens. Autofocusing motors may be in the camera body or lens itself. Active IR (infrared) autofocusing systems may also be used in the form of beams in dedicated autofocus flash units, or, in a few models, built into the camera itself. Commonly found in amateur point-and-shoot cameras. These beams are emitted from the camera or flash, bounce off the subject, then return and set focusing range.

Auxiliary Lens: An add-on optical device that alters the focal length of the prime lens for close-up, telephoto, or other special-effects photography. Close-up devices usually are available in +1, +2, and +3 powers; the higher the number, the greater the magnification.

Auxiliary Light: A flash, strobe, or tungsten lamp or bulbs used to change the character of light in a scene. Any light under the control of the photographer.

Available Light: The light that's normal in a scene, although the term is generally used when the light level is low. Available light shooting usually involves high ISO settings, low shutter speeds and apertures, and/or the use of a tripod.

Averaging: In light metering, the situation where light is read from most of the viewfinder frame and then averaged to yield an overall, standard exposure for a scene. This setup works fine in normal lighting conditions, but may need some additional input when light is flat or contrasty.

B or Bulb: A shutter setting which indicates that the shutter will remain open for as long as the shutter release is pressed. The term originated with the rubber air shutter bulbs used to operate shutters in the old days. B settings are generally used in nighttime and time/motion study photography.

Background: The portion of a scene that sits behind the main, foreground subject. The background can be made sharp or out of focus through the use of selective focusing techniques and depth-of-field manipulation.

Backlighting: Based on camera position, light that comes from behind the subject. Usually, a backlit main subject will be underexposed unless the metering system is set to read selectively off the subject, or exposure on a center-weighted meter is compensated accordingly. *See also* Fill Flash. Extreme backlighting can be exploited to create silhouettes.

Bandwidth: The amount of data that can be transmitted using a modem or patched cord

or over a network. Bandwidth has a profound effect on the speed at which data can be transmitted.

Battery: The power supply of the camera and flash. In today's cameras, no power means no pictures.

Baud Rate: The speed rating of a modem's transmission. Bits per second can also be used. Modem rates may be 28,000 baud, 56,000 baud, etc.

Binary: The numbering system used by computers that uses two digits—0 and 1—to represent all numbers.

Bit: A binary digit that is the smallest piece of information used by a computer.

Bitmap: A graphic file composed of individual pixels.

Black and White: In digital imaging programs, the most common usage is "grayscale," to denote a traditional black-and-white look. In some cameras, this may refer to a high contrast (black-and-white tones only) image.

Blooming: Digital overexposure that distorts color and sharpness and which may be seen as a halo effect around certain areas that have received too much light in exposure.

Blur: Out-of-focus result due to movement of the camera or subject during exposure. Blur can be used for many creative effects. In computer imaging, Blur controls are used to selectively soften parts of an image.

Bounce Light: In flash photography, directing the burst of light from the flash so it literally bounces off a ceiling, wall, or other surface before illuminating the subject. This method of flash is often preferred because it softens the overall light and eliminates the harsh, frontal effect of an on-camera, straightforward flash.

Bracketing: Making exposures above and below the "normal" exposure, or overriding the exposure suggested by the camera's auto-exposure system. Useful as a fail-safe method for getting "correct" exposure in difficult lighting conditions. Bracketing can also be used to make subtle changes in the nuance of tone and light in any scene.

Brightness: The luminance of objects. The brightness of any area of the subject is dependent on how much light falls on it and how reflective it is. Brightness range is the relationship we perceive between the light

and dark subjects in a scene. Brightness contrast is a judgment of the relative measure of that range, such as high, low, or normal. Brightness values are sometimes referred to as EVs (exposure values), a combination of aperture and shutter speed. Brightness values in the scene are translated to tonal values on film.

Buffer: Part of computer memory used for temporary storage of information. Some digital cameras may hold and process image information in the buffer area, allowing other images to be made during processing.

Burning In: In digital darkroom work, giving additional exposure to a portion of an image. Often used to balance tones in contrasty scenes.

Burnt Out: Jargon that refers to loss of details in the highlight portion of a scene due to overexposure.

Byte: A group of 8 bits, used by the computer as units of information.

Calibration: Standardizing different pieces of computer equipment for WYSIWYG ("What You See Is What You Get") results throughout the imaging process. Thus, calibrating a monitor with a printer means that the image on the screen will match the printer output.

Camera: A light-tight box containing a sensor that is used to make images. Today's cameras incorporate microprocessors and sophisticated exposure systems; in a sense, the instrument itself mirrors the age, just as the pictures it makes reflect the world in which we live.

Capture: In digital jargon, taking a picture with a camera or acquiring an image with a scanner.

CCD: Charge-coupled device; the sensor used by most digital cameras, and in print (flatbed) scanners.

CD ROM: A compact disc; able to store a large amount of information. The CD ROM drive reads that information. The CD R is a recordable CD for home and studio use. This and the Photo CD are "write once, read many times" discs; a CD RW is a CD that can be written over, if desired.

Center-weighted Metering: In a metering scheme, an exposure system that takes most of its information from the center portion of the frame. Most center-weighted systems also

take additional readings from the surrounding areas, but weight the reading toward the center.

Chip: Common name for the digital camera's sensor, a silicon wafer with circuit paths etched or printed in layers.

Chroma: Color information. Hue, saturation.

Close Down: *See* Stopping Down.

Close-up: Any photograph made from a distance that is generally closer than our normal viewing distance. Close-up pictures are often startling in the detail they reveal.

CMOS: Complementary metal oxide semiconductor. Currently being used in some digital cameras as the sensor.

CMYK: Cyan, magenta, yellow, black. Color separations used in the printing industry. An optional color mode in computer imaging.

Color Balance: The setting that matches the available or artificial light and faithfully renders color. The default setting of digital cameras is automatic, or daylight balance.

Color Calibration: A software/hardware system that matches color between two digital devices, such as a monitor and printer.

Color Temperature: Described by the Kelvin scale, which is defined in degrees. It is used as a standard for judging the effect a certain light source will have on color rendition.

Composition: The arrangement of subject matter, graphic elements, tones, and light in a scene. Can be harmonious or discordant, depending on the photographer, his or her mood, and the subject at hand. There are no set rules, just suggestions; successful compositions are ones that best express particular feelings about the subject or scene.

Compression: Shrinking a file's size with the use of algorithms. Some compression schemes (called lossy) discard file information in the process; others (called lossless) do not. The image information is reconstructed when the file is opened again. Compression ratios are arrived at by dividing the size of the uncompressed data by the size of the compressed version of the file.

Continuous: The shooting mode that allows for continuous firing without lifting the finger from the shutter release button. In digital SLRs, the mode in which the camera focuses

continually as the subject is tracked. In continuous mode, the camera will fire regardless of whether or not the subject is in focus. In tonality, a smooth range of tones from black to white.

Contrast: The relationship between the lightest and darkest areas in a scene and/or photograph. A small difference means low contrast; a great difference, high contrast. High contrast scenes usually cause the most exposure problems; however, their difficulty can mean they hold the potential for more expression. Though contrast is often linked with scene brightness, there can be low contrast in a bright scene and high contrast in dim light. Contrast can also describe attributes of color, composition, and inherent qualities of film.

Correct Exposure: The combination of aperture and shutter speed that yields a full-toned image and the best possible representation of the scene for the sensor. The constants in an exposure calculation are the ISO or speed of the sensor and the brightness of the scene; the variables are the aperture and shutter speed.

Crop: To select a portion of the full-frame image as the final picture.

Daylight Balanced: A white balance setting that should reproduce colors faithfully when exposed in daylight. This setting can also be used with flash, as properly made flash or strobes yield daylight-balanced light.

Dedicated Flash: A flash that coordinates with the camera's exposure, and sometimes focusing, systems. Dedicated flashes may, among other things, automatically pick up the camera's ISO setting, set the camera shutter speed, and "tell" the camera when it's ready to fire. Flashes dedicated to autofocusing cameras may also vary their angle of flash throw (coverage) according to the lens in use (even with zoom lenses), and contain autofocus beams that aid focusing in very dim light or even total darkness. For outdoor work, dedicated flashes may provide totally automatic fill flash exposure. In short, a dedicated flash can make flash photography as simple as automated natural light photography.

Depth of Field: The zone, or range of distances, within a scene that will record as sharp. Depth of field is influenced by the focal length of the lens in use, the f-stop setting on the lens, and the distance from the camera to the subject. It can be shallow or deep, and can be

totally controlled by the photographer. It is one of the most creative and profound effects available to photographers.

Depth-of-field Preview Button: A switch, button, or electronic push button on digital SLRs that allows the photographer to preview the depth of field of a selected aperture in the viewfinder. During composition the lens is wide open, thus the depth of field in the viewfinder is always that of the maximum aperture of the lens. Preview is very useful for critical selective focus shots.

Diffusion: The spreading of light in various directions as it passes through a translucent material or is reflected from a surface, for example, light coming through the trees in early morning fog. Diffusion filters can be added to a lens to create this effect.

Digital: Information used by the computer, represented by numbers. The buzzword for any capture device that converts photons to electrons. The use of that information to store, manipulate, transmit, or output images in a computer environment. Opposite of analog.

Digital Camera: A filmless camera that converts light energy to digital information and stores that information in a buffer or directly onto a removable memory card.

Digital Darkroom: The computer and image-editing and -manipulation programs.

Digital Zoom: A setting that crops into the image and gives the illusion of using a longer focal length zoom lens. Though it cannot match the quality of an optical zoom, it can bring distant subjects quite close. Often expressed as an X, or magnification factor of the longest setting on the optical zoom, such as 10X.

Digitize: To convert analog (film, print) information to digital form by use of a scanner, digital sensor, or camera.

Disk Drive: A device that may be built into a computer or peripheral apparatus that can read disks.

Dodging: In digital printing and image manipulation, the selective reduction, or lightening, of tonality in certain areas of a scene.

Download: To transfer digital information from one device to another.

DPI: Dots per inch. The output resolution of a printing device. Generally, and with sim-

ilar output systems, the higher the number of dots per inch, the finer the resolution. DPI, however, is not always the best measure of sharpness or quality; these are also dependent on the type of device used, for example, an ink-jet versus dye sublimation printer.

Dye Sublimation Printer: A digital printing output device that forms color with ink ribbons and specially treated paper. Sometimes referred to as a thermal printer.

Dynamic Range: The ability of a sensor to record a range of light, or f-stops.

Electronic Flash: Known as a flashgun, strobe, or speedlight, a device consisting of a gas-filled tube that is fired by an electrical charge. It can be mounted directly on the camera hot shoe (which links the shutter release to the flash firing), or on a bracket or stand, and be connected to the camera via a sync cord.

Enlargement: Making a print larger than the recorded image size.

Equivalent Exposure: Recording the same amount of light, even though aperture and shutter speeds have shifted. For example, an exposure of $f/11$ at 1/125 second is equivalent to an exposure of $f/8$ at 1/250 second.

EV Numbers: A system of expressing exposure that combines apertures and shutter speeds to come up with a number that yields a correct exposure in a certain scene brightness with a certain ISO setting. For example, EV 15 with ISO 100 film might mean 1/1000 second at $f/5.6$, or 1/500 second at $f/8$, and so forth. EV numbers are also used to express a meter's or autofocusing mechanism's range of sensitivity to light.

Exposure: The amount of light that enters the lens and strikes the sensor. Exposures are broken down into aperture, which is the diameter of the opening of the lens, and shutter speed, which is the amount of time the light strikes the film. Thus, exposure is a combination of the intensity and duration of light.

Exposure Compensation Control: A camera function that allows for overriding the automatic exposure reading. The bias, or shift, can be set in full or partial stops. Used in difficult lighting conditions, when the reflective meter might fail (that is, dark or bright value dominance), or for deliberate under- or overexposure of a scene. Can also be used to bracket exposures by partial (one-third or half) stops.

Exposure Meter: Light-reading instrument that yield signals that are translated to *f*-stops and shutter speeds.

F-stops (F-numbers): A series of numbers designating the apertures, or openings, at which a lens is set. The higher the *f*-stop, the narrower the aperture. For example, *f*/16 is narrower (by one stop) than *f*/11—it lets in half as much light. An *f*-stop range might be *f*/2.8, *f*/4, *f*/5.6, *f*/8, and *f*/11.

Fast: A term used to describe a sensor with a relatively high light sensitivity, a lens with a relatively wide maximum aperture, or a shutter speed, such as 1/1000 second, that will freeze quick action.

File Format: An arrangement of digital information that may be particular to an application or generally adopted for use by a wide range of devices. Image formats in wide use include JPEG, TIFF, and GIF. RAW formats are proprietary to a particular camera system.

Fill Flash: "Fill-in" flash. Flash used outdoors generally to balance the exposure of a subject that is backlit. Can also be used to control excessive contrast, add light to shadows, or brighten colors on an overcast day.

Film: A compilation of light-sensitive silver salts, color couplers (in color film), and other materials suspended in an emulsion and coated on an acetate base.

Film Scanner: A device used to digitize film images. The negative or positive film is inserted into the scanner using holders. As opposed to a print or flatbed scanner.

Filters: In computer-imaging software, a set of instructions that shapes or alters image information.

Flare: In lenses, internal reflections and/or stray light that can cause fogging or light-streak marks on film. In general, zoom lenses have more potential for flare than fixed-focal-length lenses; in either case a screw-on lens hood helps reduce the problem.

Flash: The common term used to describe light produced by passing electrical current through gas in a glass tube.

Flash Memory: A special type of RAM memory that can hold data without electrical current. It is used in memory cards, the removable "digital film" used in digital cameras.

Flat: Low in contrast, usually caused by underexposure. Flat light shows no change

in brightness value throughout the entire scene.

Flatbed Scanner: *See* Print Scanner.

Floppy Disk: A magnetically coated disk for storage of digital information.

Focal Length: The distance from the lens to the film plane or sensor that focuses light at infinity. The length, expressed in millimeters, is more useful as an indication of the angle of view of a particular lens.

Focus: Causing light to form a point, or sharp image, on the image sensor.

Focus Lock: In autofocus camera systems, a button, lever, or push button control that locks focus at a particular distance setting, often used when the main subject is off to the side of the frame or not covered by the autofocus brackets in the viewfinder.

Format: In memory cards, the type of card, such as CompactFlash, SmartMedia, etc. In image files, the choice of JPEG, TIFF, etc.

Frame: The outer borders of a picture, or its ratio of height to width. The individual image on a memory card. Also, to compose a picture.

Frame Grabber: Usually refers to a program that can digitize and process video signals to a single frame.

Gamma: A value that defines contrast of an electronic image. Gamma curves are key elements of monitor calibration. Gamma can be changed in an electronic image by working the curves in advanced programs.

Gamut: The range of colors available in an image or printer.

GIF: Animation file.

Gigabyte (GB): One billion bytes, or 1000 megabytes.

Grain: *See* Noise.

Grayscale: The range of tones, from bright white to pitch black, that can be reproduced in a print.

Hard Copy: In computer imaging, the physical manifestation of an image.

High Contrast: A scene where the range between the brightest and darkest areas is extreme, or is such that it may cause exposure problems. The absence of middle grays.

High Key: An image that relies on the

lighter shades of gray or pale colors for its effect, or one that is overexposed to yield an ethereal look. Often used in fashion, glamour, nature, and portrait photography.

Highlights: The brightest parts of a scene that yield texture or image information.

High Resolution: A relative term that defines the input and output quality of digital images (for example, sharpness, continuous tone). High resolution usually stems from a large image file and the quality of the output device.

Home Page: The main page or portal for a website.

Hot: Very intense colors. High color saturation. Also, highly reflective surfaces that can cause exposure problems. Any overexposed highlights.

Hot Shoe: The mount on the camera body in which electronic flashes are secured. Hot shoes usually contain electrical contact points that signal the flash to discharge when the shutter is fired.

HTML: Hypertext Markup Language. The coding used for creating web pages.

HTTP: Hypertext Transfer Protocol. The method used to retrieve web pages and documents from the web.

Hue: Color, as defined by words such as yellow, blue, pink, etc.

Image: A fancy word for picture.

Import: Bringing a file into an application. Bringing image information into a working environment.

Infinity: On a camera lens distance scale, the distance greater than the last finite number, and beyond. Infinity mode sets the camera's lens at this distance and is used to overcome autofocusing systems that cannot focus at long distances due to obstructions (such as glass) that cause focusing problems.

Ink-jet Printer: A printer that sprays ink onto paper or other substrate.

Input: Sending information to a computer.

Interactive: The relationship between the user and his or her application. Interactive applications allow the user to respond to prompts from the application or software.

Internet: The World Wide Web, a network of servers and connections that link com-

puter users all around the world. A generic term used to describe a connection between a desktop computer and the web.

Interpolation: *See* Resampling.

ISO: Three letters that stand for International Standards Organization, the group that standardizes, among other things, the relative speed of sensors. ISO numbers indicate the relative light sensitivity of sensors; a higher number indicates greater light sensitivity.

Jaggies: A general term that describes poor image quality in digital images, usually as a result of too-low resolution. This shows as a stair-step pattern in lines or tonal edges.

JPEG: A type of graphics file format that is often used for compressing large image files for transmission or display.

Kelvin: A temperature-measuring scale used to describe the color of light. Lower temperatures describe light with a reddish or yellowish cast; higher temperatures describe light tending more toward blue or magenta.

Kilobyte (K): 1024 bytes.

Landscape Mode: Orienting an image so that it is wider than it is tall. As opposed to portrait mode, which describes an image that is taller than it is wide. Also, an exposure mode that favors a narrow aperture and/or infinity focus setting.

LCD: Liquid Crystal Display. Usually the form of display on camera monitors.

LED: Light-Emitting Diode. Usually the form of display on a camera's top panel that shows camera settings.

Lens: A combination of shaped glasses and air spaces set in a specific arrangement within a barrel. Focusing is accomplished by changing the relationship of the elements in the lens to the film plane. The other function is to control the amount of light hitting the film by use of its aperture. Autofocusing lenses may contain small motors for moving the lens back and forth in response to changes in focus.

Lossless and Lossy Compression: Lossless compression is any technique or format that reduces file size with no loss of image information. Lossy compression usually involves some loss of image information during compression.

Low Key: A scene with no bright tones or highlights. Usually imparts a somber, moody feeling.

Luminance: The brightness of a signal or scene.

Macro: Another term for close-up photography, but specifically referring to taking pictures at or near life size. Can be defined as a ratio; for example, a 1:2 ratio means that the image on film is half the full size of the object in nature.

Manual: An exposure mode where the exposure system recommends a setting that is then used by the photographer to select aperture and shutter speeds manually. The booklet one doesn't read before using a piece of equipment.

Matrix Metering: A type of metering system that reads various parts of the scene and then calculates exposure using a built-in microprocessor. The system, also known as Evaluative or Intelligent metering, often compares the data with information stored in the microprocessor's memory to arrive at an exposure setting.

Maximum Aperture: The widest opening, or ƒ-stop, a lens affords. An ƒ/1.4 lens is referred to as fast because it has a relatively wide maximum aperture; an ƒ/4.5 lens is slow because of its relatively narrow maximum aperture. Fast lenses come in handy for handheld low-light photography.

Megabyte (MB): 1024 kilobytes.

Memory Card and Memory Card Reader: A memory card is the common name for a PCMCIA, CompactFlash, or SmartMedia card. These cards are the "film" for digital cameras, in that they can be removed from the camera for downloading the images into a computer. They come in various MB configurations, ranging from 8 MB to 1 GB. A memory card reader is a small device that patches right into the computer for easy downloading.

Menu: The available tools, functions, and commands in a computer-imaging (or any software) program.

MHz (Megahertz): The unit of measurement that relates to the processing speed of a computer.

Microprocessor: A combination of transistors that performs specific operations. Microprocessors are found in computers and all digital cameras.

Minimum Aperture: The smallest opening a lens affords.

Mode: A way of doing things. Exposure modes are pre-programmed, user-selectable ways of controlling the readings from the exposure system to meet certain subject or picture conditions. Modes include aperture priority, shutter priority, portrait, etc. Autofocusing modes allow a choice of how the camera/lens will go about autofocusing.

Modem: A computer peripheral that allows a computer to communicate via phone lines.

Monitor: The visual system in a computer. The screen.

Mount: In lenses, a specific set of pins and cams that couple a particular lens to a particular camera body. In digital SLRs, you must use the mount specifically designed for a specific camera brand.

Noise: A random pattern of pixels that interferes with an image. Also called artifacts. Noise most commonly occurs when shooting at high ISOs or in very low light without flash.

On-line: On the Internet.

OS: Operating system.

Output: To send data to a printer or other device.

Overexposure: In exposure, when too much light strikes the film for a proper rendition of the scene. Minor overexposure may cause a loss of details or texture in the scene highlights; severe overexposure will cause a serious deterioration of picture quality.

Overrides: Making adjustments or intervening to change the camera's autoexposure system reading. Some overrides include exposure compensation and changing ISO ratings.

Palette: The range of colors available.

Panning: A shooting technique where the subject is followed during exposure; generally done with a slow shutter speed.

Perspective: The relationship of objects near and far, or impression of depth when a three-dimensional scene is rendered on a two-dimensional plane.

Photo CD: A compact disc on which images are digitized and stored. Available from many processing labs and service bureaus.

Photofinishing: Generally, handing your image files to a service provider for prints or CD ROMs.

Photography: Writing with light.

Pixel: The picture element that forms the basis for digital imaging. Analogous to the grain in photographic film.

Pixel Resolution: The pixels per inch in an image, such as 640 x 480.

Plug and Play: Equipment and peripherals designed for quick and easy installation.

Plug-ins: Software products that work with host software to add functionality to that software. For example, many companies make plug-ins for Adobe Photoshop that add to that software's Filter Set. Some plug-ins can also work as standalone applications.

Point and Shoot: Generally used to describe cameras that have an integral lens, as opposed to single lens reflex cameras, which offer interchangeable lenses. Also refers to a fully automatic type of photography where all the user needs to do is aim the camera at the subject (point) and press the shutter release (shoot) to make a picture.

Portrait Mode: Orienting an image so that it is taller than it is wide. As opposed to landscape mode, which describes an image that is wider than it is tall. Also, an exposure mode that favors a faster shutter speed and wider aperture.

Posterization: A process that limits the number of color levels, thus making transitions between colors more abrupt.

PPI: Pixels per inch. The basis for figuring image size, file size, and, ultimately, image quality. Generally, the higher the ppi of an image, the better the image quality for larger output.

Print (Flatbed) Scanner: A scanner that uses a linear CCD array for digitizing prints. Generally, an image is placed on a glass plate and the array moves past the artwork.

Program Exposure Mode: A preset arrangement of aperture and shutter speed that is programmed into the exposure system of a camera to respond to a certain level of brightness when the camera is set at a certain ISO. Also known as automatic.

RAM: Random access memory. The memory that stores data as an image is being worked on. For image processing, the more RAM the better.

Rangefinder: A type of viewing system in cameras where the viewfinder is not directly linked to the lens, as opposed to a single lens reflex camera, where it is. A rangefinder camera usually provides a full framing of the scene, although when close-up pictures are made there may be some offset between what is recorded and what is seen through the viewfinder. This effect, known as parallax, must be compensated for when framing through the viewfinder. In most cases close-up photographs with this type of camera are best framed through the camera's LCD monitor.

RAW: A proprietary image file format that comes with some digital cameras. This format delivers a file equivalent of a TIFF, but takes up less space on the memory card.

Resampling (Interpolation): When image size is changed, the process by which the computer adds data. Generally, when raising image size, the computer averages adjacent pixels and adds data.

Resolution: In digital imaging, the pixel density of an image. In film photography, the ability of a film to resolve fine detail. In lenses, the ability of the lens to render sharp detail.

RGB: Red, green, blue. A color mode in digital imaging, used with desktop printers and other output devices.

ROM: Read only memory. A memory type that cannot be changed, and will not be lost when a computer is shut down.

Saturation: In color, a vividness, or intensity.

Scanner: Any device that converts film or photos to digital data. A film scanner is dedicated to working with film images, and may handle one or more formats. A print (flatbed) scanner is used for flat art, such as prints, although it may have an optional accessory film scanner. A drum scanner is for very high resolution scans, and is used mainly in the printing business.

Scene Mode: Matching an automatic exposure program with the type of scene at hand, such as portrait, landscape, night scene, etc. The system responds by choosing settings that can enhance the chances of making a more successful picture. In general, this works fine, but, being a program, cannot always handle every situation.

Selective Focus: The creative use of focus. This can be set so that one plane or subject in a crowded scene emerges, or for total sharpness (near to far) in a scene that covers miles. Selective focus is achieved through the use of various focal length lenses, by altering camera-to-subject distance, and by changing *f*-stop settings.

Shadow: In photography, usually defined as those details or image information contained in the darker areas of a scene.

Sharpness: The perception that a picture, or parts of a picture, are in focus. Also, the rendition of edges or tonal borders.

Shutter Priority: An autoexposure mode where the shutter speed is user selected and the exposure system chooses an appropriate aperture for correct exposure.

Shutter Release Button: The button that releases the shutter and "fires" the camera. Many shutter release buttons work in two stages—slight pressure actuates the meter or autofocus system (or both), then further pressure fires the shutter.

Shutter Speed: An element of exposure; the duration of time in which light is allowed to strike the film or sensor.

Silver Halide: A compound containing silver, the crystals of which are the light-sensitive element in film.

Single: In autofocus digital SLRs, the mode in which the camera will not allow the shutter to be released until the detector has locked focus on a subject. In frame advance, the mode in which the shutter is released only once when the shutter release button is pressed; sequential shooting requires repeated pressure on the shutter release button.

Single Lens Reflex (SLR): A type of camera that has a movable mirror behind the lens and a ground glass for viewing the image. The sensor sits behind the mirror assembly, which swings out of the way when an exposure is made. "Single-lens" distinguishes it from rangefinder and point-and-shoot type cameras, in which the viewing angle is displaced and separate lenses are used for viewing and determining the exposure.

Slow: A term used to describe a sensor with a relatively low sensitivity to light, a lens with a

fairly narrow maximum aperture, or a shutter speed at or below 1/30 second.

Soft Focus: A picture, or an area in a picture, that is left slightly out of focus for effect, or a lens or filter that diffuses light and "softens" the overall scene.

Solarization: An image effect where colors and tonal values are reversed in parts of the scene. This special effect can be created with ease using the Filters or Special Effects menus.

Special Effects: Any technique that converts or distorts the "reality" of nature in a picture. Special effects can be sublime or ridiculous, depending on the subtlety with which they're used.

Speed: With a shutter, the duration of time in which light strikes the film. With a sensor, the sensitivity to light. With a lens, the maximum aperture. All can be described as fast, medium, or slow.

Spot Metering: Taking an exposure reading from a very select portion of the frame. Cameras with built-in spot metering indicate this portion with a circular ring in the viewfinder screen. Some spot meters have coverage as broad as 8 degrees (this might also be called selective field metering) or as narrow as 1 degree.

Stop: A relative measure of light that can be used to describe an aperture or shutter speed, although it is more commonly used with aperture settings. A difference of one stop indicates half or double the amount of light. To stop down means to narrow the aperture; to open up means to expand it.

Stopping Down (Closing Down): Jargon that refers to making a photograph with less exposure than previously used. With apertures, using a narrower aperture; with shutter speed, using a faster shutter speed. For example, switching from f/8 to f/11 means stopping down the lens by one stop.

Sychronization or Sync: The timing of the firing of the flash to coincide with the opening of the shutter so that the maximum light from that flash records on the film.

Telephoto: A generic name for a lens with a focal length higher than 50mm and an angle of view less than 45 degrees (with 35mm format). A moderate telephoto might be in the 80mm range, a medium telephoto around 135mm, while a long-range, or extreme, telephoto might have a 300mm or higher focal length.

Thumbnail: A small, low-resolution version of an image. Used as a quick reference in image filing and archiving programs.

TIFF: An acronym for Tagged Image File Format. An uncompressed file format.

Time Exposure: A long exposure, usually not handheld, for recording scenes at night or in very dim rooms.

Tone: When used to refer to the grayscale, a step in the gradual movement from black to white. The quality of light in a picture. Tones are the range of dark to light that make up the recorded image, and may or may not match the original brightness values in the scene. Tones can be altered through exposure or later when prints are made; they can also describe a certain overall cast, or hue. Like many terms in photography, "tone" comes from music, and can be described as high or low, resonant, or discordant.

Tripod: A three-legged device with a platform or head for attaching a camera, used to steady the camera during exposure. It is most useful for exposures longer than 1/30 second, or when a constant framing must be maintained throughout a series of shots.

TTL: Through-the-lens metering.

Twain: A standard protocol for cross-platform communication from scanner or digital input device to the computer.

Underexposure: Failure to expose correctly because not enough light has struck the sensor to faithfully render the color and brightness values. Underexposed pictures are dark; the more the underexposure the darker they become. Color also suffers.

Upload: To transfer digital information to one device from another.

URL: Universal Resource Locator. The address of a website or document on the World Wide Web.

USB: Universal serial bus. A common patch between computer devices.

Viewfinder: The viewing screen on which composition takes place; viewfinders may also contain various guides to exposure, focus, and flash readiness. In some cameras, the control panel lets you control these functions without removing your eye from the camera.

Washed Out: Jargon for seriously overexposed highlight areas. It's as if the colors have been diluted to the extent that all pigments have been "washed out."

Website: Any location on the web.

White Balance: An adjustment made to a signal to insure that white will record as white.

Wide-angle Lens: A lens that offers a wide angle of view.

WYSIWYG: "What You See Is What You Get." The aim of calibration and matching input and output devices to yield the same results.

Zoom Lens: A lens on which the focal length can be varied, as opposed to a fixed-focal length lens. Zooms come in various focal length ranges.

Resources

The World Wide Web is a tremendous resource for all things digital. The list that follows includes those sites that are geared toward digital photography. Many of the company sites offer a wide range of information and services. For example, the Kodak website offers product information, photography tips, and even on-line processing services. Nikon's site offers upgrades on their equipment as well as full instruction manuals, plus other tips and techniques. Use these sites as a resource to help expand your digital photography experience.

To help alleviate repetition, we have eliminated the www. prefix from all the listed sites. To address any site, use www.name

Acdsystems.com
Presentation, storage, and editing software

Adobe.com
Tips, upgrades, and all things Photoshop

Agfanet.com
A photo company with an on-line finishing service

Apple.com
For all things Apple

Casio.com
Digital cameras

Delkin.com
Memory card readers and other digital accessories

Epson.com
Printers and tips

Flipalbum.com
A unique presentation system for digital images

Fujifilm.com
Fuji digital cameras and on-line finishing

Hp.com
Printers and supplies

Jobodigital.com
Portable digital storage devices

Kodak.com
A very comprehensive site

Lexarmedia.com
Memory cards and readers

Minoltausa.com
Cameras and scanners

Nikonusa.com
A very instructive and fun site

Nyip.com
Digital lessons and more

Olympus.com
Digital cameras

Photoflex.com
Lighting gear, plus a web photo school

Pictorico.com
Ink-jet papers and profiles

Roxio.com
Software

Sandisk.com
Memory cards and readers

Shutterbug.net
Archived articles and reviews

Sony.com
Cameras and more

Usa.canon.com
Canon digital cameras and more

Wilhelm-research.com
Archival research on papers, inks

Index

Accessories, 36
Action exposure mode, 41
Album-sharing websites, 111
Aperture, 38, 39, 41
Aperture-priority (AV) mode, 43, 44
Archiving images, 88–89
Autofocusing systems, 52–54

Batteries, 32, 69, 84
Bits and bytes, 24
Black-and-white, 18
 adding color, 140
 converting color to, 96, 129, 149, 150
 monochrome option, 78
 pen-and-ink effect, 131, 150
Blur tool, 96, 98, 99
Bracketing exposure, 50
Brightness
 monitor, 81
 scene, 37, 38
Brightness control, 95, 140

Camera, digital, 9
 customization, 69
 dockable, 87
 formats, 16
 memory cards, 18, 27, 28, 32, 61
 operating systems, 35–36
 sensor, 17, 21–26
 software, 83
Camera, film, 13, 35
Camera shake, 41, 64–65
Card readers, 30, 32, 86, 87
Close-up focusing, 43, 44, 54, 55
Color
 adding, 142
 moods, 96, 148
 paint tool, 98, 99
 Replace Color command, 135, 140
 saturation, 67, 77, 128
 white balance controls, 18, 63, 64, 96, 97, 130
Composition, 124–26
Compression, 27, 72, 73
Computers
 compatibility problems, 29, 83
 printing with, 104–5
 storage, 29–30, 33
 See also Software
Contact sheets, 107

Continuous shooting mode, 72, 74
Contrast control, 67–68, 75, 95–96, 140
Copying files, 91
Crop tool, 94, 99, 139

Digital photography *vs* film photography, 15–19
Digital Print Order Format (DPOF), 68, 80, 102
Dots per inch (DPI), 26
Downloading images, 30, 84–85, 87
DPOF (Digital Print Order Format), 68, 80, 102
Drive modes, 36, 72, 74
Dye sublimation printers, 30, 101

E-books, 115
Editing, 93–99
 on-line, 114
 software, 29, 30, 31, 91–92, 131
E-mail pictures, 111–12
Erasure button, 79
EV (exposure value), 37, 41, 47
Exposure, 36, 37–51, 73
 compensation, 47–49, 75, 76, 126, 129
 metering, 44–47, 127

File folders, 69, 79, 88
File format, 27–28, 71, 73, 79, 88
File names, 84, 88
File numbers, 79, 89
File size, 24–25, 105, 113, 114
Fill flash, 58, 59, 60
Film photography, 13–14
Filters, 144–47
Flash, 36, 47, 58–60, 66
Focal length, 54, 56, 57
Focusing, 52–57

Graduated density filters, 146

Hard drive capacity, 29
Histogram, 63, 75, 76

Ink, selecting, 101–2
Ink-jet printers, 30, 101
ISO settings, 37, 38, 41, 50, 64–66

JPEG (Joint Photographic Experts Group)
 format, 27–28, 71, 81, 88, 111

Landscape exposure mode, 42
LCD monitor, 18, 32, 35, 71, 103
LED (light-emitting diode), 52
Lenses, 36
 focal length, 54, 56, 57
 telephoto, 56, 57, 65
 wide-angle, 56
 zoom, 57, 61, 62, 74
Light
 contrast, 67–68, 95–96
 ISO settings, 64–66
 metering, 44–47
 scene brightness, 37, 38
 white balance controls, 18, 63, 64, 128, 130

Macro mode, 43, 44, 54, 55
Megapixel count, 22–23, 24
Memory cards, 18, 32, 61
 capacity, 27, 28
 erasure, 79
 readers, 30, 32, 86, 87
Memory settings, 81
Metering, 44–47, 127
Monitors
 brightness, 81
 LCD, 18, 32
 size of, 30
Motion JPEG format, 68

Opening files, 91, 92
Overexposure, 47, 75

Paint tool, 98, 99
Panorama option, 68
Panoramic pictures, 132–33
Paper, selecting, 101
Pen-and-ink effect, 131, 150
Photographic eye, 123
Pixels, 15, 21, 134
 dimension, 24–25
 megapixel count, 22–23, 24
Pixels per inch (PPI), 26
Playback mode, 61, 63, 75, 80
Plug-ins, 144
Portrait exposure mode, 41
Preview, instant, 18, 35, 61
Printers, 30, 101, 103
Print Image Matching (PIM), 104
Printing, 16, 18, 100–109

kiosk/lab, 109
 problems/solutions, 108
 templates, 136–37
Print size, 24, 25

Random access memory (RAM), 29
RAW format, 27, 71, 87
Record menu, 71–78
Red-eye reduction, 58, 98
Redo button, 98
Reset function, 81
Resolution
 for e-mail pictures, 111
 file size and, 22, 24, 105
 input/output, 26
 memory card capacity and, 27, 73
 record menu, 71
Retouching, 138
Review mode, 61, 75, 80
Rotate tool, 93
Rubber Stamp tool, 138

Save as command, 88
Scanning
 print photos, 120, 138–39
 services, 121
 software, 119–20
Sensors, 17, 21–26
Sepia tone, 78, 96, 140
Setup menu, 81
Sharpness, 66–67, 77, 96
Shutter-priority (TV) mode, 44
Shutter release sound, 81
Shutter speed, 40–41, 50–51, 65–66
Slide show, on-line, 115
Slow syncho mode, 60

Software
 compatibility, 83
 downloading, 30, 84–85
 image-editing, 29, 30, 31, 91–92, 131
 image-organizing, 88
 printer, 102
 scanner, 119–20
Sports exposure mode, 41
Spot meter, 46, 47, 127
Stitching mode, 132–33
Storage devices, 29–30
 portable, 33

Telephoto lens, 56, 57, 65
Text command, 98
TIFF (Tagged Image File Format), 27–28,
 71, 81, 87, 88, 111

Underexposure, 75
Undo, 98
UV haze filter, 145

Viewers, 19
Viewfinder, 35, 45, 52

Websites
 album-sharing, 113
 building, 116–17
 community, 115
White balance controls, 18, 63, 64, 96, 97,
 128, 130
Wide-angle lens, 56

Zoom lens, 57, 61, 62, 74
Zoom tool, 98